MOON TOAST

© 2020 Greg S. Close

Printed in the United States of America

Cover Design: Pamela Russell

Ingram Content Group LLC
Ingram Blvd.
La Vergne, TN 37086

MOON TOAST

Facing Death and Adventures in the Wilds of Alaska
Recipes Included

Greg S. Close

Ingram Content Group LLC
La Vergne, TN 37086

This novel is based on actual events. It is dedicated to the courageous, hard-working men and women of the United States and Canadian Pacific Fishing Fleets, and their families.

I would like to express unlimited gratitude to my Dear Mother, Nina, My Incredible Son, Brandon, and the Love of My Life, Pamela

TABLE OF CONTENTS

Fish On...6

Good News, Bad News.........................14

Cut and Run..17

Storm Clouds...22

Strange Customs...................................26

Alcanned..32

Williams Lake to Prince George..........35

Grazing Shipmates...............................40

Ferry Princess – Part One....................43

Ferry Princess – Part Two....................49

Hotel Juneau...57

Looking for Work..................................60

Pink Castles...68

Shoe Dogs and French Fries................70

Meeting Mo...72

TABLE OF CONTENTS (cont.)

Smoked Burgers and Cold Storages......76
Outfitting...80
First Day at JCS..83
Lord of the Rings.....................................93
Packed in Ice...100
Sheila's Uncle..108
I'll Flip You for It.....................................111
Shark Attack..117
Home is Where the Adobo Is................121
Ice Palaces..128
Frozen Frolics...135
The Eagle Flies with the Dove.............139
Encounter with the Devil.....................141
The Devil's Advocate.............................145
Glacier Bay...150
A Spot of Cappuccino...........................152
Becky...155
Meeting the Empress............................159
Bar Belles...164
Becky's Journey.....................................171
Red Gravy...176
Ringo...178

TABLE OF CONTENTS (cont.)

Dinner Party.............................183

Bugs......................................189

Making Waves in Lituya Bay...........194

Fairweather Friends...................197

Rebirth..................................202

Brokedown..............................205

The Seeker.............................207

Acid Test...............................213

Water Haul............................217

Blessings...............................224

Yakataga...............................226

Run for the Reef.......................228

Hard Day's Night......................231

Icy Bay.................................234

Calm Before the Storm................240

Death in the Air......................244

Into the Fire...........................248

I've Got Dreams to Remember.........257

A Load Lifted..........................261

Fish On

"Bet you goin' fishin' all of the time, I'm a-goin' fishin' too
Bet your life, your sweet life, gonna catch mo' fish than you."
-Taj Mahal

My alarm clock was the big new 8-92 Detroit Diesel engine starting up two feet from my head. Bleary-eyed, I pulled on my clothes, crusted with halibut slime, and struggled into my rubber boots. Pulling myself up the steep wooden stairs from the engine room, I emerged into the galley, ears ringing.

Phil had opened the deck door, and the twenty-knot breeze was blowing into the cabin, pushing through the heat coming off the oil stove and clearing the thick oily air of the fo'c'sle from my lungs. He was sitting at the chart table, coffee in front of him, cigarette in his mouth, studying the chart of Yakataga Reef, and rubbing DMSO into his crippled left hand. Smoke encircled his head like a wreath. His eyes were not twinkling. His cheeks were not merry. The truth was, he looked downright nasty. His matted beard, piercing gray-green eyes, filthy Ragg-wool sweater, and maimed hand gave him the look of a battle-worn Nordic Rasputin. He looked up and nodded to me as I passed. I nodded back. We didn't talk much at that hour. The ship's clock read 0408. The cassette deck by the wheel was softly playing "Stairway to Heaven." Page sounded in my sleep-deprived haze like he was singing, "Is there a bustle in your hedgehog, don't be a bullfrog..."

Cappuccino, our ship's dog, stood up as I walked over the top of him to get to the coffee pot sitting on the oil stove. He always lay right next to the stove to stay warm. He just about knocked me over, his one hundred-twenty pound Rottweiler-Golden Retriever body taking up half the cabin. I scratched his ears with one hand while pouring a cup of coffeewith the other. Adding a

big spoonful of honey and some cream from the icebox, I walked over to the doorway while automatically picking out the coffee grounds and a bit of eggshell floating on top. Standing there, I took deep breaths of the morning air. The salty wind flowed into me like electricity. I shivered a little from its power, feeling energized in my very soul. I knew today was going to be monumental. I took a big gulp of the hot, sweet, and creamy drink. *What day was this? Monday, September 4, 1976. Only two days to my twenty-second birthday.*

I passed through the galley door and walked outside on-deck. I automatically reached up with my free hand to touch our ship's motto hanging over the door, a yellow-cedar sign I'd had engraved at a woodcarver on the docks of Seattle three winters ago. *'Whatever it Takes.'* The plank was mottled and darkened with the oil of our hands and splattered with fish scales from being touched a thousand times.

The pre-dawn gave the horizon the color of an unripe orange, a pale yellow-green, while the sky immediately overhead was a deep midnight blue-black, the stars pulsing white. I always wanted a Ferrari that color of blue. With dove-gray leather upholstery. *Fat chance.* By habit, I found the Big Dipper, then the Little Dipper, then Draco the Dragon. I looked for Cassiopeia, my sister Maria's favorite constellation, but the Aurora Borealis was dancing right across her location. This morning the curtain of dancing lights looked mint green. I thought of mint chocolate-chip ice cream and wished we had a fancy new freezer boat. I missed ice cream. *And Popsicles.*

The fishing vessel Devil's Advocate was drifting nearly due north, which brought the wind from the south-south-east. The three-quarter moon was still up high, lighting up the deck and glinting off of the stainless-steel cables and hardware. I looked toward the wind, feeling it sharp and clean against my unshaven face. This was my favorite time of day, an hour before sunrise, and it felt good to be alive. It was going to be a glorious day. The light wind was dancing off the tops of the six-foot seas, and the boat was creaking and talking to me, anxious to begin its work.

"Great fishing weather," I said out loud to the world. Let's

knock the bastards dead today, fill this thing up and head for home. I tossed the last bit of coffee over the side, watching the cream disperse in the water. I considered it a sacrifice to the sea gods. *Couldn't hurt.* I set my lucky mug on the hatch-cover, thinking about warm kitchens and wood stoves. I missed a cozy warm bed with a down comforter, wanting to sit down to a thick steak. I was getting weary of sleeping in a diesel oil-smelling sleeping bag all the time. I missed the warmth of a woman's body, too. I shook off that thought. There was no time to waste on the Hornies now with a long day ahead. I'd save the memory of Becki's soft breasts for my bunk tonight if I wasn't too exhausted.

The Skipper came out on deck, holding two more cups of coffee, clouds of steam pouring out like pre-eruptive volcanoes.

He sniffed one and handed it to me, his nose wrinkling. "Cream and honey. How in the name of God can you drink coffee full of all that shit?" He said that almost every time he made coffee for me, it was becoming a tradition between us.

We sat down together on the gunnels, and I sipped my second cup of the day. For ten minutes or so, we just sat there, letting everything sink in. The ponderous boat rose and fell in the swells. This was what fishing was all about for me. Early mornings, beautiful weather, and the promise of hours of gratifying, though backbreaking, work. At the end of the day, you could look down into the hold and see everything that you had accomplished. Yesterday we had pulled in three fish over one hundred pounds. *Whales.* One had been close to one seventy-five. I had never seen three whales in one day before! Halibut that big were becoming almost impossible to find.

Phil drained his cup of black coffee and stood up. He took my empty mug, picked the one up off the hatch, then looked south to check the weather and gave me a huge grin. "Looks like an easy day, Stu. Let's get into position and get ready."

I pulled the sea-anchor on board, stowed it, and was sliding into my Helly-Hansen rain gear as Phil wheeled the boat around and put on the throttle. Smoke poured out of the twin stacks as the diesel-powered us back to the fishing grounds. Even with

8

the sea anchor out, we had drifted three or four miles north of our intended set.

We were heading for a secondary seamount on the Yakataga Grounds the Old Man found to his liking. It was indicated on our charts with a big green "X." *Green for money.* I would have bet my shares there wasn't another chart in the fleet that had a mark in the same place. That's why they called him the Old Man; he was almost psychic in his ability to find the big halibut.

I looked east toward shore almost a hundred miles away, at Mt. St. Elias and Mt. Logan. The two majestic peaks, eighteen and nineteen thousand feet tall, were all we could see of land this far off-shore. I considered the two my adopted guardians, breathing a silent prayer to the twins that we would have a successful day.

The first set went out without a hitch, we repositioned a quarter-mile away to set the second, and then again for the third. It was 8:45, all our gear was in the water, working. I pictured almost two miles of ground-line lying in zig-zag patterns on the bottom of the ocean, anchored at each end, hooks three fathoms apart, over one hundred fathoms down. Enticingly baited with fist-sized chunks of gray cod and whole herring and even a little octopus, luring those huge prehistoric flatfish to take a bite. *I hoped.*

I turned on the saltwater pump and began hosing off the deck. We were obsessive about how clean we kept the Devil's Advocate. Sure, she was nearly fifty years old, but she was a hard-working, proud ship. She was considered a '*Highliner.*' One of, if not *the* most, productive boats in the entire Alaskan halibut fleet.

When I finished scrubbing down, I stuck my head into the cabin. *"Moon Toast!"*

Phil nodded, crippled left hand on the wheel, Looking for the first buoy we had put in this morning, marking the beginning of the three sets. "Sounds damn good to me, too."

I lowered myself into the hold to check and freshen up the ice levels on the fish. As I was working, I heard Phil motor down and then shut off the engine; we must be within sight of the

first buoy.

Coming back up on deck, I was happy to see that Phil had started in on breakfast. 'Moon Toast' was named after a crusty old skipper of the black-cod fleet, who, when he was a kid, had been a professional chef in a Seattle restaurant. He had retired from fishing years ago, but his famous recipe had been committed to memory by everyone who had ever fished with him. Phil had been his First Mate, maybe twenty years ago.

Into the batter bowl, Phil mixed up six eggs, a half-cup of cream, powdered ginger, vanilla extract, and cinnamon. He soaked thick slices of Douglas Island Bakery French bread in it for maybe twenty seconds, then laid the pieces into our greased and smoking big cast iron skillet next to a pound of already sizzling bacon. It was our favorite meal, whenever we had the time and the weather to prepare it.

Phil used to tell me stories about the Norwegian boats he had cut his teeth on, years before. From four a.m. until they ate dinner at eleven at night, there was only a wooden keg on deck filled with pickled herring they dipped into whenever they could spare a moment. I couldn't imagine pickled herring at four in the morning, or ever. I hated the sight and smell of the stuff. *Bait. It was eating bait.*

I sat at the table after washing my hands and started filling my plate. Half-pound of bacon, four slices of Moon Toast, half a cube of butter melted on the stove. Over everything, a third of a jar of creamy Skippy peanut butter and a full cup of bubbling hot maple syrup. I was hungry.

Phil looked over at the pile of sludge on my overflowing plate. "I can't believe I have to sit here and watch you eat that. You're a fucking poster-child for cholesterol."

I grinned at him and winked over the quart carton of skim milk I was drinking in one breath.

"How can you pour syrup all over the bacon? How can you dip bacon in peanut butter?"

I put down the empty carton of milk and started shoveling in the fat-filled mess. The last bite always came out perfectly even- -French toast, bacon, butter, syrup, and peanut butter all piled

together on the fork. I reached into the cooler and grabbed another ice-cold quart carton of skim milk. I let out a monstrous "Braaaack!" then gave him my signature rebel yell. "Yeeee-haaaa! Let's pull the goddamn gear!"

Phil shook his head and piled the gooey dishes in the sink. Turning, he walked into the pilot-house and started up the engine. I got to do the dishes. That was the downside of eating breakfast. I hated washing up cold peanut butter.

We pulled up next to the first buoy ten minutes later, the galley spotless and secured for weather and dressed in our Helly-Hansen rubber raingear. Phil at the wheel, me at the rail, on the starboard side. I checked the steel points of my two favorite gaff hooks, 'Flatt,' and 'Scruggs.' They were needle-sharp, as usual. I readjusted the position of them, hanging on the cabin ladder next to the pulling davit, then checked again to make sure I could reach one of them if I got pulled out of position by a big fish.

The first set was promising, not a sign of fleas, a couple of seventy to eighty pounders along with the usual thirties, forties, and fifties. I was really on my game with my pinpoint gaff work, using all of my one-hundred thirty-two pounds to leverage the big fish onto the deck and into the holding bins where they would flop and jack-knife like crazy until I straddled them and clobbered them on the head. I used a big alder branch that I had driven a length of iron pipe onto the end. As the finishing buoy came aboard, Phil nodded his approval.

"How come we're alone out here, Phil? This place is fucking money!"

He was leaning out the pilothouse door with one hand on each jamb, looking at the nine fish in the bins. "They've tried to follow us out here, but we're too far out for the little pissers, and the big boats go farther west, closer to the Aleutians. This spot suddenly got flush about six years ago after a big storm. I don't know why exactly, but we'll take it."

No other 'inside' boats would come out this far off-shore. We were considered completely and totally insane to be out here at only forty-six feet long, the rest of the fleet we ran into

out here varied from eighty to a hundred fifty feet long. The Old Man's courage was legendary.

He looked at me seriously. "You remember this spot, Stu." He turned abruptly and went back to the wheel.

Why did he say that? Of course, I would remember this spot. What the fuck was that supposed to mean? I guessed he was making sure I was paying attention.

He was back in position at the helm, looking out the port at me again. I could hear Jerry Jeff Walker's singing leaking out of the porthole around him.

"Okay, find the next one, I'll check the radar for company."

I shaded my eyes to begin scanning the horizon for the forty-two-inch fluorescent pink buoy that would mark the beginning of the second set. We knew the approximate position of where it would be by where we set it, but currents and winds would move it several hundred yards in any direction.

Instead of the tell-tale flash of pink, I spotted a glint of metal, about ten miles to the west. "Phil! What's that?"

He turned down the stereo, and his eyes followed mine. "The *'Lady Rae.'* I picked her up on the radar last night. She's working Hilltop Seven."

Hilltop Seven was one of the seamounts I knew the Skipper never fished anymore. It had been stripped clean by Japanese trawlers a few years ago before the Fish and Game Department started rigidly enforcing the two-hundred-mile limit.

"Who's running her?"

"Lars Ericcson. His old man was a member of the Petersburg fleet for maybe forty years. Now the kid's fishing out of Seattle as a charter skipper for Westco Fish. I talked to him this morning when we were setting gear. He's been out for two weeks. It doesn't sound like he's doing so hot.

The kid's quite the hard-on, though. Get this, a couple of summers ago," he was chuckling, "a Jap trawler, for whatever reason, changed course to run over their gear right in the middle of a set. Why in the fuck they would do that, I have no idea, but Lars goes into his cabin and gets out a .30-06 BAR and starts ricocheting bullets off the steel sides of the Jap

wheelhouse until it veered off. He *hates* Japs. There's *always* an American flag flying off his boat now. I think he's daring another one to try it again. I think he might have a LAWS anti-ship rocket tucked under his bunk or something."

I laughed at the thought of that.

The second set started routinely enough. There were some good fish on the front end of it, but about half-way through I spotted something way down in the depths, I had never seen before. The water was pickle-juice bright green that far off-shore and the visibility was around a hundred feet down. I could tell how big a fish was by how deep it was when I caught the first flash of its white belly, the bigger fish showing up deeper.

This was really strange, though. I caught a flash of white way the fuck down there, like two hundred feet down—an enormous flash. I stopped the drum.

Phil poked his head out and looked at me. "What's up?"

"You better take a look at this. I don't know what I'm seeing here."

He came out on the after-deck and looked overboard. There was nothing there. He looked at me in question.

"Just watch for a second."

I started the drum, really slowly. In a few seconds, I saw it again. Phil did too. He opened his mouth to say something, then shut it. He looked at me and said, "You still got that Smith?"

He was referring to the stainless-steel Smith and Wesson .41 magnum revolver I kept in my nightstand.

"Yeah."

"Go get it. *Now.*"

Good News, Bad News

Phil was looking over the side when I came back out on deck with the handgun.

"I'll take it."

What the fuck, over? I handed him the gun. He opened the cylinder, checked the hollow-point rounds, and then stuffed it into his belt.

"Okay. Real slow, start the drum. Don't jerk it. Real easy."

I feathered the hydraulics to start the drum rolling smoothly and kept the lever on a crawling-slow speed. The ground-line was inching up out of the water. I looked over the side and saw what we had caught.

"Jesus Christ." I think I said it out loud.

I was looking at the most gargantuan halibut I had ever seen. It seemed to take up the entire ocean. We had boated one last summer close to three hundred pounds, but this one dwarfed it. It came up slowly, not moving at all, just a massive dead weight.

When it was about ten feet down, Phil said in a tone of voice I had never heard before, real quiet, "Stop the drum."

We both looked at the fish, dangling off the ground-line below us. The water was clear enough that I could see the gangion-line and the hook tenuously sticking into the side of the monster's mouth. If I jerked the ground-line when I started the drum, the hook would tear out, and we would lose her.

Phil was speaking in a low voice, filled with tension. "When her head breaks the surface, the weight of her will tear the hook out, so we have to have both gaffs in her below the surface. I'll hit her first. You're going to have to hit her hard, really hard, then we'll get her on-board. Make sure you're wedged tight against the gunnels before you pull. Okay, slow now."

I shook the hydraulic lever gently to start the flow of fluid that would turn the massive drum, winding in the line. It began to turn, and the fish rose closer to the boat. I had never seen

anything like it. It was over eight feet long and four feet wide, as big as a piece of plywood, but two feet thick.

Four hundred pounds? Five hundred? Six?

She was hanging off the ground-line, motionless and docile. I knew she wasn't dead.

When her nose was a foot below the surface, I stopped the drum. Phil had Scruggs in the iron-grip of his right hand and leaned out over the boat, getting ready to strike. I grabbed Flatt and tightened my grip, watching, my heart pounding.

Phil coiled and struck, slamming the gaff into the side of her head. She heaved once. I reached out and put my whole body into the swing, burying the gaff into her cheek, just below the eye. I wedged my knees under the side rail and began to pull. Phil had his crippled left hand wrapped around his right and was pulling on the fish with all his strength.

The moment her head broke the surface, she began to fight. She jackknifed, lifting her tail, close to five-feet across, into the air. Phil and I pulled for our lives, bringing her head over the gunnel. Phil fell backward onto the deck, feet wedged against the scuppers, gaff clamped in his hands, face purple with exertion. I shifted my weight and yanked for all I was worth. Her head touched the deck, her body started to gain momentum, and she was ours. She slithered over the side, Phil rolled out of the way seconds before she began bucking and slamming like she would blow the boat into splinters.

Phil pulled himself up using the rungs of the cabin ladder and took the Magnum from his belt. He held the gun tight to her head right behind her eyes, turned his head, and shot. He moved the barrel a little, then fired again. She went still.

Phil suddenly sank to his hands and knees, fighting for breath. He started coughing, and it was one of the worst attacks I had seen him have. He was racking and gasping for air as if he were suffocating. I ran into the galley and grabbed a towel. He held it to his mouth, wheezing, choking, and coughing. Minutes later, he caught his breath. He crawled over to the hatch cover and groped his way to a sitting position. He was pasty-white, and the towel had blood on it. He sat there with his head down

for a long time. I was scared to death that he was having a heart attack or something. After a minute he looked up at me, it took all his strength to raise his head.

I went over to him and put my hand on his shoulder. "You OK?"

He just nodded.

"*Devil's Advocate, do you read? Devil's Advocate, do you read? This is the Lady Rae. Phil, goddammit, are you there? Pick up!*" The radio was squawking softly, and we hadn't even noticed.

Phil staggered to his feet, and we went into the cabin. He turned up the radio.

"This is the Devil's Advocate."

"*Where the hell have you been? I've been trying to raise you for twenty minutes. Look to the south. Look to the south!*"

We both turned around and looked. From horizon to horizon, stretching across the clear blue southern sky was a thick, black stripe right at the waterline.

The radio crackled. "*Phil, you gotta' get moving. This thing will be here in six hours! They're reporting winds over eighty and seas cresting fifty-plus. It's a Widow Maker, Phil! Get to Icy Bay! You've got to get to Icy Bay!*"

We had gambled with the weather in our little boat one time too many. Mother Nature had called our bluff.

Cut and Run

Phil turned to me with a scowl. He still had some dried blood smeared in the corner of his mouth, and his complexion looked the color of overcooked oatmeal.

You look like ten days of bad weather, Old Man.

"We're going to have to cut off the gear. Get a buoy ready."

"Cut it off? Phil, that's close to five hundred bucks of gear down there! Why don't we continue pulling and see how bad this thing actually is. It sounds like old Lars is getting a little panicky."

"No. When the big ones come this hard, and this fast, it's always bad. Sometimes worse than bad. We're at least ten hours from Icy Bay, probably closer to twelve with this load on. Cut off, and we'll come back out and get her in a day or two after this blows over."

"Wait a sec. You mean we're not even going to anchor this end? Is it just going to be floating loose off the one anchor? There's big fish on this set! What if there's another one like that?" I pointed to the whale.

"If you think I'm happy about this, you're nuts. Listen to me. This looks like the one that hit up here maybe twenty-five years ago. It started the same way. It caught us all off guard. Even the Coast Guard got caught with all their ships in port. The fleet lost over thirty men in that storm, Stu. Whole boats and crews were never seen again. These Widow Makers are no joke. Now break the line over the side, I'm going to cut it."

Fuck! I pulled the line up out of the water as far as I could. It was almost impossible to stretch the ground-line with all the weight of it pulling against me. I held it tight over the top of the gunnel and used the oak rail as a braking mechanism to keep the line from slipping back into the water.

Phil worked as fast as he could, knowing I couldn't hold it for long. He reversed the drum creating enough slack to tie to, then pulled his Buck and cut the ground-line, making fast a buoy to

the end I was holding.

'You never cut the goddamn ground-line unless you're hooked up and either going overboard or into the pulleys.' The Number One Rule of long-lining.

"Okay, let go."

I jumped back. The buoy sailed sixty feet off the boat, skidding away over the water after it landed. *There go half of my shares for this trip.*

Realization dawned on me what we were doing. "Wait a minute. What about the third set?"

"We'll just have to hope we can find it when we come back out."

"Phil, we're a hundred miles off-shore. How are we going to find a buoy out this far?" *There go the other half of my shares for this trip. Flying fucking fucker-fuck.*

He didn't answer. He just went into the wheelhouse and hit the throttle. With smoke streaming behind us, we started running for Icy Bay, the only refuge for 500 miles.

I rigged the come-along winch to the steel ladder rungs going up the mast and hooked the cable to a sling wrapped around the monster's tail. I cranked away, and the big girl started to lift up off the deck. When I got her to where I could work with the huge mass, I pulled my razor-sharp Gerber knife and opened her up.

I'd never seen so many guts come out of one fish in my life. The liver was over two feet across. There were more eggs than a Russian caviar convention.

I was dying to see inside the stomach, and then I hoped there wasn't going to be a human hand or something in there. No, a head. A silently screaming human head with bulging eyes. No! No eyes at all, only empty sockets, and with a black watch cap on. *"It's Ramone! My Portuguese rail-man! He was washed overboard during the storm! Oh my God, Ramone!"* Everybody screams.

Too many Twilight Zones, Stuie. You've got some severe sleep deprivation.

It turned out to be a little anti-climactic, only a couple of

whole but partially digested gray cod and a crap-load of fish bones. I had to crawl completely inside Big Bertha to finish the scraping out, it was creepy being inside the cavity of such a beast, especially when the boat started rocking and the body moved from side to side.

Cleaning the rest of the catch was a snap; it was amazing how small an eighty-pounder looked next to the Big Momma. Mildred. Not Bertha, I would name her Mildred, after Mildred Pettywhite, my high-school English Lit teacher. Just a big, nasty woman.

The last fish to clean was a thirty-five-pound male. As I was tossing the sperm sacs overboard, I pondered on how halibut males only grew to fifty or sixty pounds, wondering why the females went to five hundred. *Six hundred?* Personally, I liked my women lean and hard. With cut athletic legs, small upturned breasts with hard nipples and taut, muscular abs. *Knock it off and get to work.*

I opened the hatch cover, threw the smaller fish into the port-side bin, then guided the head of the old girl into the opening. Mildred was going to have to fit wherever she landed, I guessed. I lowered her down with the come-along. She draped across the whole bottom of the hold. I jumped down, knelt on top of the big fish, throwing six or eight snow shovels of shaved ice into her cavity, then shoveled some more on top. Climbing out, I re-strapped the hatch cover closed and fired up the salt-water pump to wash the blood and guts overboard. Last was to check the deck to secure for inclement weather.

I looked at Mildred's liver I had set on the hatch, wondering if I should save it. It looked like a big slimy yellow banana slug. Maybe I could feed it to Cap. That damn dog would eat anything. *Fuck Cap.* I could eat it for lunch or something. I was hungry. I liked chicken livers. *Wait a minute, what was I reading somewhere, about overdosing on Vitamin A? It could be fatal? Never mind.* I picked up the twenty-pound slug and slithered it over the side. *Sorry about that, Mildred.*

When I finished on deck, I went into the cabin to secure the galley. Cap came over to me, and I knelt down, scratching

his ears, kissing him on the nose.

"Everything's all right, Big Boy. You stay out of the way on your bed."

He didn't move. He just looked at me. I could have sworn he looked worried.

"On your bed. Now."

The big Rott-mutt walked to his bed. He turned and faced me, just standing there, his massive head slightly cocked.

"Lie down."

He sat, but wouldn't lie down.

"Lie down. Now."

He ignored me.

Fuck it. Sit, then. Psycho Dog.

I gathered all the pots and pans and put them in our weather chest, along with the glass dishes and coffee mugs. I took a towel and tucked it around everything, then latched the lid. The charts got rolled up and stuffed into their pigeonholes. Silverware in the drawer. Fifty-pound bag of dog food in its compartment under my hinged seat at the table. I looked around some more, but we were ready.

I walked over to stand by Phil at the wheel. He was looking at the radar screen. Icy Bay showed as a tiny hole in the coastline at just over the ninety-mile line. Let's see, eight knots at full throttle, say eleven hours to safety. But the storm will be here in six. Say five and a half. Forty-four miles still left to go. Then we'll have to throttle down for the storm to four or five knots. That's, let's see, eleven *more* hours to safety.

Jesus. I was starting to get a little nervous.

Phil looked over at me, dead-eyed. "Go into my cabin and get the survival suits."

Great. That helps. I feel much better.

I had never been inside his cabin before. It was spotless. Beautiful wooden bunk frame and built-in dresser. Stacked in one corner were two bright orange neoprene ditty-bags with "*SURVIVAL SUITS*" stenciled on them.

I'm guessing that must be them.

I dragged the bags out of his cabin and set them in the middle of the floor.

"Leave them there for now, but unzip the bags so we can get to them in a hurry. When this thing hits, I want us wearing them."

Now I was getting a *lot* nervous. *What kind of storm could this be?*

Phil and I had been in twenty-foot seas with the tops blowing off them, and winds over fifty, no problem.

What did Lars say? Eighty miles an hour winds? Was that right? And seas to what? Fifty? Did he truly say fifty-foot seas? We're only forty-six feet long.

I looked over at Cap. He was still motionlessly sitting there, looking at me. I turned to look to the south. The blackness of the sky in the distance was expanding towards us. I could see bolts of lightning now, knifing through the black thunderheads, lighting the sky. The wind was starting to pick up. The anemometer gauge showed we were up to forty-five miles-an-hour.

Christ on a cracker, Cap. We are in for a rough night.

21

Storm Clouds

I awoke, startled by a clap of thunder. It was dark, and I didn't know where I was until a flash of lightning lit up the room. I was on the floor of my buddy Randy's bedroom, enclosed by the nylon heat of my good North Face goose-down sleeping bag. I looked up at the clock next to his bed. Two-twelve in the morning. July 2, 1972.

I was going to be eighteen in only two more months!

I unzipped my bag and got up. Pulling on my sweats, I opened the bedroom door that led out into the hallway of the double-wide trailer. I checked the doors to Randy's sister's rooms and his parent's bedroom. They were all closed. Moving quietly, I tip-toed down the paneled hallway to the vinyl-wallpapered bathroom and took a leak, leaving the lights off. The only illumination was the flash of an occasional bolt of lightning coming in the curtained windows of the living room at the other end of the trailer.

I went back to Randy's room and lay down on top of my bag. I looked over at my backpack, stuffed to the top with everything I owned, almost eighty pounds measured on the bathroom scale. I was leaving this morning. Randy's dad was dropping me off at the freeway on-ramp on his way to work at six. I was hitch-hiking to Alaska.

What was I thinking?

My logical side started its incessant hammering at me--I had a solid job at McDonald's. I was making one fifty-five an hour, sure, but I worked sixty-five hours a week. Seventy-seven dollars and thirty-one cents a week, take home after taxes. Randy's dad said I could stay here sleeping on the floor of Randy's bedroom until I decided where I would live. He was only charging me twenty bucks a month rent, which included all the hamburger-on-toast covered with Aunt Penny's White Sauce I could eat. My stomach growled a little at the thought. *I miss Mom's Italian cooking.*

"*Alaska,*" I whispered the word out loud.

What was I thinking? I was thinking about the story that Randy's Vietnam-vet brother had told us a couple of weeks ago about the *'Pipeline,'* that's what. Construction work was going to start next year. Bus drivers were making seventy-five thou a year. Carpenters were making ninety thou. Randy's dad even said that. He said if he went up there, he could make ninety thousand as a carpenter. But he was too old to work seven days a week anymore.

I could, though. Get a job in the Carpenter's Union as an apprentice, or drive a bus, or even just be a laborer on the pipeline and make twenty times what I could make down here at McD's. Why not?

There was nothing for me down here. My dad was an abusive drunk. I moved in with Randy after school because I got tired of watching Dad beat the crap out of my mom all the time, and my sister Maria had left me and joined the fucking Peace Corps down in Bolivia, or someplace.

She betrayed me. She left me alone with Dad.

'Couldn't hold the family together anymore,' she said. 'Couldn't be the *'Mom'* all the time. Couldn't keep Dad sober anymore.'

Boy, he sure went ape-shit when she told him she was leaving. He went after her like he was going to kill her. She didn't even flinch. Held her ground right in front of the fat bastard, with her hands on her twenty-one-year-old hips, just daring him to touch her. He was beet-red, he was so mad.

Last time I saw him that mad, he shattered my right clavicle. Just for breaking his favorite fishing pole. I didn't even do it, either. The guy at the boat rental did it by mistake, loading the poles in the car after we chartered a salmon trip at *'Point No Point'* on the Washington Coast that summer.

The guy looked so terrified at me. I was the only one who saw him do it. He snapped the tip right off on the Chrysler Crown Imperial's trunk hinge. I didn't say anything because I knew Dad would kill the guy. It was the same pole Dad had caught the record Muskellunge with, back at Fence Lake in Wisconsin when I was a baby.

We got home and started unloading the gear into the garden shed. Dad had that look on his face he got when he'd been drinking all day.

"What the fuck happened to my trophy pole?" He screamed.

"The guy at *'Fatty's Bait'* hooked it on the trunk lid, Dad. Sorry."

"Sorry? You're blaming it on the guy at Fatty's?"

Blaming? "It was a mistake, Dad. He got it hooked up on the trunk hinge when he was loading our gear."

"You lying little son of a bitch! Why didn't you tell me then if he really did it?"

I shrugged and looked down at the ground. " 'Cause I knew you'd be really mad at him."

"You chicken-shit coward! Nobody would cover for that! Nobody! You little lying faggot coward! You broke my trophy pole! Get your ass over here!"

He pulled his belt out of his pants, the heavy black leather ballistic belt he used on me sometimes. His face was contorted with anger and alcohol.

I kept my eyes on him, edging around the back of the big gold Chrysler, trying to stay away from him, grabbing on to me. I'd been hit by that belt before. It took *days* for the pain to go away.

My foot got tangled up in the tackle box, and I went down. He was on me in a second. Even though his weight had gone from one seventy-five in the Army to two-forty, after twenty years of Mom's cooking, his reflexes and quickness were still engrained in him. Twenty years as an Army Airborne drill instructor.

He grabbed my arm and jerked me to my feet, his right hand holding the belt over his head. I tried to twist away from his iron grip as he brought his hand down to whip me with the belt. But he missed because I was twisting like crazy to get away from him. His right fist hit me square on the collarbone. I heard a 'crunch,' a flash of excruciating pain, and that was all I remembered. I woke up in the hospital. My dad told Mom and

the doctor I tripped over the tackle box and landed on it. The doctor looked at me as if he didn't believe it for a second.

I was in a sling for two months and couldn't get on the Rings for the rest of the year. I missed the gymnastic tryouts for the Junior Olympics at the University of Washington in May, and a chance to show the U.S. Olympics Coach my move I had perfected on the Still Rings. The Inverted Maltese Cross. No one had ever stuck it before in a sanctioned competition. I was going to call the move, 'The LeClercq', and make our family last-name world famous.

Maybe Dad would be proud of me then.

Dad thought I was a fag, because I wore leotards, *'like a fucking ballerina.'* He had never come to even one of my meets. They had a videotape circulating around of me, sticking the move at the last West Coast Invitationals. I heard the Head Gymnastics Coach at Stanford wanted me really bad. So did Penn State, but I was loyal to the West Coast schools.

I was going to get a full ride to Stanford, Coach said. I was going to the '76 Olympics in Montreal, he said. I was going to win the Gold Medal. I was going to be the Best in the World.

Now, I had no chance. The doctor said I might never do Rings again. It would never heal completely, to handle that kind of tension. It would certainly stress-fracture.

Coach was furious at that.

Strange Customs

Randy's dad took me in his black Ford pickup to the on-ramp leading up to I-5 on his way to work at 6:00 a.m. It had stopped raining, but the asphalt was wet and gleaming in the streetlights.

There already was a guy standing there waiting, peeing into the Scotch Broom lining the ramp. I was worried that I might be there all day or something, and would never make it to Canada, much less to a campground by nightfall. I had never hitchhiked before farther than about ten miles to work. Skagway was almost sixteen-hundred miles away.

I thanked Mr. Johansen again for the last two months of room and board and put out my hand. He took it in his, scarred and calloused from years of carpenter's work and shook it once. He swiped at something that got in his eye and said, "Good luck, Stu."

I pulled my leviathan Jan Sport frame pack out of the bed of his truck, waved goodbye, and walked to the onramp. I took off the pack and set it on the shoulder, about ten feet in front of the guy.

He looked at me angrily. "You have to stand farther up the on-ramp behind me. I get first shot at cars coming by. You have to let me get a ride first. Learn the rules, *Greenhorn*".

I mumbled 'sorry' and dragged my pack up the ramp past him and set it down when I thought I had given him enough room.

"Keep goin', Rookie! You have to give the car room to pull over!"

I dragged it another fifty feet up the long on-ramp. *Any farther, I may as well start walking on the freeway.*

Several cars passed at that hour. Most of the drivers just looked like working guys going to their assigned places. My dad never had a job like that. He always was trying to scam this thing, or maneuver that, he never just worked for a living.

Maybe if he had, I'd be on my way to Stanford instead of Skagway.

About twenty minutes later, a car stopped for my cheerful companion, and I was alone. I didn't know if I was supposed to walk back down the ramp now to give the next guy room or stay where I was.

What if someone else showed up? Do I give up my spot? What if two guys showed up together?

I was breaking the rules of the road without having any idea what they were. It started to rain again. *Great.*

I picked up my pack to head down to the bottom of the ramp again, where I thought I was supposed to be, and a car stopped for me just like that. I waddled up to it, and the driver reached over and cranked down the passenger window.

"Throw it in the back seat. Where you headed? I'm going to Custer."

"Thanks, sir. I'm going to the border. Heading for Alaska."

"Alaska? Wow, that's a long way. Well, I'll get you part-way there, at least."

In Custer, I waited for an hour or so and then was picked up by a dirty, white V.W. camper-van with black California plates and peace signs and flowers painted on the sides. The windows were obscured entirely with decals and bumper stickers. *"War is not Good for Children or Other Living Things," "McCarthy for President," "Legalize Marijuana," "Flower Power."*

As soon as I climbed in the back, filled with smoke and smelling of patchouli oil, one of the passengers handed me a joint. I knew all about *that* stuff. The school had its pot-heads; there were rumors that even some of the members of the football team smoked it.

"No, thanks." I heard it slowed you down and made you stupid. It leads to harder stuff, too, like heroin. *There certainly are no Honor Students in my school that smoked that shit or top-level athletes. That is a fact.*

"Okay, M-a-an." He looked at my crew-cut and letterman's jacket. "You look a little squ-a-a-re to me, anyway." The guy was

wearing rose-colored sunglasses, covering blood-red eyes, and had a wilted daisy braided in his matted hair.

Filthy lime-green shag carpeting covered the floor, the walls, and the ceiling. There were no seats in the van except the two in front; there were four people sitting on the floor in back, two men and two women. The smoke was so thick I couldn't see the driver.

Piles of Mexican blankets and sleeping bags and cases of beer and bottles of wine were everywhere. *'Mogen David,' 'Annie Green Springs.'* My mom drank Chianti, but I'd never heard of those.

They all wore flowered shirts and bell-bottoms, except one guy, had on an army jacket with First-Sergeants stripes, like my dad's, and the nametag said *'Kennedy.'* I didn't think he was truly an army guy. His hair was down to his waist. His name probably wasn't Kennedy, either.

The 8-track was blaring. It sounded like 'The Grateful Dead.' I'd rather hear the *'Blues,'* thank you very much. I put my hand on my harmonica in my jacket pocket. *I am a Blues Man, through-and-through.* The whole group looked like they had been up all night. The van was from San Francisco and headed to Vancouver, B.C., which was terrific. I was joyously relieved I was going to get the whole way to Vancouver in only two rides.

Forty-five minutes later, we were approaching the Blaine border crossing, and there was a long line of cars waiting to go through. We kept inching ahead, getting closer.

The driver spoke nervously, "Dudes, slide open the windows back there. If you got any stash, make sure it's out of sight! Man, I'm getting totally paranoid about the pigs in the booth, man. I'm worried that they're going to go through the van, Dudes. Now be cool, and let me talk at 'em, okay? Don't anybody get freaky on me, you unnerstand? Let me do the talking!"

I looked around me at what was going on. Everybody was frantically stuffing things under blankets and sleeping bags, waving the smoke out the window, and hiding wine bottles.

Oh crap. It suddenly occurred to me what was going to happen. I spoke to the driver. "Hey guy, I'm getting out here, okay? There's a little store over there, and I've got to pee really bad. I'm getting out. I'll catch up with you guys right after Customs, I won't hold you up, I promise, I'll meet you on the other side."

Without waiting for an answer, I turned the sliding door lever and opened the door. A mushroom cloud accompanied me out of the van. I stood there for a second, really dizzy, and tried to catch my breath. It must have been hotter and stuffier in there than I realized.

I slung my pack and walked over to the store. I was starving with hunger all of a sudden. My mouth was all dry, too. *I hope they have candy bars or something to eat.* I read a sign on the front window:

*"Duty-Free Cigarettes and Alcohol
Discount Perfumes."*

I went into the store, hoping I hadn't hurt anybody's feelings in the van. I didn't think it would be such a hot idea to go through Customs with those guys. I didn't think I could explain that I was only hitching and wasn't part of their group.

I hoped I didn't insult them or anything.

I bought a Coke at the vending machine and gulped it, reading all the perfume bottles in front of me. Next, I purchased three Butterfinger candy bars, a Heath Bar, and a candy bar I had never heard of, *'Cadbury's Coffee Crisp.'* It sounded delicious.

I was eating one of the Butterfingers, looking out the window and watching the van pull up to the Customs booth. I could see the driver waving his arms and saying something to the guard. In less than thirty seconds, the van pulled over into a cyclone-fenced area, and as I watched, four uniformed customs agents surrounded the vehicle. The doors opened, and everybody got out, along with another cloud of smoke. The agents went into the van and began throwing the contents all

over the ground. One of the wine bottles shattered, and red liquid spread all around it.

I left the store and moseyed over to the second booth, steadfastly ignoring the V.W. van.

The Customs guard looked at me cynically, eyes hardened with years of tall-tales. "Where you headed, Son?"

"Alaska, Sir."

"You hitchhiking?"

"Yes, Sir."

"How much money do you have?"

"Six hundred twenty dollars in 20-dollar traveler's checks, Sir. And eleven dollars and..." I reached into my pocket to count the change.

"Never mind that, Son. How old are you? Driver's License and Draft Papers."

"Nineteen the day after tomorrow, sir," I lied. I stood up as tall as I could. "I don't have them, sir. The after-school drivers-ed program is mailing my license to my uncle in Juneau, and I'm 4-F, sir. I've got a heart murmur." *Was that right? Or was it F-4? Or was that a jet plane? Shit! I told you to rehearse this!*

"You have family in Juneau?"

"Yessir. I'm working for my uncle in Juneau this summer. He owns a hardware store. Uh, Chanel Hardware." *Shit. Chanel? Where did that come from?*

He motioned another older customs agent over. White hair and a Captain's hat on, with gold braid on the brim. His badge said, 'Commander.'

The ranking officer looked at me, deadpan. Then he looked through the barred windows over at the V.W. van for a long moment, then back at me. He sighed. "Where's your mom and dad, Lad?"

I couldn't think of what to say. "They're all dead, sir. In a car crash. I'm going to Alaska to...to...start...my uncle..." I couldn't say anything else. I stood there with my head down, and to my surprise, started to cry. I was scared to death they wouldn't let me in.

Then what was I supposed to do? Go back home to Dad?

I raised my head and wiped my eyes with the leather sleeve of my letterman's jacket.

The older man looked at the "1972 West Coast Gymnastics Invitational Champion" patch that took up the whole front of my letterman's jacket, glanced at my crew cut, then nodded to his partner.

"You have two weeks to get out of Canada, do you hear me, Laddie? *Two weeks*. We'll be watching you."

"Yes, Sir! Thank you, Sir!"

I grabbed my pack, not daring to look back, and headed for Trans-Canada One, with connections north. I passed the cyclone fence enclosing the white V.W. They were taking off the wheels. The occupants were in a brightly lighted room with barred windows that looked just like a jail cell. That duty-free Coke and those Butterfingers saved my ass.

Chanel Hardware. You dumb fuck! Chanel was the name of Mom's perfume.

Alcanned

I ended up walking the few miles to Trans-Canada One, there was no telling where everyone was going from the border crossing, and I felt like walking after the cry-baby-scene at the customs window.

I got on the intersecting onramp and stuck out my thumb. Drivers waved at me, or shrugged, 'no room,' but everybody seemed nice. In about fifteen minutes, a huge station wagon filled with Mom, Dad, and four kids in the back seat slowed as it went by, and then stopped on the wide paved shoulder. I double-timed it up to the light blue Ford Torino 500, as big as a small yacht, feeling an enormous sense of relief. I was so worried that I wasn't going to be able to get any rides. I had nightmares of walking almost two thousand miles to Skagway, but maybe this was going to actually work.

The family was heading north to go camping. My pack got wedged tightly on top of the Coleman stove and camping gear already stuffed in the back. I squeezed into the cargo area of the big Ford behind the back seat, kneeing one of the kids in the head in the process, and made myself sort of comfortable, half lying and half sitting, propped up on one elbow. I was really glad for the ride and thrilled the Canadians were so civilized to hitchers.

"Where you headed, son?" The father said into the rear-view mirror at me.

"Alaska, sir."

"Hitchhiking all the way, eh?"

"I was thinking about it, Sir, but I'm not sure about the Al-Can."

The Al-Can, or Alaska-Canadian Highway, was a dirt and gravel road finished just recently to handle the one hundred thousand pound, twenty-two wheeled semi-trucks supplying the pipeline.

"You'd be better served going up to Prince Rupert and getting on the Alaska State Ferries, lad. The Al-Can is very difficult to drive. Very, very dangerous, much less to hitchhike on, eh?"

"I've heard that too, sir." I had also heard once that the truckers would swerve at you and spray you with gravel at 70 miles an hour.

Where would I camp? Were there even any cars on it at all? Jesus, what if there weren't any cars on it? I had no idea if I could even be on that road. What if it was against the law? What if I needed a permit or something?

"How's the old money situation? Have you enough for the ferry? Sorry, a personal question, but I've done some thumbing myself, you know, probably before you were born."

I watched his wife roll her eyes, then she looked at him with a *'no stories right now, dear'* look.

He shook her off and continued to look at me through the mirror.

"OK, I guess." I really didn't feel like telling him.
He just nodded, looking at me in the mirror, and then turned his attention back to driving.

I was going to take my time, camping along the way, moving steadily to avoid dwindling my cash reserves. I had started the trip with six hundred twenty dollars in twenty-dollar traveler's checks, enough to grubstake me for my first months in Juneau, and hopefully give me a little traveling money. Juneau would be my jumping-off spot. I would hitch to Skagway, up the Al-Can, and then take the ferry south the few miles to Juneau and regroup, find out about jobs further north. I thought the boat must be about fifty bucks. If I took the boat all the way north from Prince Rupert, it could cost three times that, crap, *ten* times that.

Where the hell was Prince Rupert? It had to be on the coast somewhere. I needed a map. But what if I couldn't hitch the Al-Can after all?

I was suddenly filled with doubt and despair.

They dropped me off about two hours up the road, in front of a big campground crowded with tents and motor-homes.

The dad got out to help me unload my pack. It took two of us to wrestle it out of the back of the stuffed wagon, where it thumped to the ground at my feet. I would have preferred to travel a little lighter, but *everything* I owned was in that pack. I had given away or sold everything else.

The man shook hands with me and then reached into his pocket, glancing through the window of the car at his wife. She nodded at him, and he pulled two bright-green Canadian twenties out of his wallet and stuffed them awkwardly into my hand.

I opened my mouth to object, not wanting to feel like a beggar, but he insisted. "Look, son, I've been where you are now. I know you've got a lot of pride. Just consider it a loan, eh? Someday you'll find someone who needs it more than you, and you can pass it along to them. Besides, this might make your decision easier on taking the ferry from Rupert."

I had tears in my eyes for the second time that day when they pulled away, kids waving. "God bless you," I murmured as the blue station wagon pulled into the campground in a cloud of dust. I stuck out my thumb and looked for my next customer.

Williams Lake to Prince George

My second and third rides ended up taking me over a hundred thirty miles farther north to a cute, tree-filled Provincial Park, with two-dollar campsites. I got up early the next morning and made coffee over my little Coleman one-burner camp stove. I was using my Bialetti Italian three-piece Moka-Espresso Maker I had swiped from my mom's camping box, a squeeze-bear of honey, and a plastic bottle of condensed milk to kick-start my morning. I decanted the liquid as soon as I bought it into one of my little plastic camping bottles to keep it from spilling all over the pack, but it wasn't going to last much longer before it spoiled. The squeeze-bear got a little piece of plastic wrap screwed under the lid to keep my food sack from turning into a caramel apple.

I planned to have an early breakfast fire that morning. There were eight or ten other hitchhikers staying at the campground, and I wanted to get a jump on them. I had the fire built before sunrise. While the coffee was brewing, I broke down my tent and packed my backpack. By the time the sun cleared the trees, I had made my way out of the campground before anyone else had even come out of their tents.

I was encouraged by the ground-speed I was making. I had allocated two weeks to get to Skagway, but since I had changed my mind to go only as far as Prince Rupert and the ferry, it was going to save me a lot of travel time. The boat left every Friday, according to the guy I rode with last night, and today was only Tuesday. Wednesday night in Prince George, Thursday in Prince Rupert, one day to spare. Canadians seemed to act like hitching was a natural form of transportation. I didn't get any suspicious looks, even from the Mounties when they drove by. The Customs Commander at the booth said they would be watching me, so that must have been what he meant.

Traffic was light as I moseyed out to the road, crossed over to the northbound side, and settled in. I liked to put my pack twenty feet or so behind me, so when the car stopped, I didn't have to run so far with the eighty-pound deadweight.

I waited fifteen minutes before I got my first customer, and there was no way he was going to stop. Little red Datsun 240Z sports car with two people in it, going close to ninety. I didn't even put out my thumb, just waved. They smiled and waved back. Good karma to be friendly, you never knew when you were going to need a friend out here.

Another ten or fifteen other vehicles passed before my first decent prospect. Pickup truck, faded light blue paint, single guy in the driver's seat. *Perfect.*

I stuck out my thumb and waved with my left hand. The guy looked over at me, smiled, and pulled over onto the dirt shoulder. A big cloud of dust billowed around us as I threw the pack into the bed of the truck. As I approached the passenger door, I could barely read the faded writing on it:

Rentminger Farms
Fresh Produce – Hay and Feed
Since 1919

I opened the door and said, "Howdy!"

"Howdy to you, friend!" He was wearing a cowboy hat that was so large I could hardly see his face. I figured he was my age or so, lean and lanky. Tall, but only 118 or 120, soaking wet. Big smile.

"Where you headed? I'm just goin' to just outside of Quesnel. Where you from, the States?"

"Yeah, North of Seattle."

"Hop on in!"

"Thanks so much." This ride would give me a huge jump on my fellow travelers. I was determined to be one of the first that day to arrive in Prince George. The hostels always filled up by noon, one of the guys was telling me.

"So, you goin' to P.G.?"

P.G.? Oh, yeah. Prince George.

"Actually, heading to Rupert to catch the Alaskan ferry."

"Alaska? I always wanted to see Alaska!"

"Yeah, me too! That's kinda' why I started this trip, to see what's going on up there."

He looked over at me with undisguised envy in his look. I was feeling really proud that I had overcome my nerves to go ahead with this trip.

We chatted up small talk for the next hour or so, we were moving steadily down the highway at an even 100kph. His name was Loren.

"Loren Rentminger! My Poppy's Harlan Rentminger. Momma's Elisa. Grampa died last year. Built the farm with his own hands, in 1919! Two little sisters. Twins! Lana and Lisa. Lisa's older by eleven minutes! You got any sisters? They're nice enough, I guess. Do lots of chores 'n' stuff. So's I don't gotta' do everything, eh? Look what I got 'em!"

He reached into a paper bag and pulled out a cassette tape. *"The Archies! 'Sugar-Sugar'!* My sisters love those guys! I prefer Country, myself!"

I smiled at his chattiness. I pictured him alone on this little farm with nobody to talk with, except the animals. I didn't answer his question about siblings. Sis was nobody's business. *Neither was anybody else in my family.*

The mileage markers showed us getting closer to Quesnel and my end-of-the-day destination, Prince George. *P.G.* It was going to be a pleasantly short day, with a hot shower and a bed at the hostel to look forward to sleeping in. I was still two days ahead of schedule to catch the ferry.

On the outskirts of the big town, right next to the *Entering Quesnel, pop. 8400* sign, he pulled over. We were at the junction of the highway and a narrow dirt road twisting away up into the mountains.

"Well, good luck, friend!"

"Same to you. Thanks for the lift!"

And he was gone, rocking and bouncing down the dirt road in a cloud of dust. I wonder what it would be like to live like

that. Three or four generations of farmers on the same land, from the moment you were born, you knew what your destiny was. Just workin' the land. *Sure was different from the cards I was dealt.*

Two rides later, I was in Prince George. The hostel was easy to find, and only four dollars a night to stay in the dorm with a bunch of other vagabonds. I had never been to a hostel, but they were popular in Europe, I'd heard, and the people were kind travelers just like me.

Right before I got there, though, I slipped on a patch of mud and went down, straight on my back in a mud puddle. I was like a turtle on the beach. I couldn't turn over. I just lay there, arms and legs sticking up in the air. My pack, the backs of my legs and my butt all muddy and wet. Another guy with a rucksack on came across the street and gave me a hand up. I was covered in red slime. *How dignified. How suave.*

I checked in, left the muddy pack on the floor next to my bunk, and went out to get something to eat. I was *starving*. All I had eaten in the last two hours were some cheese and crackers during one of my rides earlier. I stopped at a local burger joint and had a cheeseburger, fries, and a cherry shake. I hadn't had a cherry shake since I was a kid. When I got back to my bunk in the hostel, there was a group of travelers all together, talking excitedly. I moseyed over.

"He took the most valuable thing out of each person's gear! My bracelet is gone!"

"My camera! It was brand-new! I bought it for the trip!"

Uh-oh. "What's going on?" I was afraid of the answer.

A tall guy with a denim jacket and pants spoke, "That guy with the long black hair went through all of our packs when we left for dinner! He took the most valuable stuff from everybody! If I catch that son-of-a-bitch.."

I went over to my pack, and the outside zippers were all undone. *Oh shit.*

I searched through the pockets, but my new Buck knife with the Kalinga wood handle was gone. I paid fifty-five dollars for

that knife in Seattle. It was the only thing I had that was worth anything. *Gone! Motherfucker!*

Nothing to cut my salami and cheese with, no self-defense, I saved up for two months to buy that knife. It was the only thing I owned that I was really proud of.

"Do you think he would be dumb enough to be going to Rupert to catch the ferry? He'd have to know that's where we're all going!"

"No," the tall guy said, "I talked to him earlier. Nice as could be. He mentioned he was going to Vancouver. That *cocksucker!* He wanted to know where we were going to dinner. 'Have a good meal!' he said. It's so he knew how long we would be gone. We can't very well chase him down, or we'll miss the ferry, and he knows that. My brand-new camera!"

I swore I would never leave my pack alone or stay in a hostel again as long as I lived.

Grazing Shipmates

The next day I rolled right up to the ferry dock, thanks to a shipwright that picked me up in Terrace and drove me straight to his work in Prince Rupert. The ferry dock was right where it was supposed to be, and the ferry 'Columbia' hadn't sailed yet. I let out a long sigh of relief. I wasn't sure if my sailing schedule information was correct or not.

The Columbia looked like a cruise ship. It was twice the length and six times the mass of the Washington State ferries I grew up around.

I paid my fare, general boarding ticket, eighty-five dollars out of my dwindling cash. Making my way on-board, I followed some other back-packers up four levels to the solarium on the top deck. The roof was built out of white-painted steel I-beams supporting large plexiglass panels. There were white lounge chairs scattered around the big area, and six-foot-long radiant heaters hanging from the steel beam framework of the roof.

People were rushing around, gathering up the lounge chairs, and positioning them right under the heat lamps. Since there were ten lounge chairs for each heat lamp, my mission became obvious. I grabbed one of the lounge chairs right before another guy got to it, centered it under one of the heat lamps, and spread out my sleeping bag to claim it.

The entire area was filling up fast. Amazingly, even a few families. Mom and Dad and three kids were setting up a perimeter with their five chaises in a pentagon. The rest of the passengers were like me. Single travelers, or small groups. Some of the faces looked vaguely familiar from the truck-stops and campgrounds during the last several days.

Not being sure of the security of the area, I stayed with my stuff until I got a feeling for the crowd. It seemed all right, but

you never know, especially after that asshole in Prince George. *My brand-new Buck Kalinga knife. That motherfucker!*

I pulled out my book and halfway got into it, split between it and the people-watching. I had picked the book up in Seattle. It was a history of the North American Native Americans right before and right after the white man came to the continent. It was genuinely flabbergasting how many we had infected with our diseases, and how we just slaughtered them, wiping out whole tribes "after contact." Thousands and thousands died at a time, a total of over a half-a-million dead. The book had fifteen hundred pages and was an alphabetical encyclopedia of every tribe in existence from 1600 to the 1850s.

The thing I liked to do the most was to open it at random and discover a tribe I had never heard of before. It was totally creepy that everyone was gone now. The language, the culture, everything. *Just ghosts now.*

I set down the book and looked around at the activity, taking in the rest of the travelers in the open-aired space. Groups of three and four and five, mostly. There were a couple of really hot looking California-Blondes stretched out on their lounges, surrounded by a bunch of guys standing. The atmosphere really made the place feel like a cruise ship. Maybe I was over-exaggerating how 'arduous' my journey was. *Just a little, maybe.*

There was a group of eight or ten hippies sitting a few chaises over, holding big brown paper grocery bags in their laps. One reached in and pulled out an over-flowing handful of grass, and began munching on it. The others in the group were just as calmly stuffing handfuls of the stuff in too, looking for all the world like a bunch of grazing Merino sheep.

The one closest to me caught me staring, mouth agape. "It's wheatgrass," he said. "It contains every nutrient the human body needs to survive. It is all we eat. And water. Quite tasty, actually. Want a handful?"

"Um, no. Thanks." *Mown grass?*

He smiled at me condescendingly and kept on eating. I watched them out of the corner of my eye for a while, in semi-

disbelief. *What the fuck? Grass? That's the craziest thing I have ever seen.*

I read for a while longer, totally absorbed in my book, until it dawned on me I *really* had to go to the bathroom. I didn't know if I could leave my pack. I didn't want to ask the grass-eaters if they would watch it, so I just went for it. I didn't want to leave my baby alone for long. I knew there were tons of them strewn around, but that pack was all I had. *Minus one Buck knife.*

I finally found the men's room down a floor and through a long hallway, then hustled back to the solarium. The crowd was still around the blondes, but the flock had left. There were grass clippings scattered all around the chaises where they had been eating. It looked like someone had just mown the fucking lawn. *Unbelievable.*

Ferry Princess – Part One

The sun was pounding through the glass roof of the solarium, and it was getting hotter than hell. I pulled off my t-shirt and sat there, reading in just my cut-offs. I had made them myself, out of some old holey jeans. I had cut them so short that the pockets were sticking down in front. I shoved them back underneath. I even kicked my shoes and socks off. *Might as well get comfortable.*

I caught a couple of looks from some of the guys around me. I sat up straighter and tightened my abs. I was seriously proud of my abs. It took me years of gymnastics training to get them to look like this. *Perfect washboard, baby.*

I opened my book again and began to read. Even though my Mom was Sicilian, and my Dad was French-Basque, and neither had made it to the Wild West until 1951, it was still pretty embarrassing to read how the Natives were treated by the early settlers. Not just greed and selfishness, but the matter-of-fact disregard that they were even human beings.

"Not Christians." "Animals." "No more than wild beasts."

It seemed ideas like that were the prevalent beliefs during the 1800s. I had never known a Native American or anyone that was considered a minority. The whole time I was growing up. Just a sea of middle-class white people. There was only one black guy in my *entire* high school. I didn't understand why people couldn't tolerate other people's beliefs or existences. *Maybe it was like the Democrats and the Republicans. Everybody just thought different shit.*

A shadow fell over my book, and I looked up. The tall blonde from over at the worship convention was standing over me. The sun was glinting off her shoulder-length wavy hair. She was wearing cut-off denim short-shorts and a white ribbed sleeveless t-shirt. Period.

She smiled down at me and spoke. "How come you didn't come over? We were just getting to know the rest of our fellow travelers. Are you kind of a loner, or what?" Her baby blues were staring right at me, pinning me to the plastic chair.

I swallowed, then coughed. "Well, it looked like you two had plenty of company. I didn't want to intrude."

She laughed. "Those guys? No, they were just checking us out. Not you, though. Are you a student or something?" She was looking at my book.

"No, just like to read, I guess."

"Do you mind if I sit for a while?"

She didn't wait for a reply, just sat right down on my chaise. Her bare leg was touching mine. I shifted slightly to give her more room. She slid closer. Our legs were touching again.

Thank God I had changed into my cut-offs.

Her legs were perfectly smooth and the color of cinnamon toast. The muscles rippled under her skin. *Athlete. Track or volleyball, probably. Don't all Californians play volleyball?*

She had bare feet in little leather sandals, the kind that Dr. Scholl's had made his millions with. Her feet were small and high-arched and perfect. She had a delicate gold chain around her ankle. Her toenails were pink, the color of her lipstick. Her tongue was protruding slightly, moistening her lower lip.

My lips were getting pretty dry, too. I licked them, looking at the woman's mouth. *I wonder if I should put my shirt back on?*

She kicked her sandals off and was bouncing her foot up and down a little, which was making the muscles in her thigh jump. Her legs were perfect. Absolutely, flawlessly perfect.

"You're a shy one, aren't you?"

I coughed again. "Uh, no, well...maybe."

"What's your name, Shy Guy?"

"Stu. Ah, Stuart. Yours?"

"Linda. My girlfriend is Ronni. We're from Anaheim."

I knew it. This was why Disneyland was the happiest place on earth.

"I'm from Seattle, mostly." I hoped she didn't think Seattle was full of...well, whatever she might think Seattle was full of.

She beamed that perfect smile with the perfect teeth and perfect lips and perfect face. I had never even *talked* to a girl this cute much less sat next to one. *Is this what California guys have had going for them all these years? The Beach Boys were right.* She was talking.

"I'm sorry, what?"

Her eyes flashed for a split-second.

"I *said*, where are you heading all by your lonesome, Stu?"

I told her about my desire to go to Juneau, and then up to the oil pipeline, and start a new life on my own. As I was talking, the short one came over and sat on the other side of me, too.

Huge boobs, the size of bowling balls. Red *'Venice Beach'* t-shirt, no bra, white shorts, chubby legs. Bright red lipstick on. Pink bandanna in her hair. Barefoot, toenail polish matching her lips. *I was the filling in a blonde sandwich. Hold the mayo.*

"Hi! I'm Ronni!" She was bubbling over with enthusiasm.

I put out my hand to shake. "I'm Stu."

She took my hand and forcefully put it around her, making me give her a hug.

"Don't shake my hand, Cute Guy, give me a big hug!"

I glanced over at Linda. She was smiling, but her eyes were spitting fire. I got the feeling the two were friends, but fierce rivals, too.

I extricated myself out of the strong embrace. Ronni's boobs were soft and insistent on my bare chest. I wondered if their diaries were full of *'cute guys.'* The two of them smelled like heaven—the heady aroma of flowers, Patchouli, and linen sheets.

I glanced around the upper deck, I was getting more than a few stares, and some pretty hostile looks from the boys.

Ronni got up. "I'm going back over to read some too! I've got a brand-new Jackie Collins! Let's have dinner together tonight in the restaurant, OK Cute Stuff? You've got great tummy muscles!"

Guess I'll leave the shirt off. "Uh, sure, OK."

She was gone, wiggling her way across the deck, watched by every male eye in the solarium. *I've never seen a woman's ass*

move that much just by walking. The married guy got a hard elbow from his wife. Linda and I watched her until she was settled into her chair and picked up the romance novel. She waved at us. I waved back, my fingers waggling.

Linda abruptly changed position, straddling the chaise like a horse, facing me. Her cut-offs slipped up even higher. I was sweating with the effort of trying not to look between her legs. Her quadriceps were striated with ropy muscle. *This girl had seen some workouts.*

"Well, now you've met us both, what do you think?"

Think? I think you two are the most beautiful, sexiest, most desirable women I have ever seen.

"I think you two are beautiful. I'm glad we get to travel together." I edited my thoughts, "I'll certainly look forward to dinner with you two tonight, but you're making more than a few of the passengers jealous as hell."

She laughed again and ran her tongue over her teeth again. Her lips were slippery wet. *A wonderful habit that.*

"Too bad. I've already made my pick." Her eyes were gleaming.

What? "I'm sorry?"

She gave me a long once-over and then looked straight into my eyes. "What, do you think I'm forward? I've never been very shy."

I didn't know what to say. These women were more aggressive than anything I had ever dreamed of. I absolutely loved it, but it was scaring the hell out of me.

"Do you mind if I pull my chair over here next to yours? Ronni can fend for herself, and I want to be able to show these other studs I'm already taken." She nodded towards the groups of guys scattered around the solarium. "Juneau is three days away, so we don't have any time to waste!"

I nodded speechlessly. I think my mouth was open in shock. Picking up my book, I watched Linda walk back over to her stuff, then set it back down again immediately, as she dragged first her pack, then her chaise over next to mine.

"Not much of a double bed, but we'll make it work."

What the fuck? She was speaking completely matter-of-factly. I had never seen such directness. No games? No dating? No beating around the bush? No innuendo?

I was breaking out in a cold sweat at the thought of being with the most picture-perfect woman I had ever seen in my life, and she was acting like we were playing a game of gin-rummy. No self-consciousness at all.

She settled in next to me and looked at my book. "You're not going to keep on reading, are you?"

I dog-eared the page I was on, and quickly put it under my chair. "Uh, no. I'd much rather talk with you."

My legs were starting to tremble. Linda settled back on her chair, and kicking off her sandals again, swung her leg over mine. I reached out and put my trembling hand on her knee.

She slid as close as we could get without falling between the two chairs. Leaning over, she whispered in my ear. "How are we going to wait all the way until dark? I am *so* horny! I am just *dying* to screw!"

She pulled my head around and kissed me hard. Her tongue slipped inside my mouth and fought with mine like a bantam-weight trying to win a 10-round decision. Her small hand was urgently making circular motions on my stomach.

I came up for air. She was looking at my mouth, eyes wide.

"You're *really* a good kisser!" she gushed loudly, "Now I'm *positive* I'm going to screw you." My neighbors all turned and looked at me.

She winked at me and gave my thigh a squeeze. I was as hard as blue steel. She noticed, grazed me down there with the back of her hand, and winked at me again.

My eyes wandered back over to Ronni's chair. She had made her choice too; it looked like. A mountain of a guy with hair down his back in a long braid, and four or five earrings in his left ear. Big work boots, red plaid flannel shirt, leather vest. Blue jeans. Shoulders like a defensive lineman. Big tummy. Big belt buckle. *This boy had seen some beer*. 250, maybe 260 pounds.

She whispered something into his ear. He laughed a loud bellow. The passengers all turned to look. He stood up, some

6′5″ tall, and took her by the hand. He was a foot and a half taller than her. They disappeared below-decks.

Linda was smiling. "She *loves* the big ones. The harder they fall, the harder they come, I guess. She's going to sneak a little head if she can find a place. She's been talking about him all afternoon."

My face must have shown what I was feeling. My mouth was open with amazement.

She looked at me. "Don't worry, Lover, I like my men lean and hard, like you. Size really isn't everything." She giggled.

You are in for one hell of a rodeo ride, Stuie.

Ferry Princess -Part Two

The sun was setting, and it was getting cold. Linda shivered. Her nipples stood out through the thin ribbed shirt like maraschino cherries on a vanilla milkshake. "B-r-r-r-r!" she said.

I put my arm around her and brushed one of my hands over her nipple. She smiled and snuggled closer. Her leg was still over mine.

I stroked her thigh. "Where in the world did you get such magnificent legs? They are just incredible!"

She beamed a beautiful smile. "Genetics. My parents were both track stars at U.C.L.A. Daddy went to the Olympics in Japan in '64 as an 800-meter runner. He came in fourth, though. He swears the Kenyan guy tripped him. The U.S.A. won gold anyway. Canada silver, the Kenyan got the bronze. I guess I must have the genes. I tried out for track, the 440, but the coach was a real bitch. I quit my Junior year. My folks were devastated. I tried volleyball because of my height and basketball, but I'm not cut out for team sports."

She winked at me again, a practiced and smooth gesture. She had winked at a lot of nervous men, I thought.

She reached down into her pack to rummage around for a sweater. Her shirt pulled away from her body. I looked down at her firm, upturned breasts. Her nipples fully erect and no sign of any tan lines. *Promises of future joys.*

She looked up and caught me staring. "Nice, huh?" She winked at me again. *She was playing me like a four-pound trout.*

I could only nod. I was flushed, and my ears were buzzing. Linda laughed that wonderful, carefree laugh again. After she put her sweater on, *Rats!*, she settled back into her chair. I asked her to continue her story.

"Well, as I said, my parents met at U.C.L.A., they were both big into sports. They both had full rides on athletic scholarships." She looked at me quickly. "Not that they needed

them! Grampa Hugh was a *very* affluent doctor in L.A., and Daddy would have gone to U.C.L.A. anyways."

She looked at me carefully. I guess making sure I knew her family was plenty wealthy. "They dated for three years and got married in their senior year. After they graduated, Daddy's parents put him through Med School, and Mommy's bought them a house for a graduation present. Wasn't that sweet?"

OK, OK, I got the idea.

"Mommy settled right in as a housewife and had three kids, just right away. I don't think I could do that, do you?"

Ah...which part? "No, me either!"

"So here I am going to Alaska to find my *true self*! Of course, when I get bored of it, Daddy said he would buy me a house back on the beach in Santa Barbara, all I have to do is ask!"

As much as this chick turned me on, she was seriously pissing me off, too. I tried to control my frustration with her. She was sweet enough and incredibly sexy, but why in the hell was she ramming this shit down my throat? I shook my head. *After all, who am I to judge? What the fuck did I have to offer anybody?*

She was still talking. "...went to public schools, my parents don't believe in segregation at all! My second boyfriend was *black* even! Mommy didn't mind at all! Sooooo, I'm in my Junior year at U.C.L.A., studying Veterinarian Medicine. I love animals so much and want to take care of them!"

Speaking of small animals, I have a small animal that needs some care right about now—a little Levi's trouser-snake.

She was still talking. "...So, anyways, I screwed for the first time when I was 13, all of my girlfriends had lost their cherries already, and I had been going steady with Carl for almost four *months*! My mom got me the pill, and I've been on it ever since!"

Thank you, God.

Apparently, she had had "a bunch" of boyfriends and considered 'Screwing' a natural body function. I was obviously anticipating our future intimacy with a lot more nervousness than her. I had only been with one girl in my life, and Kerry and I

had only done it four times, *ever*. I lost my virginity to her right after I had won the West-Co Invitationals. She wanted to give me a present I would never forget.

My adventurous blonde companion leaned over and whispered into my ear, "I *hate* the missionary position! *Bo-o-o-oring!* Have you ever done anal? It's so *naughty!*"

It was getting dark. The overhead sunlamp heating fixtures were coming on automatically, radiating a ten-foot circle of heat below them. We repositioned our chairs a little to get the maximum benefit. I could see the other passengers scrambling to try to claim the last few heaters. I wondered what the cabins looked like, and then pushed the thought from my mind. The room would have doubled or tripled my fare, and I had a toasty-warm sleeping bag.

Linda clearly was carrying a lot more money than me but had decided to brave the solarium. "You never know who you might meet, and see? It worked! The cabins were all sold out by the time we bought our tickets, anyway," she confided.

It was 7:00 p.m. People were filtering down to the restaurants for dinner. Not a sign of Ronnie and Grizzly Adams. I was jealous as hell of him. Ronni was unbelievably sexy. I had never seen boobs that big. What would *that* be like? I shook off the thought and gave thanks for the gift I had just received. It looked like I was going to get laid too. *Finally!* It had been six months since Kerry had moved to Oregon.

The only way I had ever done it with Kerry was in the missionary position. If Linda thought that was boring, what was I going to do then? *What other positions were there?* I was starting to get performance anxiety. *What if I couldn't get hard?* I hadn't even masturbated in a week or so. I casually brushed my hand over Little Walter. I had named my thing after the blues harmonica player on Chess Records.

Little Walter pretended like he didn't know what was going on. *Shit. Maybe I'm going to have to sneak into the bathroom and slap the little bastard around until he wakes up.*

I re-focused on dinner plans. I didn't have enough money to eat in any of the lavish ferry restaurants. I was pretty sure. I was

planning on having salami and cheese and Seasoned Rye-Krisp crackers from my food sack, just sitting on my chaise.

I wasn't going to let Linda know I was almost broke, especially after hearing her story. I counted my poke at just under five hundred dollars after the ferry ticket—$ *477.45 total.*

I stopped worrying about it. We went downstairs to the main restaurant. As we entered, we could hear the booming bellow of Ronni's boyfriend, laughing at something. They were sitting near the window, watching the twilight over the islands of the Canadian Coast. We would be in Alaskan waters sometime after midnight.

They saved us a spot, and we sat down at their table. The big man looked Linda up and down as she took off her sweater in the hot cabin. Her t-shirt pulled up a little, showing taut abdominals, and her nipples showed through the nearly transparent ribbed shirt for all to see.

I introduced myself to him.

He shook my hand. His paw was as big as a leg of lamb. "Jake McLaughlin. Howdy!" His eyes danced with humor and energy. "You got a grip 'lak a mule-skinner! Little feller 'lak you! You're about as big as a tree stump!"

I just smiled at him.

We ordered drinks. *Three-dollar beers! At home in the taverns, they were a quarter!*

Jake began to weave his tale. "Houston born and bred. Twenty-two years old. Played football since I was four. All-State in high school. Defensive Tackle. Broke ev'ry Texas high school state record there was fer' tacklin' and sacks. The colleges were droolin' over me. I had rides to A&M, Oklahoma, U.T., *(That's Texas, ladies, not Tennessee)* Nebraska and 'Bama. Chose the Longhorns at U.T.

"My Sophomore year blew both knees out in the Sugar Bowl against Oklahoma. Bastard Sooner center cut-blocked me. We won, though. See the ring?" He thrust out one ham-sized hand and showed a ring the size of my fist. "Y'all may have seen it on T.V.! No? Figures, you're *Yankees.* Anyhows, six surgeries later, end of story." He shook his massive head.

"One-a my Old Man's amigos put me to work in his welding shop, and got me an '*In*' with one of the pipeline crews on the North Slope about a month ago. I'm a-headin' up there fast as a 'coon with a hound-dog nippin' at his balls. (*Oops, sorry there, Ladies!*). I figger I'll work five or six years up there, seven days a week, then buy me a spread down 'roun San Antone. Bandera maybe. God's country. You ever been to see the Alamo?"

We all shook our heads.

"Damndest thing you ever seen. You could swear you could hear the gunfire and the Messicans playing the Deguello."

We all looked blank.

"You goddamn Yankees! The *Deguello*! The music the Messican's played day and night before they overran the boys there. Austin, Boone, Crockett, Bowie, Travis. Ever seen a real Bowie Knife?"

He reached under his leather vest and pulled out the biggest knife I had ever seen. I didn't even notice the sheath hanging below his shirt-tail. The blade was sixteen inches long, and the handle, made out of some type of antler, was another eight.

He turned it slowly, reflecting the light from the dinner spot-lights so we could take a long look. It was unmistakeably razor-sharp. The couple at the table next to us were looking at him in absolute horror.

"Uh, wow, Jake, You'd better put that thing away before someone calls the Purser or something!"

Jake smiled at me and slid it back under his shirt. "That's a *real* 'Bowie,' by God. Cost me over two hunnert bucks in Houston. "Don't matter tho, I figger I'm a-gonna make fifty, sixty grand up on that fuckin' pipeline! (*sorry, Ladies!*) I'll be lookin' fine as a steer's eye."

A steer's eye. This guy was weirder than a Shithouse Mouse. I was grinning, in spite of myself. I really liked this big redneck.

The waiter brought us menus. I opened mine and grimaced. *$8.50 for a burger? This was not going to be fun.* The girls ordered fresh fish, thirteen dollars, and Jake, a T-bone steak, sixteen dollars. *Steak Jake. Oh, well, here goes my first month's living expenses in one meal.* I ordered the steak too, blood rare.

Jake smiled at me. "There's a Yankee that knows meat!"

We talked about a little of everything during that meal, from the promises of wealth on the pipeline to what we were going to be when we grew up. I really had no future prospects, so I mostly let the three of them talk. The girls were going to Fairbanks to try to get work with the unions. Rumor had it there were extravagantly-paying jobs for women because the unions had a quota system they couldn't honor. There weren't enough minorities and women to fill the bus driver and carpenter, electrician, and welding jobs. They were all screaming for women and minorities.

Ronni said she had heard that a friend-of-a-friend had gone up there last year, and had gotten a bus driver's job. "Listen to this! She gets up at five o'clock in her free apartment, she goes to the mess-hall and has free breakfast. She goes to her bus and picks up the crew at six. She drives them one hour to the Pipeline, then get this, because the Union contract *insists* on it, she sits in the bus, *with the engine running and the heater on*, so the guys can take their breaks in a heated bus, for *twelve hours*! Then she drives everybody back to the mess hall for dinner. She gets paid for a twelve-hour workday, and she only works *two hours*! She spends all day doing homework for her college degree, and not only is she making $70,000 a year, but she is coming home with her teaching degree! Is that crazy?"

I felt a pang of jealousy. A white guy like me couldn't get a job up there without a solid connection. The union B, C, and D-lists were a laughingstock. You could pay dues for a year and actually move *down* on the list. You could be waiting forever to be called, while oil roughnecks and carpenters, and women, from Texas and Oklahoma, and everywhere else, were walking right onto the jobs.

Big Jake nodded his head. "It's true. I got a call from a guy I worked for in Tulsa. He said to come up, and he could put me on immediately. I don't even have a fuckin' Union card."

My anger flared, remembering my trip to the Union hall in Seattle, but I kept my mouth shut. *That was the way it was, that's all. What did I expect?*

After dinner and dessert, we went into the bar for some after-dinner drinks, eight more bucks. They talked about everything and nothing, and I listened. The hours went by as we steamed northward, the steady thrum of the engines up the Inside Passage towards Alaska.

After a while, we wandered around, exploring the boat. It was a veritable cruise ship, with viewing decks, private cabins, three restaurants, the whole nine yards. Linda and I were holding hands, as were Jake and Ronni. It was full dark now, and the air had a bite to it even on a July night. The Inside Passage was silently passing by in the night. You could see the silhouette of countless trees and jagged mountains. I was sorry we were missing the sights of such a barren and desolate place.

The four of us left the heat of the interior cabin and opened the passageway to the solarium. The heat lamps were radiating their hearts out, trying to fight back the cold bite of the cloudless sky.

Linda and I rolled out our sleeping bags over the two joined chaise lounges. Unzipping them flat and using one on top as a quilt. Most of the other passengers were asleep by now. It was almost midnight, and we had all had a long travel day. The herd of grass-eaters were sleeping with their chairs in a circle, heads almost touching.

I grabbed my sweats and went back below to change. I didn't want to sleep bare-ass in such a strange place.

Linda had other ideas. When I returned, my sleeping companion was between the bags, with just her head sticking out. When I got close, she flipped back the top layer. She was totally nude. How she had undressed with everyone around was a complete mystery. *This woman had no modesty in her entire body!*

I climbed between the bags. Immediately I was inundated with a blast of heat and the delicious smell of sex emanating from her body.

She whispered, "I was getting ready for you."

I frantically pulled off my sweats under the sleeping bag, one elastic ankle band getting stuck. I finally wrestled it free.

"I want you. *Now*," she whispered fiercely.

I obliged, climbing on top of her. When I slid inside her, she moaned, a little too loud for my comfort. I peeked up out of the sleeping bag and looked around. One of the grass-eaters was awake. Eight feet away, on his side, watching us.

She was moving her hips in a circle, grinding her pelvis against me, eyes shut tight. I pulled the bag back over our heads. I lasted about two minutes flat. Little Walter was playing a riff called 'blue steel.' Her rock-hard legs were clenched around me. When she came, she almost bucked me right off the chairs. She kissed me on the shoulder, and her eyes opened for the first time since we started.

She smiled at me and kissed me on the mouth. "That was great, Baby. Did you get off?" I nodded, amazed she hadn't even noticed.

I peeked out of the top of the bags again. The cold night air poured into the bags, chilling our sweating bodies.

She whispered, "We'll spoon for a little bit, then go again. You behind me. Okay, Lover?" She backed herself tight against my still-hard instrument of joy. Her butt was slippery-wet and hot.

I was in for a long night. Good thing, I was a trained athlete.

I glanced over at Sheep-boy, who was still watching. Quite the show. *I wonder if wheatgrass makes you horny? B-a-a-a-a-a-a-a!*

Hotel Juneau

The Columbia finally finished docking, and I shouldered my load. I hadn't been wearing it for three days and had forgotten its unwieldiness. I kissed Linda goodbye and wished her luck.

The last three days had been a complete fantasy. I had never dreamed a woman would want that much sex in a semi-public place. We did it in the Men's Room, the Ladies' Room, behind one of the lifeboats, and in an unlocked storage closet. I had memories to look forward to for a long time.

They were headed on down the road, and though they promised to see me in Juneau if they came by this summer, I knew I'd never see them again. The thoughts of what she could do with her mouth, her hands, and her body made my chest hurt. *I kind of like anal.*

I looked around one last time for the two girls before I disembarked, but they were staying on the boat to Haines, then to their *'guaranteed'* jobs on the pipeline. I flashed on them up there, breaking hearts and getting anything they wanted because of their perfect faces and bodies, and got jealous as hell. I was going to have to build a grubstake here before I could go farther north, my money wouldn't last me three days in Fairbanks. *Crap.* I got my land legs back and headed for the main road into Juneau, some ten miles away. I got a ride immediately with a couple of guys in a brand new bright-school-bus-yellow four- wheel drive pick-up truck that dropped me off downtown. It was getting dark fast, and starting to rain.

There was a park we had passed on the way in, a half-mile or so up the road, and I hustled back to it to set up camp. Another guy with a backpack I recognized from the boat was following me, obviously with the same intentions.

A big sign on the front gate said:

No Overnight Camping
Day Use Only

57

Shit! It was pounding cats and dogs now. I went into the bathroom to take a leak, and the other backpacker followed me in to do the same. We stood at the door, watching the rain come down.

"What are we gonna' do?" he said.

We? Who's 'we,' White Man? I just watched the rain and shook my head. I looked around the cavernous bathroom, four sinks, three toilet stalls, a handicapped-accessible stall, and made up my mind.

"I'm sleeping in here," I said, opening the door to the spacious handicapped stall. It was three times bigger than my tent. I started pulling the Ensolite pad off of my pack.

The guy looked at me like I was daft. "Here?"

"Yeah, I ain't going out in that shit tonight. It's *pouring.* I'll worry about it tomorrow."

He shook his head and wrinkled his nose in disdain. "Well, there's got to be a motel or something around. I'll see 'ya around. Have fun in here."

He left. I watched him go, knowing a motel would probably be close to thirty or forty bucks. I turned and looked at my stuff, then around the bathroom. *What the hell.* I dragged everything out of the handicapped stall into the main area and unrolled my sleeping bag under the sinks. Sitting with the door propped open by my butt, I ate some stale Rye-Krisp and drank some tap water, after refilling my water bottle. Everything else I'd bought fresh in Prince Rupert three days ago was moldy. Cheese, fruit, everything. The four-dollar block of imported aged Swiss cheese looked like Roquefort. My little plastic bottle of cream looked and smelled like cottage cheese. I poured the sludge down the sink, throwing everything else in the garbage.

There wasn't a soul in sight, just a lot of trees and driving rain. I watched it come down. Hard, angular, and knifing, lit from behind by the big sodium park lights lining the walkways. My eyes started to sag as I sat there, thinking black thoughts.

I took off my boots, leaving all my clothes on, in case of unwanted visitors. I climbed into my warm little down bag and

lay there for a while, reminiscing how beautiful the two girls were on the ferry. What it would feel like to have a warm, willing body next to me right now. I squeezed my hard cock through my jeans, thinking of her mouth on me. We would have privacy, and I could pull back the covers and see that magnificent body in all its splendor. *I can smell her all over my bag.*

I shook my head and knew this was going nowhere. I choked back a sob and rolled over on my side to fall asleep on the hard concrete floor. *Welcome to Juneau.*

Looking for Work

I was up at sunrise. It was a beautiful sunny day. The birds were singing, and the black thoughts from last night were just a memory. I loaded my pack and walked into town. I was starving. *Maybe a chocolate croissant and cappuccino, or sausage and eggs, with hash-browns.*

I found a little cafe on the waterfront, *'The Gold-Panner,'* and went in. All working guys there, dressed in wool clothes and work boots. Some had red rubber boots on, although it wasn't raining outside anymore.

I sat at a little round window table, covered in speckled red Formica, and opened the menu. *The prices must be a typo. Are you kidding me? Seven dollars for sausage and eggs?*

The waitress hustled over. Her nametag said, 'Shirley.' "What'll it be, Hon? Want coffee?"

"Um, do you have lattes here? What kind of baked goods do you have?"

"No. We got butterhorns. You want coffee?"

"Yes, please. Cream and sugar, please. And a butterhorn. Warmed up, please."

She was already gone. When she returned ten minutes later, she slammed a white chipped porcelain coffee mug on the table and a plate that had some sort of pastry on it. It was dark brown and spiral-shaped, the icing was melted, burnt black, and welded to the plate. It had been microwaved for a minute, at least.

"Cream and sugar, please?"

She pointed to the table. Two fluted glass pouring containers, with little chrome flaps. One with sugar, the other with a cream-colored powder in it. I turned to ask her about the cream, but she was gone. I looked over at the table next to me. A guy was pouring the powder into his coffee. I put two tablespoons of sugar into my mug, then picked up the cream-colored powder. *What the fuck was this shit?* I had had Milkman

Powdered Milk before when we camped, but this wasn't that. I poured some into my spoon and ate it. *Hey, not bad!* I dumped it into my coffee. First, it floated, then it coagulated and sank, turning the coffee light gray. I sipped it. *Not bad. Must be some kind of powdered milk.*

I took my fork and tried to cut the pastry. It shattered all over the plate and sent pastry shrapnel onto the table. It was crunchy and as hard as a rock. I took a bite anyway. I was starving. It tasted like burned Styrofoam. I pushed it away and sipped my coffee. I poured a couple of spoonfuls of the powdered stuff out and ate that instead.

Shirley came by and stared at me. *"You're eating Coffee-Mate?"*

I shrugged.

She peeled a ticket off a pad, slammed it down on the table, and stormed away. I cautiously turned it over. "Butterhorn and coffee. $5.75". The price of ten Big Macs and an order of fries, in Seattle. *Well, it was expensive, but at least I'm still starving.* I left seven dollars on the table and walked out into the sunshine.

Shirley didn't even wave goodbye.

I walked through town. Front Street was pleasant and flat down by the water, but the majority of the roads went straight uphill as soon as you left downtown. As I wandered the waterfront area, I was thinking it would be good to ditch my pack before trudging up and down those hills. *Where was I going to do that? The ferry terminal had lockers, but that was ten miles north of town.*

There was a two-block-long, one-story building built right on the water, with docks attached to it. Instead of boats, the docks all had seaplanes tied to them, in all different sizes. One of the planes had a single-engine that was every bit as big as a V.W. Bug.

The building had a big red and white sign, *'Juneau Air Service.'* I walked in. There was a spacious, open room, with a desk on one side, and piles of equipment and baggage spaced all around, each with a different sign over it. *'Pelican,' 'Bartlett*

Cove,' 'Elfin Cove,' 'Tenakee Springs,' 'Petersburg,' 'Hoonah,' 'Gustavus,' 'Angoon.'

I moseyed on over to the terminal counter. A dynamite-looking girl was behind the desk on the telephone. The cutie nodded at me and held up a finger to wait. I took my pack off and set it on the floor. When she said goodbye, I said hello.

"What can I do for you?" she said.

"Do you have any lockers? I am looking around town for a job, and don't want to lug this monster with me. I'll pay for one."

She shook her head. "No. No lockers here. Maybe out at the ferry dock. No jobs around here either, unless you want mine, and believe-you-me, you do not want mine!" She shrugged.

"No place I can put this? Everything I own is in here! It weighs a ton!"

She looked over at the mounds of gear, spread all over the room. "Tell you what. You just set it over there in the pile that says, 'Elfin Cove.' Haida John won't be loading the plane until 4:00 this afternoon, and it's as safe as a bank vault in here. I won't tell anybody, but be sure to come back before four, or your pack is going to ElCo!"

"Thank you so much!" I shook her hand a little too hard.

She winced. "Easy there, guy! Don't you worry about a thing. I'll watch it for you. 'Bye!"

The phone rang, and she picked it up, nodding over to the pile. I dropped my pack next to cases of food, equipment, outboard engines, and a stack of army-green duffle bags and walked out into the sunshine feeling two hundred pounds lighter.

Ok, now where to start? She said, 'no jobs.' I hope she was wrong.

There were little groups of travelers on nearly every corner, backpacks or duffle bags at their feet. Most of the men had long hair, looked dirty, and kind of like the group that I went through Customs with, in Blaine. I went over to a group of eight or ten, standing around a park bench.

"Hello," I said to no one in particular.

One of the guys shoved through the group to look at me. He was tall and skinny, dirty red baggy tank-top, and torn blue jeans. Long greasy blonde hair to his shoulders, six earrings in his left ear. His arms were the size, color, and consistency of over-cooked angel-hair pasta.

He looked at my crew cut and letterman's jacket with a sneer. "Where you from in the *Real World*, man? *Squares-ville*?"

The group laughed.

Ha-ha. Very funny.

I had only heard that '*Real World*' phrase used by the guys that had been in 'Nam. He clearly had never been through the rigors of boot camp. I thought about Dad being a Drill-Master Sergeant, and what he would have done to this pansy. *He would have eaten him alive.*

"Seattle. You?"

"Minneapolis." He nodded at the group. "All of us. We all took the bus to Seattle, the train to Rupert, and then the ferry up here."

I remembered the Grass Eaters on the boat. One or two of them looked familiar.

He sneered again. "What's your problem, *Jock*?" The group laughed again.

"No problem, just looking for work."

"You lookin' for work? *Forget it*. This place is a black hole. Nobody will hire us. *No-fucking-body*. I've heard almost *everybody* say that. I hear they think we're lazy freeloaders and hippie drug dealers. Thieves."

The group nodded as one.

"There's nothing here, man. Juneau is a *Shitpot*. Buncha' fuckin' *Staties* in fuckin' suits and ties. We're going up to Haines on the next boat, then on to Anchorage. At least there's a city up there and not all these small-town rednecks."

Again with the 'No Work'? Now, what was I supposed to do? I couldn't possibly afford another ferry ride, then how far was Anchorage? It was close to Russia, wasn't it?

"Well, thanks, Guys. See you around."

"Like a doughnut!" Said one of the girls. Her eyes were all bloodshot, and she had close to twenty bracelets on her wrists. She was barefoot in the sun, and her feet and ankles were filthy.

They all laughed as she said something when I walked away. *No work. Fuck. I am in deep shit.*

I began the systematic search for a job. Every street, every person, if I had to. The little Capitol City had eighteen thousand people, I had read, and nearly half were State workers. *Staties.* I didn't want to work for the State I didn't think. *Probably couldn't, with just a high-school diploma.*

I hiked up and down the steep streets, my letterman's jacket now slung over my shoulder in the warm weather. *At least it's stopped raining.* The architecture was all over the place in that little town. One hundred-year-old houses next to concrete boxes, four and five stories tall, marked with *'Department of Health and Social Services,' 'Bureau of Indian Affairs,' 'Social Security Division.'* A bunch of office buildings that just said, *'State of Alaska.'*

I walked passed a little Mom and Pop shoe store. *'Comfort Shoes.'* There was a sign in the window:

'Help Wanted'

I walked in and stood in front of the cashier's desk. A portly bald guy in a white dress shirt and red polyester tie came waddling over to me, looking nervous. "You can't use our bathrooms! They are for our customers only!" He turned to a young woman coming out of the back room. "Patty, get back to the cashier's desk, I told you to stay there!"

"Mr. Warner, I was only helping Aggie get a pair of shoes from the back. I am right *here.*"

He whispered fiercely at her, "Don't leave the cash box alone!"

He looked at me again. *"No public bathrooms!"*

"Actually, I am here about the sign in the window. Help Wanted?"

The two looked at each other in disbelief. "You want a *job*?" He exclaimed.

"Um, yeah. Night cleanup, or if you need trucks unloaded, or janitor work?"

"No, no, nothing like that. Have you ever sold shoes?"

Sold shoes? I hitchhiked over two thousand miles to be a shoe clerk?

"Um, no."

"Are you interested? I will train you. The legislature is in session, and we are *desperate* for help! We are the only full-service shoe store in Juneau. We have been since 1957."

"Um, how much does it pay?"

"You start at five-fifty an hour, then if you sell over-draw, you get a straight commission."

"Over-draw?"

"*Yes!*" he sounded exasperated. "In an eight-hour day, if you sell over seven hundred dollars in shoes, I pay you a straight six-percent commission. It's about one pair an hour."

"And if I sell more?"

"Like I said, six-percent commission!"

"What are the hours?"

"We open at nine, close at five. You get an hour for lunch. Unless we are really busy."

"When can I start?"

"*Now! Today!* I will start training you right away!"

Where am I going to live? "I'll take it. I, uh, have some errands to run, I will see you after lunch, OK? Say about two? My name's Stu, by the way. Stu LeClercq."

"Fine! Fine! I will see you at two!" The guy acted like he had won the lottery.

I went back outside elated. *A job! Who cares what it was! I could afford to eat! Now, what about a place to sleep? And lunch! I am starving!*

I walked back down to the waterfront and smelled burgers cooking. That was it for me. I bee-lined straight for the smell. 'Big Lou's Burger Shack,' written on the side of a faded red-shingled dilapidated building that looked like an auto garage

from the 1920s. It was right down on the docks. The next pier over from an enormous block-long concrete warehouse marked, *'JCS.'*

I walked up to the window and stood in line. There were already three people in line waiting to be served, and more sitting and eating on weathered picnic tables out by the water. I was drooling; I was so hungry. I read the plywood-sign menu:

1/2 pound Hamburgers and Cheeseburgers
Single or Double
Hand-Cut Fries
Hand Filleted Cod and Halibut –
Sandwiches or Fish and Chips (in season)
Onion Rings
Hand-Dipped Milkshakes and Malts

I was dying at this point. I could've eaten the plywood; I was so hungry. One other little hand-painted notice:

'Help Wanted.
Cook for Night Shift.'

It was my turn at the window. The waitress was wearing a nametag, *'Lena.'*

"Hi! I'll have a double cheeseburger, onion rings, and a vanilla malt, please. Um, who do I talk to about work?"

The forehead of the girl was a slippery sheen. She looked at me through greasy bangs, then yelled over her shoulder, "Lou! Somebody here for a job!"

An enormous man, perhaps six-foot-six, came out from behind the grill and looked at me. He had a greasy, torn black t-shirt on, that couldn't hide the most prodigious stomach I had ever seen. *He has to weigh over four-hundred pounds.*

"You looking for work?" he said in a surprisingly high voice.

"Yes, Sir. I, uh, I worked at McD's, uh, McDonald's all through high school, Sir. I ran the grill. Fries, shakes, stockroom, everything. Forty-two-hour-weeks."

"Can you work evenings, say five to midnight? The Cold Storage crew gets off at ten, and we get *buried* then. I've been working double-shifts for *three months*. No one will take the job."

"Sir, I am used to getting hit with two or three school team buses at a time where I worked, we could get 150 people at once. I worked the Five-to-Midnighter there, too. No problem."

"When can you start?"

"Uh, tonight? But I need a place to stay."

The girl jerked her head up. "I need a roommate! My girlfriend just moved back to St. Louis! You'll have your own room, and we share a bathroom and a kitchen. We split 450 a month."

Two-twenty-five a month! I was paying twenty at Randy's! "Yes, Yes, I'll take it!"

She looked ecstatic. "Lou, can I take him over there after the lunch rush? We'll only be a half-hour or so!"

He looked down at me. "Well, I guess you're hired. You start at $4.75 an hour. If you're my go-to night guy, I'll give you a raise to six. But you have to have this place cleaned up when you go, ok? Spotless!"

"Deal, sir!! Thank you both!!"

I sat on the dock and ate my lunch, not believing my luck. I watched the bee-hive of activity over at the adjoining warehouse as I devoured the burger. *Two jobs!! Hot Fuck!*

Pink Castles

I went and got my pack from Juneau Air Service, waving to the girl behind the desk. She smiled and waved back.

I wonder if she has a boyfriend?

I sat at a picnic table, pack at my feet, and waited for Lena to get through the lunch rush. I followed her up the hill, walking right past my new shoe store to my new apartment.

It was a faded pink concrete block of a building. It could have been built maybe in the 1940s: four stories tall, no elevator. We walked up to the third floor, and Lena unlocked Number 303. Two tiny bedrooms, one completely covered in clothes and debris, one empty. Minute kitchen, one bathroom with every conceivable surface buried in girl-stuff. One-piece bath and shower combo, flowery shower curtain.

"It comes fully furnished, and the laundry room's in the basement!

In Seattle, maybe $150 a month. For the whole place. I threw my pack on my bed. *In my own bedroom. The first one since I moved out of Mom and Dad's.*

"We split the 450. Utilities are included. Roxy and I each just took a shelf in the fridge, please don't eat my food. Same with the cabinets, one each."

She was willing to move in with a complete stranger, a guy, and she didn't even hesitate. "You sure it's ok? I really need a place, but..." I couldn't believe how carefree she was.

"It's because it's hard to find a roommate in this town! Nobody wants to even work, much less pay rent! Roxy tried to waitress at the 'Gold Bar Saloon,' but her tips weren't enough to pay the bills. The State is almost impossible to get into without a college degree unless you want to be a night watchman or something. Who wants to walk around in the middle of the night, twisting door handles?"

I would. I would do anything to eat.

"Thank you so much, Stu! I would have lost this place if you hadn't come around."

Suddenly the door opened, and a guy was standing there, looking back and forth at the two of us.

"Hi, Cookie! This is Stu, my new roommate! Stu, this is Rod, my boyfriend."

He was looking at me like I was something he found on the bottom of his shoe. "You've got a *dude* for a roommate, now?"

"Rod, you know how hard it is to find someone who will go in halve-sies with me on this. It's expensive! If you would move in with me, instead of living with your parents, we might be able to swing it!"

"Why should I blow a couple of hundred here, when I get free room and board?" He looked at me again. "I stay here three or four nights a week, so don't get any slick ideas about my girl."

"Just looking for a place to stay, guy. I'm no back-door man."

"What? A what? There's no back door in this place. It's a fucking *apartment.* What are you talking about?"

"Never mind. Lena, I am headed to work, can I swing by Big Lou's to get a key made in a couple hours?"

"No, there's one right here. It was Roxy's. The front door code is 5656. I have to get back too! Honey-Bunch, walk me down the hill?"

"Fuck, no! Then I have to walk all the way back to my house. I'll wait here and watch the box. See you tonight after work." He gave her a leer.

This guy was a real romantic, I can tell. "Lena, I'll walk you as far as the shoe store."

She looked surprised. "Why, thank you, Stu. A real gentleman!"

Rodney-Cookie-Honey-Bunch shot daggers at me as I walked past him and out the door.

Shoe Dogs and French Fries

I walked into the shoe store. There weren't any customers at that hour, just Mr. Warner, and a couple of girls. I forgot the name of the blonde one smiling at me.

"Hello. I'm back!"

"Hello, young man. Tell me your name again?"

"Stu, Sir. Stuart LeClercq."

"Very well. I am Mr. Warner. This is Aggie and Patty." The two girls smiled at me. "You are a very clean-cut young man. *What a pleasant change of scenery.* Do you have any work clothes?"

"Umm. What kind of work clothes? I have some clean jeans."

"No, no. That won't do at all. You will have to go to 'The Elegant Executive' over on Fourth, and get some dress clothes." He looked me up and down. "You're certainly not very large, are you? Well, we'll get you looking sharp in no time. You will need some shirts and ties, nice slacks, dress socks. Nothing *tacky*, please. No jackets required here, we will be working very hard, and it will get *much* too hot."

"I don't suppose I can wear these?" I pointed to my Adidas Stan Smiths.

"Oh, dear heavens, no! If you don't have any dress shoes, I might be able to find you a pair from the 'returns' bin, until you can afford something better. These are Johnson-Murphy's, one of the finest." He indicated the brown lace-ups he was wearing, with little holes in them in the shape of a bird wing.

Oh boy.

Alright, let's get started. I will show you what to do, then if you have questions, my girls can answer them." He pulled out a flat metal contraption with numbers and sliding things on it. "This is a '*Brannock Device.*'"

I learned about measuring feet, and the locations of all the different colors of shoes in the stockroom, and how to run the ancient cash register and cash box. "*Never leave the cash box unattended! The hippies will come in and steal us blind!*"

Aggie and Patty were very sweet for shoe clerks. "Not clerks! We are *salespeople!*" Aggie giggled. "Some people call us '*Shoe Dogs'*! I have no idea where that came from!"

With a nine o'clock starting time tomorrow morning, I walked over to the Elegant Executive on Fourth Street. I got some major-league looks when I walked into the store in my jeans, all the customers and clerks were dressed in suits and ties. I heard somebody say something about the Lieutenant Governor *himself* being in the dressing room, getting a suit fitted.

I bought two blue polyester dress shirts, a red polyester tie, and a navy blue pair of dress pants, that didn't even need a belt. I couldn't afford a belt, anyway. I still had to eat until payday. They had my waist size, 28, in the Kids' Section. They were nineteen dollars cheaper than the Men's Section. Ninety-six dollars lighter, I walked back up the hill and dropped my clothes off on my bed, ignoring Rod watching TV, then hustled down to Big Lou's to get ready for my shift at five.

Big Lou's is going to be a piece of cake. I can do this kind of cooking in my sleep after McD's. The equipment was a little worn-out, the grease-fryer looked twenty years old. I learned where the meat was stored, frozen foods over there, cheese over there, condiments here, fresh cod and halibut fillets in the reach-in, along with big plastic screw-top containers of tartar sauce.

At the end of my shift, at midnight, I was going to have to clean the place up and do a policing of the picnic tables out on the dock.

"The hippies sleep on the tables at night, and they poop right over the dock into the water!"

I had to make sure the padlocks were all in place on the doors, and serving windows, or *'the hippies would steal everything.'*

I was in Juneau. I had two jobs and an apartment. On my first day. This was going to be a piece of cake.

Meeting Mo

Three weeks later, I was hustling out of the shoe store to run my lunch errands. *That's the problem of working eighty-something-hour-weeks, there's no time to do anything.* I needed to get some laundry detergent to wash the fry grease out of my work jeans, and a couple more pairs of socks. *What else?* I couldn't remember. I flew around the corner of one of Juneau's brick buildings and straight into two very large men.

One was six-three or four and weighed two-forty. He looked Native American, but the man was enormous. The other was just about four inches taller than me, about five-seven, but weighed over two hundred. His shoulders took up the whole sidewalk. He was pure Native, with thick black hair cut straight across his eyebrows, square-headed, black gleaming eyes. Tattoos were covering his muscular forearms. He was frowning at the intrusion.

Shit. "Sorry! I'm sorry, Guys! I wasn't paying attention! Excuse me!"

The tall one looked down at me, didn't say a word, just took a drag off his cigarette. When he took a drag, it looked like he was cupping water into his mouth. Palm up, cigarette between thumb and forefinger. What it reminded me of was when we used to take Holy Communion in church on Sundays. He did it with a sort of reverence. It would have looked effeminate on someone else, but this guy was the meanest looking mother I had ever seen. It looked like an old knife scar across his jawline. His eyes were surrounded with laugh lines, though, which was encouraging.

Maybe they wouldn't kill me right away.

His face looked like he had been working outside his whole life. He finally spoke. The shorter man just looked at me with those black eyes.

"Where's the fire, son?" His voice was so deep and low you could hardly hear him.

"No fire, sir. Just running to get some stuff done on my lunch break."

"And you work where?"

"Comfort Shoes,' Sir. I, uh, just got to town a few weeks ago, and they were hiring. It's not something I want to do for very much longer. I'm working over at Big Lou's in the evenings, too. I'm the Night Cook and clean-up guy. I work every day but Sundays, but Lou is thinking about opening up at noon on Sundays because I am working out really well. You know, after church, and I might work then, too. He says he might give me seven dollars an hour to work on Sundays, 'cause I don't go to church anymore, and I could work the place alone for the people who want to go, to church, that is, and we would be open for the people getting out of church and walking home..."

He was looking down at my outfit, eyes twinkling with humor. I was completely embarrassed by my blue polyester shirt and my bright-red polyester tie. My pants were double-knit navy blue slacks, Sansabelts. *Out of the Children's Department.* The dress shoes that Mr. Warner had sold to me for twenty bucks out of the 'returns' bin were these Dexter two-toned burgundy and navy-blue spectators that had brass eyelets for the navy blue laces, bulbous toes and inch-and-a-half-high blocked Cuban heels. Standing in front of these two hard-asses with their working clothes on, and rubber boots, I felt like a fucking clown. *All I needed was the fucking big red nose and the orange hair.*

"Work's kind of hard to find in Juneau," I was looking down at my shoes. "I hitched up here from Seattle, and don't have a lot of money."

The big guy just looked at me and smiled again. "No need to apologize for working, Son. I admire someone who will do whatever they have to, to survive. How old are you?"

"Nineteen, Sir...no, I'm not. I'm really, only seventeen. Eighteen in September."

"I'll tell you what, Son," he looked over at the Native guy and nodded, then back at me. "When you feel like you want to do something different, you come and see me over at the Cold

Storage. I'm the foreman at JCS, and Frank here is the head of the Freezer Crew. We aren't 'officially' hiring right now, but I bet we can find a spot for a young man who is as willing to work as hard as you. Whadduyou think, Frank?"

The Native just looked at me and slowly nodded that massive head.

"I heard you guys are booked years in advance, and that the Union waiting list is over *five hundred* people long!"

He chuckled in his deep voice. "Well, you'd be surprised. I can sometimes get around Union waiting lists. You come see me. My name is Mo."

"Stu. Stuart LeClercq, Sir!"

"Don't call me sir. Call me, Mo."

Thanks Sir! Mo!"

I reached out and shook his hand. His eyebrows raised a little, and he nodded to Frank. I shook Frank's too, calloused and strong as iron. He and Frank were both smiling as they turned away. I slowly made my way back up the hill to the shoe store, forgetting my errands completely. I rubbed my sore right hand. *I'm getting out of shape.*

Last summer, the guys and I went to the Washington State Fair in Puyallup. They had one of those twenty-five cent coin-op grip-strength-tester-thingies there. We all tried it. The winner gets a buck from everybody. Randy squeezed one hundred and ten pounds. Zephyr grunted his way to one hundred forty. Drager, the left tackle on the football team, six-three and two fifty-five, squeezed two hundred sixty. I put my quarter in and gave it all I had. It went to three-hundred and five pounds. I had been working out on the Still Rings five days a week since I was a Freshman. I had a pretty strong grip.

Chugging up the steep street, I recalled what I had heard from the other newcomers on the street corners about the Juneau Cold Storage.

"Seven days a week, all summer long. Too much work for me!" *"Union, you know. Impossible to get into the Longshoreman's Union. Almost six bucks an hour! Time and a half after eight hours and all-day Saturday. Double time on*

Sunday! One-hundred-hour work-weeks the entire fishing season. I heard six hundred fifty bucks a week!" "My friend has been on the waiting list for two years, trying to get in. You 'gotta be an Indian or know somebody to get in."

Jesus. Imagine the money. Six hundred fifty dollars a week! Almost ten times what I made at McD's. What would a one-hundred-hour workweek be like? Hell, I'm working over eighty now.

Right in front of the shoe store was a bench that I took my breaks on sometimes. Leaning up against it were these two unbelievably hot girls, with their backpacks propped up on the ground next to them.

They were both dressed alike—minuscule short-short cut-off jeans with the pockets hanging down. Faded blue denim shirts completely unbuttoned, with the tails tied in a little knot at their waists, showing matching pierced belly-buttons. The smooth, soft curve of their tanned braless breasts peeking out. Earrings and rings and bracelets. Hiking boots and knee-high hiking socks. Slim, tanned, curved thighs. They were both looking at me as I approached. I suddenly was completely out of breath.

When I got closer, I smiled at them, and gasped, "Hi!"

They turned and said something to each other I couldn't hear, then burst out laughing. I felt myself turn beet red and went into the shoe store, completely humiliated.

Double-knit navy blue pants. Cuban heels. That's it for me. After my shift that day, I went up to Mr. Warner and quit. I threw my tie in the trash can next to the bench when I left, swearing as I walked out of there to my burger joint job, that I would never compromise myself again for money. *It wasn't worth it.*

Smoked Burgers and Cold Storages

Now, what was I going to tell Big Lou about leaving? He had been so kind and generous to me for the last month or so, allowing me to get there a few minutes late when the shoe store needed me. Letting me eat anything I wanted on my breaks. Fresh filleted halibut and chips were the best food I had eaten since I left Mom's kitchen. *Halibut was fantastic!*

I rounded the corner at the top of the hill and looked down the half-mile towards the burger joint. It was engulfed in smoke and flames. I could hear the sirens now, approaching the burning building. I ran all the way there.

Lou and Lena were standing on the dock, watching the building burn. Across the water, at the next pier, the entire crew of JCS was lined up, watching the spectacle. I ran up to the big man. He was sobbing.

"I should have turned off the deep-fryer before I changed the oil. I was in a hurry. *I am so stupid!* So stupid! All that work is gone! I've had that restaurant for *eighteen years!*"

"Lou, are you ok?" His arms were red and covered in blisters.

"I should have turned off the deep-fryer!" He was sobbing and obviously in shock.

I ran over to one of the firefighters and told him that there was an injured man. The paramedics came running to him.

"No, no, I am fine!"

They gently led him to the ambulance and closed the back doors. Sirens wailed as they pulled away. Lena and I looked at each other.

"What am I going to do, Stu? How am I going to pay the rent?"

"I'll cover us this month, Lena. I have a little set-aside. Oh, and I know for a fact the shoe store needs some help."

I looked over to the cold storage dock. Mo was standing there, smoking, looking at the show. He nodded at me, then beckoned me over.

I walked around to the next pier, where the main entrance to the building was. Huge sign overhead, *'Juneau Cold Storage.'*

There was a gargantuan steel roll-up door I walked through, into a room half the size of a football field. It was dimly lit with florescent lights, hanging twenty feet off the ground. The floor was concrete, puddled with water. It was easily thirty degrees colder inside the building than in the warm July sun.

I walked towards the open doors facing the water, where I thought Mo would be. There were forklifts parked in haphazard positions all around the warehouse and three rows of stainless steel tables down the middle of the room. Each row was fifty feet long. The tables were choked with dead salmon and ice. Guts and blood were overflowing the sides of the tables, forming rivers of red that flowed along the floor. The blood made its way to four-foot-square drains cut into the concrete, covered with iron bars two inches apart. Ice chunks the size of basketballs were clumped on the grating. The ice was covered in slime, fish scales and pink blood.

There were stainless steel handcarts on wheels, dozens and dozens of them, scattered around the floor and lined up to the ends of the tables. About five feet long, three feet tall, and three feet wide. Filled to the tops with salmon and ice, they had holes in the bottom, dripping fish slime and blood.

The smell was incredible. Ammonia, fish, seaweed, and diesel exhaust coming in from the docks. The place was deserted. Everyone was outside on the pier watching the fire. The only sounds were the blood dripping on the floor, the cracking of ice melting, and in the background, sirens from the restaurant fire.

I walked outside onto the dock, back into the bright sunlight and heat. Everyone was standing and watching the firetrucks working on the next dock. The drivers of the fishing boats had their heads out the windows, looking at the spectacle. I went over to Mo and Frank. They were watching the fire and

smoking. The two men were surrounded by fifty or sixty workers, wearing green rain suits with yellow sleeves, and red rubber boots, everything covered in blood and gore. Right around Frank, were eight or ten guys dressed entirely differently. They had on down jackets and wool pants, and the funniest looking shoes I had ever seen. They were white, with bulbous toes on them, air valves on the ankles, and white Vibram soles.

One of the guys caught me staring. "They're *'Bunny Boots,'*" he said. "We use them in the freezers to stay warm. It's thirty below zero in there. These are World War Two and Korean War U.S. Army surplus. Guaran-damn-teed down to one-hundred-below-zero."

I shook my head and just stared. He laughed and followed Frank back into the building.

Break's over. Fire's out.

I looked up at Mo. He was watching the last of the efforts to clean up after the blaze. "Big Lou, ok?" he said.

"Yeah. Some burns on his arms, but not too bad. He's broken-hearted."

"He's a good man. Looks like you need a job."

"Yeah. I guess so."

He turned to me. "Ok, here's how it works. You go down to Cadman's Supply on Front Street. You talk to Angus in there, tell him you work for me. He will set you up with a line of credit and get you outfitted. Helly's, gloves, get a whole case of 'em, Ketchikans, sleeves, hat, wool pants, wool shirts, the works. You can pay him back from your paychecks as you get 'em, don't worry about that, you're good for it, and he knows it. Be here at 5:15 tomorrow morning, work starts at six, and you've got some learning to do before the Horn. Now get going. I'll see you tomorrow.

I put my hand out to thank him.

He just smiled at me through a cloud of smoke and said, "Don't worry about thanking me, Stu. Just be here ready for work, that's thanks enough. Besides, after a week or so, you might not think you've done so well, after all."

His eyes were laughing at me again. He clapped me on the back, which almost knocked me off the dock into the water, then turned and walked back inside the ancient concrete warehouse. I turned to follow him just as an enormous air-horn went off right next to me. I must have jumped a foot because the people working at the tables all laughed at me. I grinned and hot-footed it to Cadman's Supply.

Outfitting

I walked into Cadman's and up to the counter.

"Yes? May I help you?" A bearded man in a plaid shirt walked up to me. He had a very thick accent, maybe Scottish, though I had never heard one before.

"Are you Angus?"

"*Yarr*, that I am."

"Mo sent me from the Cold Storage. He said you could get me outfitted for work?"

"Startin' 'em young, are they?"

"I'm seventeen, Sir."

"Of course you are, Laddie. Have you ever filled out an application for credit?"

"An application? Does that mean I might not get it?"

"Calm down, Lad. It just means I need some information from you. Where you live, your real age, and such." He winked at me and slid a form across the counter.

Relieved, I filled out the form as he watched me with amusement. I slid it back over to him. He read it for a minute, scowled, then looked up at me.

"When do you start?"

"Tomorrow at six."

"Well, let's get started, then. Oilskins first. The good Helly-Hansens. They're the heaviest-duty you can buy, but you don't want to be buyin' a bunch of junk, do you? You'd be back in here every week replacin' your gear." He looked me up and down. "You'll have to cut the legs off. They're much too long for you. Do you want the jacket with a hood, or not?"

"Hood?"

"For the rain, lad!"

"Uh, sure. Hood."

"Rubber boots, next. What size, eight? You'll be lookin' like an' eight." He brought me some of those red rubber boots I had seen around town, with a patch on the top that said, 'Xtra

Tough BF Goodrich.' I tried them on. They were a little loose, and I said so.

"Well then, use two pairs of socks, they'll fit just proper. Gloves, size medium, one case. Sleeves." He handed me a pair of yellow plastic tubes, with elastic cuffs on each end.

"What are these for?"

"You put them on tight around the sleeves of your oilskins, lad. It keeps the slime from running down your arms when you raise your hands over your head."

"Oh. Why 'oilskins'?"

The local Indians used to use oiled sealskins for their raingear. The nomenclature just stuck around. After a hundred years, it's a throw-back to the gold-rush days." He continued. "Woolrich ten-ounce wool pants, what waist?"

"28."

"Well, we start at 30. You'll need a belt. Pick one out. Osh-Kosh striped logger shirt, Woolrich wool halibut shirt, Duofold long underwear, eight pairs of Duofold socks." He was ticking off the list on his fingers as he pulled the gear off the stuffed shelves, piled to the ceiling with gear. "Six pairs of cotton gloves, better make it two cases of rubber gloves..."

The pile on the desk was getting enormous.

"Ok, I think that will be the lot."

"Um, Mo said something about Ketchikans."

"Ketchikans? Oh, sure now. The rubber boots. The Slimers call them Ketchikan Reds. Everybody in Alaska that's not a Cheechako wears 'em."

"Slimers? Cheechako?"

"Don't you know your own job, lad?"

"I guess not."

"Well, you'll find out tomorrow, sure enough. A Cheechako is a young lad, still wet behind the ears. Like you." He began ringing everything up and stuffing it into big blue plastic bags.

"Ok, Lad, I've extended your credit for six months. The total will be $493.55."

"What? That's over two month's rent!"

"It's Alaska, Laddie, not your Mama's kitchen. I can sell you cheaper goods, but you'll be right back here buying everything again, and Big Mo will have my arse."

I shook my head and signed my life away. *Owe my soul to the fucking company store—another day older and deeper in debt.*

"I expect a little something every payday, at least a hunnert dollars. There's no interest on the credit. Just pay me back. Your handshake is your bond." He looked at me solemnly and forcefully put out his big hand.

I reached my hand across the counter and flashed on the poor, uneducated gold miner from 100 years before doing exactly the same thing.

They say the ones that made the millions during the gold rush were not the ones panning for gold, but the ones selling the gold pans. I could see why.

First Day at JCS

The next morning, I set my alarm to go off at 4:30. *I seriously don't want to be late on my first day.*

I swung my legs over the side of the bed, and what I had done finally dawned on me. *One-hundred-hour weeks? No days off 'til fall? You have got to be kidding me!* I was muttering to myself as I got into the shower. Lena was staying over at her boyfriend's parent's house, so I wasn't worried about waking her up.

I started putting on my new uniform—two pairs of socks, wool pants, way too long. I rolled up the cuffs twice so I could walk in them. Cotton long underwear...*no that must be for later in the season, it was still sunny out.* I left them in their plastic wrapping on the bed: T-shirt, Osh-Kosh logger shirt, Woolrich wool shirt, rubber boots. I put the rain gear and the gloves and the funny yellow sleeves into one of the big plastic bags and was carrying it as I left the apartment.

Its July. Why am I wearing all these clothes? I carried the bag over my shoulder like a Santa sack as I duck-walked the half-mile towards my new job, trying to break in the stiff, ungainly rubber boots. They were chafing my ankles, and I had hotspots all over my feet in a matter of minutes. I missed my Adidas already. *Still better than the Dexter Bozo the Clown shoes.*

I walked past the restaurant that I had my gourmet breakfast my first day in Juneau. It occurred to me that I hadn't eaten anything, and had made no plans to do so. I just thought I would be getting my free meal at Big Lou's, and I had forgotten Big Lou's wasn't there anymore. I spun around and went into the restaurant, walked up to the counter, and looked at my watch. I had ten minutes to eat. The cook was behind the order counter, dispensing himself a Coke.

"Excuse me, do you have any food already prepared? I don't have much time."

The dark-skinned Native man looked at me silently, then reached over behind the cash register and put a domed glass platter of doughnuts on the counter in front of me. I looked at him in disbelief, but he had already turned and gone into the kitchen, his waist-long ponytail flipping goodbye.

The waitress came out of the back and asked me, "What'll it be, Hon?"

It was Shirley. I lifted the glass dome and took three chocolate-glazed doughnuts off the plate and put them on a napkin. I looked at the pile and added two maple bars.

"Just these. Thanks. Shirley."

She shrugged and wrote out a ticket for $7.50. I paid and walked out the door, eating the doughnuts off the napkin, balancing my plastic bag of equipment on my shoulder. I got to the Cold Storage at exactly 5:14, and stuffing the last doughnut in my mouth, walked into the door marked 'Crew Room.'

The stink and the heat almost knocked me out. It was at least ninety degrees in the long, narrow room, about ten by forty feet. It smelled like a sweaty locker room, which I was used to, but with an overpowering stench of dead fish on top of that. The room was filled with cigarette smoke being blown around by a huge fan built into one end wall. There were lockers with padlocked wire mesh doors all along one wall. At the end of the room, at the opposite end of the big fan, was a little coffee table, where Mo and Frank sat playing cards and smoking. There were half-full white Styrofoam cups of coffee on the table, along with a glass sugar dispenser and a big cardboard tube of Coffee-Mate. On the table between the two men was what looked like a deer antler with a couple of hundred holes drilled in it in long rows, and four toothpicks randomly stuck into the holes. Mo was squinting at the cigarette smoke, looking at his hand. He slapped down two cards face down in front of Frank, who put two of his own cards on top of Mo's.

"Nine," Mo said cryptically, putting a nine of spades face up between them.

"Fifteen, two," Frank replied, setting the six of hearts on top of the nine and moving one of the toothpicks two holes.

"Twenty-one for two."

"Twenty-seven for six."

It went on like that for a few minutes. I had no idea what game they were playing. The back-and-forth dialog suddenly stopped, and Frank started shuffling the cards. Mo looked up at me and smiled.

"You made it. Good. I want to introduce you to 'Mone. *Ramone*! Here's some new *meat* for you."

An Asian-Indian-looking guy walked over to us from where he was changing at his locker. He was my height, but he didn't weigh 120. He could have been twenty-five or fifty-five years old. Lean and hard and tough-looking, like a street-fighter from one of those Kung-Fu movies. He scowled at me and looked at Mo.

"Who 'da hell's 'da kid? You kiddin' me, Mo? He ain't gonna' last ten minutes on the line. Es 'mo bettah you get me a little girl, so I can at least get a little..."

"*Ramone*." Mo looked at him, hard.

"Okay, okay, he's your nephew or sometin'. Mo' bettah fo' you." He looked me up and down and shook his head.

"You meet me outside in five minutes, dressed. Your locker is Number 13." He suddenly had no Pidgeon accent left at all.

I went over to locker number thirteen and slid up the metal latch, swinging it open. I took my new raingear and gloves out of the big plastic bag and began putting them on. I put the extra gloves in the locker and shut it. I didn't have a padlock, but there wasn't anything in there besides the gloves, anyway. I couldn't figure out how to get the sleeves on over the top of the heavy raincoat, so I was carrying them in my hand as I walked out onto the work floor. My wool pant cuffs had come unrolled, and I was conscious of dragging them across the wet floor.

Ramone was all alone, waiting for me at the end of one of the tables. He was holding a white-handled knife that had a long, narrow blade and a needle-point. A second knife was sitting on the table, within reach. He had a headless salmon on

the table in front of him. As I walked up, he opened up the salmon's belly, slicing it from the anus to the throat with one quick motion of his knife. The fish's guts spilled out onto the table. He spun the fish, so the head-end was facing him, and made two quick flicks with the knife, cutting around inside the neck. He reached in with his other hand and pulled the guts out of the fish, throwing them onto the table. He then picked up the second knife that was lying on the wet stainless table and slit the blood vein attached to the backbone inside the fish, and with three or four scraping motions with the round blade of the second knife, scraped it clean. He took the fish and slid it into an empty cart at the end of the table. The whole process took eight or ten seconds.

He looked at me and said, "Got it? That's what you do. The Slitter slides you a fish. You clean it just like 'dat. You work fast, you unnerstand? OK. When you're finished, slide it into the truck." He gestured at the cart parked at the end of the table.

He handed me the second knife. The blade was an inch-and-a-half wide, four inches long, and it had a rounded end instead of a point. It had a white handle, and the edge looked razor-sharp.

He looked at the yellow sleeves in my hand and shook his head.

"'Gimmee 'dose."

He grabbed the knife out of my hand and threw it on the table, then roughly pulled the sleeves up over my hands and up my arms, the larger end at my elbow, and the narrower end tight to my wrist.

He shook his head and walked away, muttering. *"Two days, max."*

I just stood by the table, all by myself, and not sure what to do, so I thought I'd practice on another fish. There were hand-trucks of fish everywhere, at least twenty of them. They were filled to the top and covered with the snowy ice. I picked up my knife, then walked over to the closest one and dug around to take a fish out.

A skinny Native guy in a wool shirt with the sleeves cut off, showing tattooed arms, came walking out of the crew-room and yelled at me. "Hey! Don't do that!" He sneered at me, showing he only had three front teeth, one up and two down.

I let go of the salmon.

"*Nobody* touches the trucks except for the *'Header,'* unnerstand?" He talked like his tongue was sliding all over his mouth, with no teeth to control it.

"Sorry!" I mumbled.

He walked over and stood right in front of me, scowling.

"You the new guy?"

"Yeah, I'm Stu."

"Well, I'm the *'Header.'*"

I just looked at him. "Is that what I call you?"

He looked at me sharply, not sure if I was being a smart-ass. Glancing around, he said softly, "You can call me...*'Blade.'*"

"*Blade?*"

He nodded, eyes squinting like Clint Eastwood in *'Hang 'em High.'*

Just then, a hefty native woman, maybe two-hundred-fifty pounds and five-nine, came out of the crew-room. She was pulling on her yellow sleeves as she walked towards us, moving so lightly on her feet, she reminded me of a big cat. She was shaking her head and rolling her eyes at the guy.

"*Normie! Don't be an asshole!*"

He glanced at me and looked embarrassed.

"He thinks because he's at the head of the line he's some kind of *danger* to everyone. An *'Artist with the Heading Knife.'* An *'A-sas-sin.'*" she said, drawing the word out dramatically.

"Just ignore him. Norm, don't make me trade places with you. I'll show you what dangerous really is."

She held out a gloved hand. "Annie. I'm the Union Shop Steward. I.L.W.U. Local 44."

"Stu. Pleased to meet you."

Her handshake just about crushed me. "OK, Sweetie, here's the drill. Normie's the Header; he pulls the fish out of the trucks

and slices their heads off. He's at the *'head'* of the table and the Number One Man on the Line."

She looked over at him and rolled her eyes. "We could make jokes all day about it going to his head." She turned back to me. "I'm the *'Slitter.'* I open 'em up and get them lined up just right, so they're turned the right way, and then slide them down the table to the *'Slimers.'* That's you. You pull out the guts and slice open the big vein along the backbone, then scrape the blood out of the fish. Don't forget to get the two glands up by the neck. They're hard to see sometimes if you're in a hurry, and believe you-me, you're 'gonna be in one *hell* of a hurry. Since you're the low man on the totem pole, you'll be at the very end of the table. You'll also have the responsibility of pulling all the guts off the table and pushing them to the floor drains. Use that squeegee leaning against the truck over there."

She pointed to a tool that looked like a push broom, but with a curved rubber blade-attachment at the base instead of bristles.

"You keep the ice off the table too, if we get buried in guts and ice, it slows us down. Questions?"

Suddenly the deafening air-horn went off, and I almost jumped out of my skin again.

She smiled at me. "Six o'clock. That's the *'Fucking Horn.'* You'll get used to it. Goes off at 6, 8, 8:15, 10, 10:15, 12, she was ticking off the times on her gloved fingers, 1, 3, 3:15, 5, 6, 8, 8:15 and 10. Fifteen-minute breaks at 8a.m., 10a.m., 3p.m. and 8p.m. Lunch noon to one, dinner five to six. We quit at ten pm. You have to be on the line ready to go when the second horn sounds after breaks. I mean *on the line*, not putting on your gear or putting out your cigarette on the dock. Questions? OK, have fun!"

She walked over and began helping *'Normie-the Blade'* unload salmon onto the table.

I moved to the bottom end of the table and got ready to go. All four of the tables were filling up with workers. Everyone seemed to have their designated spot. There were all different ages and races of people, from all over the place, it seemed.

Some even looked European. Lots of Natives, they had the "Heading" and "Slitting" jobs exclusively, as well as driving the three forklifts that had started to buzz around the big room.

The smell of burning propane started to mix with the fish smells. The forklifts were obviously propane powered. When I was a kid, four or five or six years old, our ice-cream man drove a little white propane-powered truck around the neighborhood, with pictures of all the ice-cream bars he sold on the side and his stupid jingle playing so loud and distorted through the speakers you couldn't hear yourself think. I always ordered the Heath Ice Cream Bars and had thought for years the sweet smell of burning propane was the smell of Heath Bars. The smell made me want one right now.

I snapped out of my reverie and continued my observations. There were lots and lots of Asian-looking guys that looked kind of Spanish, too. Like Ramone. I didn't know where they were from.

Every table had a Header and a Slitter and ten or twelve Slimers. Less than ten minutes after the 'Fucking Horn' went off, the operation was in full swing. I was immediately buried in ice, and fish, and guts. Everybody was sliding their finished fish down the table to me, along with a mountain of ice and a river of guts and blood.

The guys in the middle of the line were looking at me with annoyance. "Hurry up! Get the shit off the table!"

They angrily shoved cleaned fish at me. It was all I could do to empty the table, throwing fish into the truck and scraping the guts onto the floor. I was ankle-deep in entrails. My feet were freezing from standing in the icy mess. My hands got cold, then colder. Then they froze entirely; then they started to hurt, stabbing pains of pre-frostbite. I still hadn't 'slimed' a single fish. I had ten or twelve stacked in front of me, guts oozing out of them, but I was so involved with clearing everybody else's I wasn't able to even pick up my knife.

Where was my knife, anyways?

I think it had slid onto the floor along with the last pile of icy entrails. I bent over to look for it, and somebody slid a thirty-

pound salmon right over the end of the table, hitting me right in the back of the head and driving me to my knees. I was kneeling in the pile of crap, feeling the icy slime leak into the top of my boots and up my soaking wet pant legs. I guess I should have cut them off shorter, or at least tucked them into my boots like everybody else had. I grabbed the handle of my knife and stood back up. Everybody was looking at me really annoyed, the end of the table was clogged with fish and ice, and I didn't know where to put my knife to keep from losing it.

Annie hustled over to the end of the table to help me, throwing cleaned fish into the truck until it was full. She hurriedly motioned, indicating over against the wall where the empty trucks were lined up.

"Get another one."

I ran over and grabbed the stainless cart; it had swivel wheels on each end and fixed wheels in the center. I couldn't get it away from the wall, because it kept swiveling back into it.

"Goddammit, Let's go!!" One of the Slimers yelled over at me.

I finally pivoted the truck off the wall and ran it over to the table. There were cleaned fish falling on the floor and a waterfall of blood and guts. I finally caught up with picking up the ones on the floor and started throwing the cleaned fish off the table into the truck. With one hand, I was scooping the guts onto the floor and shoving them towards the floor drain with my foot.

I caught up long enough to grab the squeegee and shove everything to the drain, then trotted back to the table in time to grab the fish that were sliding at me. Finally, I caught up. I breathed a sigh of relief. *I was getting the hang of this.* The guy next to me in line looked at the uncleaned fish in front of me, their guts oozing out of the cut bellies.

"You're not doing your share. I'm cleaning *your* fish *and* my fish. Get your ass to work and stop fucking around."

I grabbed my knife and pulled the guts out of one of the big salmon. I sliced at the big vein inside the fish, but missed, and cut the flesh and the bones. I grimaced. The guy next to me

shook his head, and grimly kept working. I scraped the blood out and slid the fish into the truck. My first fish! The guy reached over into the truck and pulled it back out, opening it up and jabbing his knife at it.

"You missed the glands, there's still a bunch of blood in there, and you cut the goddamn meat. You wanna' turn it into a Number Two? Do it right, Rookie!"

Number Two?

I carefully did the work again, finding the little blobs of blood that must be the glands up by the neck, and carefully finished scraping all the blood out of the fish. I opened the belly up and showed it to him.

"Whoop-ti-do, you did one. You're a real fuckin' prodigy."

He shook his head and concentrated fiercely on his own fish. I threw the cleaned ones that were being slid in front of me into the truck and grabbed another salmon. By the time I finished sliming it, the guy next to me had done four. I grimly kept working, head down, and trying to find a rhythm. Slice the vein, scrape, scrape, scrape. Find the glands, scrape, scrape, slide the fish into the truck, slide all the cleaned fish in front of me into the truck, shove the guts away from the table with my foot, grab the squeegee and shove the guts and ice to the drain-hole, where they fell into the open water below the dock. Grab a fish, scrape…I looked up at the clock hanging over the crew-room door. It was 6:23 in the morning. I was exhausted already.

As I was working, I glanced around quickly at the other workers and what they were wearing to stay warm. It was mid-July, and they looked like they were dressed for the Arctic. Hooded sweatshirts under heavy down or wool jackets under the heavy rubber raingear. I was cursing my decision to leave the long-johns on my bed that morning. I was shaking; I was so cold. My hands were frozen solid, no feeling in them at all, I could hardly hold the knife, and it kept twisting out of my hand. I held it tighter and kept going.

The trucks started to fill next to me. When there were six of them full, the guy from yesterday on the dock with the bunny-boots on trotted over and grabbed onto one and started to

wheel it away. His moustache was frozen in a block of ice, and his head was steaming through his stocking cap. He winked at me, and using his whole-body weight, shoved the thousand-pound cart ahead of him. As soon as it started rolling, he quickly grabbed another one and pulled it behind him towards a big roll-up door across the room. I could see the forklifts going through the door, and ice vapor was pouring out of it into the main work area. There was a huge fan cowling stretched across the top of the door, blowing air back into the other room.

Cold Storage. Those must be the blast freezers back there.

I could see Frank through the door with a clipboard directing traffic, pointing at the forklifts, and giving instructions. He had on one of those rabbit-fur hats with ear flaps that made him look like Elmer Fudd. *I wasn't going to say that to him, though.* The little forklifts had waxed cardboard boxes five feet square on wooden pallet jacks on their forks, the boxes filled with frozen fish. They were zooming around, taking the cartons outside to a loading dock with semi-trailers backed up against it. The ice vapor was swirling around on the floor, making it look like that creepy scene in "The Hound of the Baskervilles."

No sign of Dr. Watson and no shit, Sherlock.

I kept cleaning and shoveling guts and flexing my hands to try and keep them from having to be cut off from frostbite. I must have looked over at the clock two-thousand times. Eventually, the Fucking Horn signaled the eight o'clock break. I was too tired to jump at the noise, and it was time for our first break of the day.

Two hours down, fourteen to go.

Lord of the Rings

Everybody dropped what they were doing, half-heartedly washing themselves off with white handled brushes, floating in pink disinfectant solution, in buckets at the end of each table. They started slowly filing outside into the sunlight on the dock. Their raingear was still covered with blood and gore and soap bubbles.

The sun felt wonderful. I was too tired to even take off my gloves. I just sat on the edge of the dock and looked around. There were the charred remains of my old job over there on the next pier. The other workers were congregated in small groups. Most had lit up cigarettes and were sitting in the sun, legs stretched out in front of them, fatigue covering their faces.

There were two fishing boats tied up to our dock. The tide was out, so they were maybe thirty feet down below the dock level, only their masts sticking up above. There was a big aluminum crane over on the corner of the dock, at the end of its lifting cable was an aluminum box that could be lowered down to the boats to facilitate the unloading. The crane operator was working straight through break-time, skillfully threading the box down between all the mast cables, and setting it down right on the ship's deck. There was a guy down in the hold of the boat throwing salmon into the bucket. When it was full, the crane operator would slowly lift it back up and set it on the edge of one of the same kind of trucks I had been filling-up all morning. Another guy unhooked one set of chains, the crane operator lifted the box up, emptying it into the truck. There were two full trucks on the dock and eleven empties. Out in the harbor were a dozen or more fishing boats sitting. Waiting to be unloaded.

No wonder we were working sixteen-hour days.

At 8:15, the 'Effing Horn' went off, and we filed back inside into the cold dark warehouse. I felt like Cool Hand Luke on the road-gang. *How in God's name was I going to survive fourteen more hours of this? It was only Thursday! Sixteen more*

tomorrow, then twelve, then eight, then five more sixteens in a row! I began doubting my sanity at accepting this workload. I shuffled back to my station, pantlegs sopping wet, thoughts filled with despair. I grabbed a fish and began slashing at it with my knife. *Maybe if I do shitty enough work, they will fire me, and I could go home. Back to Bellingham. Back to McDonalds, back to Randy's trailer park bedroom floor.*

I hate this. Pipeline, my fucking ass. Get rich on this, you stupid, ignorant little fucker.

The fifty-foot table was so full, I had to keep shoving fish out of my way in order to get the one I was working on to even turn around.

The guy next to me watched me rage for a minute. "Calm down for Christ-sake. You've got a long way to go."

I just glared at him.

"Here. Let me show you a trick." He reached over and took my fish.

"Turn the head towards you and get the glands first. Then turn it like this," he was working so fast I could hardly see what he was doing, "scrape the threads out of here, slit the vein, three or four scrapes, and you're done. Slide her into the truck."

He looked at me to see if I got it. "Sorry for snapping at you earlier, I'm a little cranky at 6 a.m. My name is Jeff."

I shook his bloody, gloved hand. "Stu. No problem. Thanks a bunch for the help. How long you worked here, Jeff?"

"This is my seventh summer. I come up and make eighteen or twenty thou and then go back to school at Michigan State in the Fall."

His hands were a blur as he talked. He was barely even looking at the fish, just working by feel. "I started when I was twenty. Now it pays for my tuition, my car, everything. I am graduating from Pharmacy School next year. I want to run a little drug store in the Midwest somewhere. How about you?"

"Uh, I just kinda' just got up here. I'm just working."

"Your parents live here, or what?"

No, I'm kinda' on my own."

"You a *runaway*?" His eyes widened.

"No, I'm not a runaway! I'm just on my own!" I snapped at him.

"Alright, take it easy. You're kinda' young to be on your own, aren't you? How old are you really, like fourteen?"

"No! I'm seventeen!"

"Ok, ok, cool your jets. Don't bite my head off. I think you're pretty brave to do this at your age, all by yourself. Hell, my aunt lives here, and I have always stayed with her. You got an apartment and everything? I can't imagine having to pay for rent and food and all. Pretty groovy, man."

As we were talking, we were scraping fish, shoveling ice, and loading the trucks with salmon. The fish were coming a lot slower, or I was getting faster at the work. There were no fish stacked up in front of me, the floor was clear around my feet, which kept me a lot warmer, and nobody was yelling at me anymore.

At the ten o'clock break, Mo walked out of the office and sat by me on the dock rail. The whole crew warily watched him come over.

"How's it going, Stu?"

"Just fine, Mo. I think I'm getting the hang of it. Jeff has been a real help."

He nodded. "I knew you'd be able to do this. Just pace yourself and keep thinking about what you're going to do with all the money."

I looked out at all the fishing boats. "Mo, you ever do that?"

He followed my look. "Fish? No, never have. I started working here when I was fourteen, and I've been here ever since."

"How long ago was that?"

"Thirty-five years this summer."

I jerked my head around and looked at him. "Thirty-five years?"

He just nodded, looking out at the stout little boats, circling around the harbor, waiting for their turns. He took a drag from his cigarette. *Palm up, cupping water.* "I thought I saw a little of that in you when we met the other day."

95

"A little of *what*?"

"Me. You reminded me of myself when I ran away from home and was trying to make it on my own. Except a lot shorter."

I pretended to take a swing at him. Lightning fast, he blocked my punch, and in the same motion, put his other fist a quarter of an inch from my face. It was huge, with scars all over the knuckles. I didn't even see his hands move.

"*Jesus*! You a real boxer?"

The other workers around us were staring, wide-eyed.

Nodding, he said softly, "Ranked seventh in the world once. I was twenty. Light-Heavyweight. 22-1-1. Got in a drunk-fight one night in a bar, and accidentally killed the guy who did this to me." He touched the scar on his face. "I was going to fight the Champion in eight months. Never got a shot. Never boxed again. I got sixteen months at McNeil Island for Voluntary Manslaughter. They stripped my license. I got out and just came back to work here." He shrugged. "It's a good living. I feed my family."

He was looking at me intently. "It's a good place for us orphans, Stu. You'll do good here. You'll see."

I nodded.

The Horn went off. I got up and walked back inside, into the dimly-lit room, so no one could see the tears running down my face, just like a weak little girl. *So many dreams destroyed.*

At lunch break, Jeff and I walked over to the little Juneau Grocery on the corner, and I bought two packs of Twinkies, a quart of chocolate milk, those coconut puff-ball-thingies that came two in a package, one white and one pink, and beef jerky for protein.

We went back out to the dock, sat down in the sun with our raingear off, watching the boats, eating and talking about college. I told him about my almost-full-ride to Stanford, my championship medal in West-Co, and the Coach's nickname for me, "Lord of the Rings." Coach loved Tolkein and thought the nickname was hysterical. I was the size of a hobbit anyway, he said. He even had one of those satin jackets made up for me,

just like the boxers wore. Blue and white, with *'Lord of the Rings'* embroidered on the back, and the five interlocked Olympic rings. It was at home in my apartment, hanging in the closet.

"You lying sack of fish guts! You were not!" Jeff said angrily. Everybody turned and looked at us.

I stripped down to my t-shirt and kicked off my boots. I jumped up into a handstand and hand-walked down the dock, getting creosoted splinters into my palms for my trouble. Everybody was staring at me. I turned and hand-walked back, did a pike, and flipped back up on my feet. *"Ta-Daaaa!!"*

The dockworkers hooted and clapped for me. There was this *really* adorable blonde from one of the other sliming tables who was looking at me, really amazed, with a big smile on her face.

Grinning, I sat down again.

"That's fucking unreal! *Nobody* can do that!"

I put my clothes and boots back on just as the 1:00 horn went off. As I was walking back inside, the cute blonde came over. A little shorter than me, slender, with a gorgeous face. Bright gold eyes that reminded me of a South American jaguar.

She looked right into mine, unblinking. "Nice work, Cowboy," she said in an Australian accent and gave me a wink.

I went back to my station on the table, not feeling the least bit tired.

The rest of the day ground by, break, dinner, break, then it was finally ten o'clock. We covered the fish in the trucks with ice, washed off the tables and floor, and filed into the crew-room. Everybody silently changed out of their raingear and coats, leaving everything hanging in the lockers. I just left mine without a padlock. *Who in God's name would steal that smelly pile of shit? Tomorrow I'll buy a padlock at lunchtime. Maybe.*

I walked up the long hill. The little town was completely silent at 10:40 at night. Trudging up the steep hill, under the streetlamps past my old shoe store, to Lena's and my apartment.

My stomach was growling from the day's diet. Mostly sugar, really. *I am seriously going to have to buy some food if I'm going to maintain this regimen of work.*

I walked into the apartment, Lena and her boyfriend were watching TV. They both looked up as I approached, and Lena screamed, "Auugh! What a *disgusting* smell! Get out of this apartment with those clothes! Take them off *right now!*"

I did an about-face and dove into the bathroom, tearing off my clothes. Lena opened the door and threw in a big garbage sack. I stuffed my clothes into it and jumped in the shower. It was the most deliciously excellent shower I had ever had. Hot, steamy water, washing away the slime and scales, loosening my sore muscles.

I got out and dried myself off, the steam in the bathroom stunk of dead salmon. So did my towel. I walked through the living room towards my bedroom, just wrapped in a towel around my waist.

Lena sniffed loudly. "You still stink! But not as bad. *That's nasty!* Are you going to smell like that all the time?"

I shrugged. "I guess I'll go do laundry more often. I don't know when, though. Maybe Sundays after work."

"You *guess*? I'm not allowing that smell in this apartment!"

I didn't mention I was paying the rent this month, and probably next month too, because she hadn't bothered going out to find a job yet. I just nodded my head and agreed to try not to stink up the whole place.

Her boyfriend Rodney was laughing at me. "I can't believe you're working in such a *shit-hole!* Do you really clean fish all day long with the Indian Squaws?"

He currently didn't have a job and was living with his parents, who owned the big grocery store out by the ferry dock. Sometimes he would be a box-boy there for $3.90 an hour, *'When he damn well felt like it.'*

I went into my room and put my sweats on, then bee-lined for the kitchen. I found a big block of Tillamook Medium Cheddar cheese in there, and a jar of mayonnaise. The loaf of bread on the counter was looking a little green around the

edges, but it didn't stop me. I made four cheese sandwiches, dripping with mayo, and bolted them down, without remembering how they tasted.

I walked into the living room to join them watching TV, but they were already in pre-intercourse groping, and I didn't need that action right now at all. Back into my bedroom to read a little before lights out. My stinking clothes were in their garbage bag at the foot of the bed, waiting for tomorrow morning. *One day finished.*

Packed in Ice

I got to work the next day at five-thirty, got dressed, and was the first one out on the floor. I walked out on the dock, and instead of two or three little fishing boats waiting to get unloaded, there was this enormous ship tied up to our dock.

It towered above me, standing there. It *had* to be over 150-feet long. It even had its own cranes, one on each end of its enormous deck, and its wheelhouse, stretching the entire width of the ship, was three stories tall. I went back into the crew-room to check and see if it was supposed to be there. Maybe some freighter had gotten turned around and was supposed to be unloading somewhere else.

Mo and Frank were huddled together by their cribbage game, talking. "She's carrying just over eighty-eight thousand pounds. The season in Upper Admiralty Island is going strong. We should expect a record haul this season."

Frank shrugged. "Only one problem. Kevin is all by himself now. With Billy gone, we don't have a strong team to unload her."

Mo nodded. I saw Frank look over at me, then turn back to Mo. "What about the kid?"

Mo turned towards me. "Stu, would you join us for a moment?"

"Sure, Mo, what's up?"

"Our first packer of the season just showed up, and our unloading team needs some shoring up. You interested in a change of scenery?"

"Sure. What do I have to do?"

"Basically, just climb down into the hold of the packer and empty her out. Kevin and Billy have done it for the last three years, but now Billy's gone, and we need a new second man. It would mean taking you off the 'Line' for the day."

"Absolutely. I'll do whatever you need. Where do I start?"

"Just be out by the *'Dauntless'* when the horn sounds. We'll get you up to speed."

"Okie-Dokie." I walked out to my usual spot at the end of the table to tell Jeff the news that he was going to have to load the trucks without me today.

"You're going to unload the *packer*? You wonder why nobody else is available to do it? It's because it is simply the shittiest, filthiest, nastiest, hardest job in existence on the whole fucking planet, that's why! You might as well be a scuba diver for Roto-Rooter, Brother. Besides, Kevin is crazy as an outhouse mouse, meaner than shit, and nobody else, but Billy would *ever* work with him. Good fuckin' luck, Buddy-boy. They have sold you the goddamn farm!"

"Nobody sold me anything. There's a job to do, and I signed on in this place to do it. Period."

I walked away from his negativity, thinking, how tough could it be? If it was life-threatening, that was one thing. Like those Native Indians in New York that build skyscrapers. I seriously couldn't do that. *This is unloading a boat. So what?*

I walked outside to the packer *'Dauntless'* just as the horn went off. Mo and another guy I had seen around were standing there waiting for me. The guy was in his mid-twenties. About five-eleven, two hundred pounds—powerful, sloping, linebacker's shoulders. Oilskins on, hoodless jacket snapped up to his thick neck. Bare-headed. Short curly black hair, and a black curly beard six or eight inches down his chest. Dark-skinned and piercing blue eyes. Fierce looking. Except for the eyes, he looked like he was from the Middle East. Turkish, maybe.

When I walked up, the guy turned and gave Mo an *'are you kidding me?'* look.

"Stu, this is Kevin. Kevin, your new unloading partner, Stu."
He looked me up and down, scowling. "You sure you want a piece of this? This ain't pussy-work sliming. This is the real thing. You will never work so hard in your whole fucking life. How old are you, anyway, like twelve?"

Mo was smiling at me.

"Just show me what to do," I said.

Kevin reached down and picked up two pieces of plywood, sitting at his feet. Two-and-a-half feet square. Originally painted white, but now chipped and faded and covered in fish scales. A two-inch hole drilled in one corner. He checked to see if I was following, then climbed the steep rusted-steel portable stairs up to the deck of the packer. We climbed over the side of the boat, onto the main deck.

Two hatch covers, twelve-feet square, were being lifted off by the ship's crane, exposing the grandest number of salmon I ever thought existed. Thousands and thousands of dead fish in the hold of the massive ship. I was looking at a million eyeballs, all looking back at me. The top layer of fish was perhaps three feet down below the hatch opening. Kevin handed me one of the pieces of plywood, then threw the other into the hold, where it landed on the fish. He sat on the edge of the hatch opening and jumped down onto the square piece of wood, arms out to keep his balance. I flashed on the 'Silver Surfer' comic books.

"The Skipper will keep pumping out the hold, so we don't drown in here. We're standing on fish about ten feet deep, maybe 12,000 of them. *Don't fall off the board.*" He was looking up at me, waiting.

I threw my piece of wood down and followed suit. I sat on the edge of the opening, pulled my hood over my head, and jumped down onto the plywood. It squirted away from me like it was on ball bearings. I landed on my back in the fish and began to sink. The hood of my oilskin jacket filled up with blood and slime, and it was oozing down my back.

Kevin pulled my plywood back to within reach and pulled me out. I gingerly stepped onto the slimy plywood, trying to keep my balance. Ice-cold slime was in my boots and running down my back. He pulled a sheathed knife off his belt and grabbed my slime-filled hood. He cut it off and threw it up on deck.

"My new oilskins! I paid sixty bucks for this coat!"

"Hoods are for little girls walking home from school in the rain. You won't be able to see the buckets coming in, and you'll get brained. Here they come now."

Our crane man lowered two three-foot-cubed aluminum buckets together into the hold, Kevin guided them, so they sat between us, and unhooked one of them, where it teetered unsteadily on the backs of the fish. The other was still attached to the cable, and Kevin began to grab fish to fill it.

"Let's go! We've got to get this motherfucker unloaded!"

I started throwing fish into the bucket, but couldn't figure out how to pick them up. I couldn't grab the head, it was smooth and slippery, and they were too heavy to pick up by the tail. I watched Kevin. He grabbed the tail section with one hand, slid his other hand down the fish to the middle, picked the fish up out of the slime-water, and tossed it into the bucket.

"Let's go!"

I picked one up and got it in. He had ten or twelve in there already. One for me, four for him. One for me, three for him. One for me, one for him, I was getting it.

No talking, just a blur of motion. Kevin was as strong as a bear and relentless in his speed. The first bucket was full. He reached his right arm up over his head, and with his index finger pointing at the sky, made a quick circular motion. The bucket lifted in a rush, swung over to me on the end of its cable, and its three-hundred-pound mass knocked me into the fish again. The bucket had holes drilled in the bottom. I was deluged by the blood, slime, and ice water pouring out of it. I was blinded by the liquid, stinging my eyes, running down the inside of my jacket, and getting in my nose and mouth. It burned like a thousand wasp-stings.

He fished me out again. "You ok?"

I was coughing and choking, and couldn't see a thing. He wiped my eyes with the sleeve of his coat. "You gonna' make it?"

I just nodded. I just wanted back on my sliming line where I could simply do my thing all day, and go home. *This was the nastiest job I had ever seen.*

"Keep one hand on the bucket, coming or going, ok?"

He was watching me out of the corner of his eye as we filled the next bucket. He was probably worried I was going to quit, and he'd have to do it alone. *No wonder no one would do this job.*

We were halfway through filling the container when the other one came back down. We guided it between us.

"*Shit!* This is no good! We have to have the second one filled before the first one comes back in! Work faster!"

We filled the second. Kevin unhooked Number One and hooked up the one we had just filled. Watching me warily, he raised his hand and made the signal. I held the edge of the bucket to guide it away from me, turning my head away from the shower of slime, as it jumped up out of the hold. We frantically started filling the new bucket.

This time we almost had it full when the other came back. I changed over the cable, we filled the last few fish, and Kevin gave the signal. Now we had the rhythm. By the fourth bucket-full, we were actually waiting for the bucket to come down and had a second to catch our breath. Kevin looked pleased for the first time.

"You know, Frank and Mo have the record for doing this, they set it maybe eighteen or twenty years ago. They unloaded 70,000 pounds in fourteen hours. Five thousand pounds an hour. Billy and I tried, but we could never get close. One of these days, I'm going to do it."

I thought about gymnastics, and the world records I wanted and kept my mouth shut. My face was caked with dried slime, like a salty mask. A stinking, itchy, salty mask.

I wonder if it would catch on with the health spas? No mud masks, ladies, just a layer of this shit.

I looked over at Kevin. His beard was saturated in scales and slime, and it looked like he had blown his nose all over it.

He turned to me, covered in snot, just as the bucket came into view, "Could you imagine breaking their record? We'd be *legends*!"

I shrugged. "Wanna try?"

His eyes got wide. "You think we have a chance? We'd have to finish this by the ten o'clock horn!"

"Why not? You're a fucking animal, and I'm learning it quick enough. What would it take?"

He called out to the crane operator. "Paul! Send down *'Bertha'*!"

The crane operator gave us the 'thumbs-up' signal. The next bucket lowered in was four times the volume of the ones we had been loading.

"We use this when we unload the Korean freezer-freighters. It holds over a thousand pounds of boxed frozen herring. If we could get this filled in time, we could do it!"

We had it loaded half-full for the first exchange, then three-quarters full, and then we did it. We had her full in time for the switch. The eight o'clock horn went off. Kevin grabbed the top edge of Bertha and nodded at me to do the same. Paul lifted the full bucket up and out of the hold slowly, with us dangling off the sides of it. My hands were plenty slippery, but if I lost my grip, I would cannonball right to the bottom of the hold, under all those fish. We were lowered gingerly down to the cold storage dock. Mo came over.

"Good job, Guys, over seven thousand pounds in two hours. Keep it up. He looked at me completely covered in slime. "Having fun?"

I just grinned at him.

Kevin went over to Paul on the crane. "You willing to work through lunch and dinner? We're gonna' go for the record!"

Paul looked at us like we were nuts. "Really? You don't get a bonus for finishing today, you know. It'll still be here tomorrow."

"We know, but we're gonna' try. We need your help, though. Those buckets have to fly, man."

"OK, it's your funeral."

By the end of the fifteen-minute break, everyone was talking about it. "They're going for the all-time record! They're really going to try!"

"What the fuck for?"

When the break ended, Paul lifted the empty bucket up off the dock waist-high, and we grabbed hold. "Good luck!" Somebody yelled, and we were doing it. I caught a glimpse of Mo as we dropped down into the hold. He was just smoking and smiling at me.

For the next four hours, we worked as men possessed. Not a word was spoken. We knew the drill, and it became a dance between us. Fish for fish, we matched each other, the bucket exchanges were automatic, we had maybe ninety seconds to catch our breath after filling the smaller container, that was the only pause we had. We were powering through lunch when Mo stuck his head over the side. By now, we were ten feet below the hatch.

"In the last four hours," he called down, "you two have unloaded 22,000 pounds. If you can maintain the pace, you're going to break the record with ten minutes to spare. Are you sure you're ok down there?"

Kevin managed to answer while trying to keep his mouth shut from all the slime flying, "OK! Keep it coming!"

I just kept working. I had gotten to where I was just a half-a-beat faster than him, and I wanted to keep that pace.

By 5:00, we had unloaded 58,500 pounds of fish. Only the two of us, one fish at a time. Our breaks were five minutes long, just enough time to drink water out of the wash-down hose on the dock. I ran to the vending machine and bought us two Snickers Bars each for dinner. Back to work. We were way down deep in the hold now. We needed another man on the edge of the opening to convey our hand signals to Paul on the crane. By 8:00, we knew we had it. Only 10,500 pounds to go, and two hours to do it.

We finished at 9:35 pm. The last two buckets entailed chasing the fish around the bottom of the slippery fiberglass hold and getting them to hold still long enough to pick up. I was so delirious with fatigue; it seemed like they were swimming away from me. We came out hanging onto Bertha with all the strength we had left. Exhausted, starving from hunger, but ecstatic. The news got around the floor that we were finished.

Everybody stopped working and came out to congratulate us, Mo and Frank included. I looked over at Kevin. You couldn't see anything but his eyes. He was coated from head to toe in blood, scales, and slime. I'm sure I must have looked the same. Even with all the congratulations we were getting, no one got within ten feet of us.

Mo announced loudly to the crew, "In honor of Kevin and Stu's hard work, we're going to quit early today! Everybody gets paid until ten. Let's start cleaning up!" Cheers from the crew.

Kevin grabbed the wash-down hose, gave us both a long drink, then said, "Hold on!" He turned the full force of the hose on me. I put my head under the icy-cold water, and it felt terrific to get that itchy, stinking mess off me. I held my jacket open, doing a little pirouette as my overalls got clean. I took it from him and did the same. He scrubbed his head and beard, lifting his pant legs to get his boots. Mo waited until we were finished, then walked over to us and shook our hands.

"Really remarkable, you two. I thought if anyone could do it, it would be you two. I am really proud of you." He studied the fatigue in my face. "Stu, good job."

I felt like I had just won Gold at the Olympics. Kevin put his arm over my shoulder, and we went to find some food.

Sheila's Uncle

The next day, at the 8:00 break, the Adorable Australian came over and sat down next to me.

"Good Morning!" *In that magnificent accent.*

"Hi! I'm Stu. Stuart LeClercq. Pleased to meet you!"

"Jeannie." She pulled off her rubber glove, holding her hand out to me. Her fingers were covered in rings.

Who slimes with rings on?

She looked at me with those surreal golden eyes. "That was pretty spectacular, what you did the other day. That hand-walk thing. Are you in competition?"

"I used to be. I thought I was going to the Olympics once. Now I'm just up here working. You? I mean, what are you doing way up here?"

"I come up here every summer." *Pronounced summah.* I used to live here for a few years, but now I go back to Australia in the Fall. Pretty catchy, really. I spend summer down there, and summer up here. It works out fetchingly. This is my sixth, no seventh, summer here."

"Sounds like a wonderful plan. No winters anywhere. I'd like that, too. Where in Australia?"

"Forster. *Fos-taa.* It's three hundred kilometers north of Sydney."

"Is that on the Barrier Reef? I've always wanted to dive the Great Barrier reef!"

"No, that's a-ways north. But we have great surfing, yeah? You surf?"

"No. I've never been surfing. The water's too cold. How about family? Is your family all down there?"

"Yeah, some. A sister. Say, you on for some dancing? Today's Wednesday, yeah? It's hard to keep track of the days. You want to put on your toggers and go out with the Sheilas on Saturday?"

"Put on what, and do what?"

"Toggers! You know, dancing clothes? Sheilas are girls, yeah? A group of us go out to the Northern Star every Saturday and go dancing. You fancy a join?"

"The *Northern Star*? Where's that?"

"In the Filipino Barrio, south of town. What, you've never been there? You don't like Filipinos?"

"Don't like them? No. I mean, I've never even *known* a Filipino."

She scowled, then gestured with her hand, indicating the people sitting on the dock. "What do you think half these people are? A bit thick, aren't you?"

Just then, Frank walked up to us. Everybody around us stopped talking and looked up at him. Jeannie stood up and gave him a huge hug. I almost fell off the dock. *Frank? Hugging?*

"I'm glad you two are getting to know each other," Frank said with a little smile. "I thought you two might get along. Jeannie, Prez wants you to come over for dinner Saturday if you're not busy."

"No! In fact, the girls and I are planning to collar Stu and bring him to the 'Star for dancing!"

He nodded. "Then, I'll see you then." Looking at me, he said, "You come for dinner, too." he turned and left.

"You know Frank?"

"Of course, I know Frank. He's my Uncle, in a sort of way. He and Prez kind of adopted me, when...oh well, a few years ago."

"It's hard to think of Frank as anyone's Uncle."

"What, you don't like Natives, either!"

"I didn't say that! He's just, so...ferocious."

She laughed a beautiful laugh. "He's just a beautiful man. You don't know him at all. He's not *blokey* like the rest."

"Blow-key?"

"You know, *macho*. Most of the blokes up here are swaggering little children. That's why I don't tolerate Aussie blokes. Frank is a responsible man. He's quite beautiful, really. So, you're coming out with us Saturday night?"

"Of course! What time?"

"You live in the pink apartments, yeah? I'll pick you up at eleven. You'll get to meet the Sheilas!"

"See you at eleven!"

Yahoo! Frank is her uncle? Yikes!

I'll Flip You for It

Ten o'clock Friday couldn't come fast enough. Although we were working in the same building and took breaks at the same time, I didn't get a chance to talk to Jeannie for the next two days. She was always busy talking to someone, like Frank, and I didn't want to interrupt. She had a lot of friends.

I told Larry about going out dancing with Jeannie as we were getting changed to go home, to see how he would react.

"You're going dancing at the Flip bar with the Aussie? Are you fucking crazy? Those guys will cut you into ribbons! Half of 'em are her fucking boyfriends, for Christ-sake! You know what a butterfly knife is, don't you? The Flips invented it to kill American G.I.'s during the Philippine-American War. They hate Americans! Stay the hell away from there! The only reason the Aussie goes there is 'cause she's got the hots for those guys."

"Really? Well, I'll be careful." *Great. Well, maybe he's exaggerating. Or jealous.*

I hustled up the hill to my apartment, bagged my work clothes, and hit the shower. I washed and shampooed three times, then doused myself with half a bottle of English Leather Bitter Lemon After Shave. *I still smell like fish. Lemony fish.*

I went back in the shower and tried again, running out the hot water in a vain effort to try and abate the stink. I used the rest of the aftershave, too, to no avail.

I went through my clothes to find something to wear. Even my good jeans smelled a little like fish. *Fuck it. Everybody else there works the same place I do.* I got my cleanest black t-shirt and put on my 'Lord of the Rings' warm-up jacket. I might as well flaunt the gymnastics thing; she did mention it, after all. I put on my Adidas and checked the clock. 10:28. I guess I'm a little anxious. I picked up my book and started reading.

She pulled up, driving a dirty white V.W. Bug, at 11:35. I guess punctuality wasn't as critical away from work. I walked up to the car as the passenger door opened, and a tall girl got out,

five-ten in heels at least, wearing a skin-tight, minuscule black dress that showed off killer bare legs. She flipped the seat forward and motioned into the back seat. I looked in, and there were two girls back there already, filling it up.

"Lots of room, hop in!" one said, and I squeezed into the car.

"Stu, these are the Sheilas. Sheilas, Stu."

Jeannie twisted around in the front seat to talk to me. She was wearing her cowboy hat in the car, and if it wasn't the kind that was folded up tight on the sides, it would have put someone's eye out. She was wearing a light blue cowboy shirt with the top three pearl snap buttons undone, the tails tied in a knot at her waist, a denim jacket, and spray-painted skin-tight jeans. Strappy gold high heels. Pink toenail polish. The others were wearing their versions of *'dancing toggers,'* mini-skirts and high heels.

We settled in and drove through town to a neighborhood I hadn't explored, farther south by the industrial docks filled with workboats and barges. Down a little dirt alley, we turned and pulled up in front of a building covered in channeled plywood.

We parked behind a car that had fuzzy dice hanging from the rear-view mirror, with the car's body almost touching the ground. There was a little flag decal on the back window with red and blue stripes on it and a white triangle with a sun and three stars. *I'm going to stick my neck way out and take a wild guess that it's a Philippine flag.*

We approached the building. It was the size of a small warehouse, built with a plywood exterior and painted brick-red with a glossy black door. There was the same flag painted over the door, lit by a single bare light bulb. I was surprised there wasn't a sign about entering at your own risk or something. Instead was a little hand-painted sign with a gold star painted on it, and the words in cursive, 'L'Estrella Norte.'

'The Northern Star.'

We walked through the door. Me, and four drop-dead gorgeous girls. *This is gonna' be good.* The whole room turned towards us as we came in. I figured my life expectancy was

about the same as a Huey chopper door-gunner in a Viet-Nam firefight. *Maybe fifteen seconds.*

The place was full of cigarette smoke. Hank Williams was singing '*Honky Tonkin*' on the jukebox. There were a couple of fluorescent lights on the ceiling, and hanging lights over the three pool tables lined up on the right side. On the left was a long bar, with ten or fifteen guys standing at it, and twenty or more people seated at little round tables scattered around.

There may have been six women in the whole place, and four of them were with me. There was a big vacant linoleum dance floor in the center of the room, with a light-bar over it shining different colored spotlights.

As I scanned the room, I recognized several guys from the cold storage. There were at least four of our inside freezer workers, Ramone the floor foreman, a couple of Slimers I recognized, and there was Frank, playing pool.

He was dressed up, which was a surprise to see. I only saw him in his ratty freezer garb. He was wearing this shiny polyester blue dress shirt, rolled up at the sleeves showing off his thick arms and his tattoos. He had on new jeans, pressed so you could shave on the crease. His hair was slicked back with this oily stuff that made it look all wet. All the guys were wearing that stuff in their hair. Long black hair slicked back. Some had a little duck-tail in the back or on the side. I pulled my hand through my crew-cut. *Oh well.*

The girls swept in, Jeannie saying 'Hi!' and 'Howdy!' to almost everybody. The men were all smiling at her, but one of the women was scowling.

Jean took over a little table by the back door. I followed, not having any other plans at the moment. We all sat down, and I didn't know what to do next. Everybody in the bar was drinking, but there wasn't a waitress. This was the first time I had ever been in a real bar. *I wonder if I'm going to get carded?*

Jeannie said, "Stu, would you mind getting us drinks? The girls and I are all having Foster's. You need to go up to the bah-tender and order. He'll run a tab."

Okay. Here we go. I got up and moved towards the bar around the tables of Filipinos. They just looked at me, a complete outsider. I bellied up to the bar. The bartender had an oiled pompadour and a sleeveless shirt that looked like snake-skin. Or shark-skin. Skin-tight black pants and black boots with pointed toes. His arms were covered with tattoos. He looked as mean as his shirt. *He probably killed the shark with his teeth.* He just looked at me with his shiny black eyes—me, in my powder-blue gymnastics warm-up jacket and crew cut.

"Um, four Foster's, please. No, five, I guess. We're sitting over there. Could we run a tab?"

He didn't say anything. He reached into the cooler and pulled out five mega-sized cans of beer. He put them on the counter and walked away. I picked them all up, balanced them in my hands, and brought them to the table.

Frank was standing next to Jeannie. She was holding his hand. They were talking about something when I walked up and put the beers on the table.

"May I get you a beer, Frank?" I said.

"No, thanks, Stu. I don't drink anymore. Just coffee. Would you ask Mauricio behind the bar if he's got any fresh-made?"

"Sure, Frank." *He's being really polite. That's a pleasant surprise.*

I walked over to the bar. Mauricio just looked at me again, eyes half-lidded. He looked like a crocodile eying its next meal.

"Mauricio, would you get some fresh coffee for Frank, please?"

He nodded and immediately turned to comply. His nonchalance was gone. He hurriedly poured a cup and came around the bar holding it.

"I'll get it, that's all right," I said.

Ignoring me, he walked right past and brought it to Frank himself.

"Thank you, nephew." I heard Frank say to him.

No wonder. Mauricio returned to his bar.

Frank turned to me. "I'd like to introduce you to my sister-in-law. She's got dinner waiting for us in the house."

The girls stood up and followed Frank into the back room, a Sheila Parade, with me trailing behind. The back door opened into a hallway, connecting with another attached building.

We walked through a door right into a big kitchen, with a giant white dinner table on the left side and a big white porcelain stove dominating the right. The smell was absolutely delicious. Chicken, and spices, and I didn't know what else. Entirely different from the aromas Mom and I created cooking, but my mouth was watering nonetheless.

There was a short, dark-skinned woman at the stove. She had thick black hair to her waist, with a red flower placed behind her left ear, and was wearing a red-flowered dress with a white apron. She was stirring a giant kettle with a big wooden spoon.

She turned with a huge smile. "Girls! Welcome! Dinner is all ready." She held out her arms to Frank. "Hello, Aquilino. How is my eagle?"

They embraced for a long time, just holding each other tight.

When they broke the embrace, the woman looked over at me. "This must be the young man. Hello, my name is Presciosa. You may call me Prez. I am very pleased to know you. I have heard you are *very* strong and a diligent worker. Like a Filipino."

She smiled. "My boys," she gestured out towards the bar, "have told me that. They are all 'My Boys.'" She laughed. "Welcome to my home. I hope you enjoy Filipino food, even just a little!"

We all sat down at the table, and Prez began to serve. There was enough food for the whole community. The Chicken Adobo was the star of the show.

At my insistence, Prez described the preparation. "This is my Lolah's recipe! That is how you say grandmother in Tagalog. I watched her cook for many hours when I was a child. In the Philippines, women do almost all of the cooking. She would start with the thighs of the chicken, boned and skinned, and a huge cooking pot, enough to feed ten or twelve people. So, ¼ cup vegetable oil, until it starts smoking. Add 24 cloves of chopped garlic, stir for thirty seconds only! Add the chicken

115



gpt

until it turns white. Pour in two cups soy sauce, two cups vinegar, and two cups water. Put in a handful of pickling spices, wrapped tightly in gauze-cloth. Cover and simmer for one hour, then remove the lid. Simmer until the sauce thickens. Very easy! Very traditional!"

There were eggroll-looking things called lumpia that I would kill for. There was rice and sausages, and all sorts of hot sauces and chili peppers, and it was incredible. For dessert, we had Champurrado, which was rice covered in chocolate!

After dinner, we sat and talked.

Prez was explaining. "The Filipinos have been in Alaska since the last century! We came here to work in the canneries and have stayed ever since. We are called 'Alaskeros' in our country, and it is a great honor to have a relative who is here working and carrying on the strong Filipino tradition. Many of us send everything we make to our families back home. There is one man whom you work with, whom you know, that lives here in Juneau with his father. He sends every penny back to his mother in Tacurong, a city-town in the south. She is keeping it for him until he returns and finds himself a bride. He will go back in five more years."

"How old is he?" Jean asked.

"Thirty-nine." Prez nodded.

"Thirty-nine? Who would marry him when he goes back in his forties?" The tall girl smirked.

Prez sat up straight. "The women of the Philippines value a hard-working man who will provide for them no matter what his age. I know for a fact his mother has over one-hundred-thousand American dollars that her son has sent home."

"Jesus Christ! A hundred grand? How long has he been here?" Jeannie's other friend asked.

Frank answered. "Timbang has worked for me for nineteen years. You two know him as 'Tim.'"

"*Freezer-Guy, Tim?*" I said. "He's so quiet. He never says anything. Jeez, a hundred grand!" *Imagine that!*

"He is a hard-working man," Prez said. "Now, who wants to try and beat me at a game of pool before we start dancing?"

Shark Attack

We went out onto the floor of the tavern. The bar was standing-room only at this hour, but there was an empty table for twelve in the corner that Prez sat us down at. I thought it might be her private table. As soon as we sat down, Mauricio brought over a cup of black coffee, and a snifter filled with a brown liquid. He set the coffee in front of Frank, giving the snifter to Prez. He looked at the girls and me.

"Fosters, please. Five." I said. The girls nodded agreement. He turned away.

Prez picked up her drink in both hands, holding it to her nose. "Ahhh, *Frangelico*! I so love the smell of warm hazelnuts!"

When the beers arrived, we kicked back and chatted about Juneau, and what a pleasant summer it was that year. Jackie, the tall one, walked over to the jukebox and stood in front of it, in her tiny little black dress and four-inch heels, making a selection. One of the young Filipino men went over and stood beside her, saying something. She was six inches taller than him in her heels. I could see her smile at what he was saying, and he brushed his hand down her arm.

Linda Ronstadt's *'You're No Good'* came on the jukebox, and I asked Jeannie if she wanted to dance. She smiled at me and got up, pulled her cowboy hat off, and set it on the table. She walked out to the dance floor, where Jackie and her friend were already dancing.

I got ready to dance with her, but Jeannie turned her back to me and just stood in the middle of the floor with her eyes shut, swaying to the music. I stood behind her and danced a little, but it seemed like she didn't even know I was there. She was swaying gently with her eyes shut.

I glanced around, feeling like a dummy for even being there. Jeannie didn't seem to notice me at all. After several long moments, she turned around and looked at me. She held her

hand out, I took it, and she pulled herself into my arms. I noticed several of the other men were watching us dance.

She put her head on my shoulder, and her arms tightened around me. I could feel her hard breasts through the thin fabric of her shirt as we danced. I wanted to hold her forever. She stayed right there through the next dance. I wasn't even listening to the music, just feeling her arms around me, and the smell of her hair. When the music ended, she looked up at me.

"Stu, I have never felt so safe in the arms of a man in my whole life. You are so strong. Would you keep holding me like this? Would you let me wake up with you tomorrow morning, holding me just like this?"

I was flushed and nervous, looking into those golden eyes, her body now tight against me.

"I...I would like that very much.'

We danced apart from each other, the next song, a faster Santana number. She was smiling and laughing and starting to get more relaxed. Her shirt had come unsnapped, it was held together only by the knot in front. Her tummy and lower back were completely bare. As she gyrated, I got a flash of the dark brown of one of her inadvertently exposed nipples. I was getting turned-on, anticipating holding that lean, sexy body against me all night long.

In a burst of noise, the door swung open violently. A blast of air poured through the thick cigarette smoke, and a gang of young Filipino men walked in together. The leader was thin and dark-skinned, with skintight black pants on and pointed-toed, black boots. He wore a black, long-sleeved shirt, rolled up to his forearms, and unbuttoned to his waist. A tattoo of a coiled snake was on his chest. He was wearing black sunglasses in the dim light and wore four or five gold chains around his neck. His hair was slicked into a black, oiled wave over his head, and he had a sneer on his lips. *He looks like a vicious Fabian.*

Jeannie stopped dancing right in the middle of the song and just froze, staring at him. Everyone in the bar was staring at him, including Frank and Prez. He strutted up to the bar, his four comrades following him, all of them looking the room over as

they approached the bar. Mauricio looked at them like a mongoose looks at a nest of cobras.

I heard him loudly order a round of tequila for his boys. He turned around to face the crowd. The music had stopped, and the entire bar was silent. He put his elbows on the bar, slid his sunglasses on top of his head, and scanned the place. When he saw Jeannie, he just looked at her, unblinking. She was standing motionless next to me on the dance floor, just staring back at him with wide eyes, a deer-in-the-headlights look on her face.

I didn't know what to do. I tried to take her hand to return to the table, but Jeannie shook me off impatiently. I walked back alone and sat down.

Prez and Frank were murmuring to each other. "I didn't know he was out," Frank said.

"Me either. I thought he received seven years for what happened to that boy." Prez's face was blanched, almost white.

Frank slowly turned his chair around until he was facing the men at the bar. I watched him put his right hand on the hilt of his knife.

One of the gang members walked over to the jukebox. The guy standing there vacated the spot immediately, returning to his table. The hood put some money in, and in a moment, a song started playing I had never heard before. It sounded like it must have been a Filipino artist. Guitar, and a sensual male voice, singing a love song in a foreign language.

Fabian walked out onto the dance floor, where Jeannie was standing by herself and held his hand out. She slowly took it, he whipped her into his arms, and they began the sexiest dance I had ever seen.

His hands were all over her body, caressing her bottom through the tight jeans, slipping his hands into her back pockets. He was petting her bare lower back and running his fingers through her hair. He even slipped his hand into her shirt and touched her naked breast. She bent her knee and lifted her leg. He ground it into his crotch. Her head was back. Her eyes were shut. She melted into his arms, letting him control her completely.

fort>3

When the song was over, he whispered something into her ear. She walked over to our table, grabbed her purse, and dug through it. She wasn't making eye contact with any of us. She pulled out her car keys, flipping them onto the table.

"Jackie, take my car home."

She grabbed her hat and denim jacket and went back to the guy. He put his arm around her, and they swept out the front door, the other four following closely, turning around to see if anyone was going to follow. The door shut, and they were gone. The bar was completely silent.

Frank looked at me. "That was Adriano. He and Jeannie used to live together. She left him because he beat her when he drank. She said that they were through, but he didn't believe her. He caught Jeannie with another man in her bed, and almost cut him to pieces. Nearly killed him. He broke Jeannie's nose and cheekbone. They sent him away for aggravated assault, but for some reason, I am going to have to check into it, he is out of prison."

Prez spoke up. "This is not good. Not good for Jeannie, not good for the Filipino community. He is everything bad you have ever heard about Filipinos. He is deadly violent, and a drunk. He doesn't care if he lives or dies. He despises *all* men, Native, Filipino, and White. He is a drug dealer and has been accused of running children as prostitutes in Los Angeles. Why Jeannie would love him, I do not know. I thought she had changed. I thought she was *healed*."

The pool players continued playing, but no one put on any music. I stood up to go. *This night didn't end so well.* Jackie offered to drive me home, but I said I would walk. I thanked Prez and Frank for the evening and turned away.

Frank said loudly in the quiet bar, "Stu, come see me here after work tomorrow, ok?" It seemed like the whole bar turned and looked at me.

"Sure, Frank. Right after I clean up." I walked home alone through the quiet town.

What did he want to see me about? What the fuck just happened?

Home is Where the Adobo Is

After work the next day, I went home and jumped in the shower, hoping I had clean clothes to wear. Today was Sunday, laundry day, but I wasn't going to get down to the basement at this rate. Maybe after dinner, I'd gather up my bags of clothes and do that. *After dinner.* I was a little nervous about eating alone with Frank and Prez.

In the shower, I realized how tired I was from last night. I hadn't had four hours of sleep after the long walk home. I was glad it was Sunday, so we had only worked eight hours today.

As the hot water coursed over me, I thought about my experience with women. My mom seemed like she never backed me in front of Dad. He would be working on me, telling me what a loser and a coward I was, and she would walk away and go in the kitchen. My sister Marie left me for the fucking Peace Corps. Linda, on the ferry, fucked me and left me, just like I was the woman, and *she* was the man. Jeannie told me how strong I was and how safe she felt with me and walked out the door with an ex-convict.

I was getting a little discouraged with the opposite sex. It didn't seem like I could trust any of them. *But I was crazy about women.* I relived the experience of having Jeannie in my arms last night, remembering her hard body, with her nipples poking through her shirt and the excitement of seeing a glimpse of her naked breast. *I want her with every cell of my body.*

The thought of making love with her while looking into those golden jaguar eyes kept me in the shower until long after the hot water ran out.

I recovered my composure and got dressed, then walked with trembling legs through the quiet town towards the Filipino section. Being Sunday, all the stores were closed, and the place was almost deserted, with just a handful of people out walking. As I walked down the middle of the street, I felt the deep ache of loneliness and a shiver of grief that I didn't get to wake up

this morning in Jeannie's arms. My throat closed at the thought of losing her forever.

In my reverie, I almost got run down by a bright-red four-wheel-drive pickup truck suddenly appearing around a corner, bombing down the empty street. I jumped to the sidewalk and watched it blast by. In its wake, I was pelted in the face with gravel and debris.

Wake up Stu, she is more than you deserve, anyway.

I walked through the black-painted door into the Northern Star. Mauricio was behind the bar, drawing beer. There were three guys playing pool, and a couple more at the bar. I walked up to Prez's son and ordered a cup of coffee with a shot of Kahlua in it. Yes, please, cream. Mauricio just nodded at me, which was a vast improvement over the sneer he gave me last night. He almost acted sympathetically. I sat at the bar, sipping my coffee for thirty or forty minutes, soaking up the feel of the place, watching the guys play pool. The two guys next to me at the bar were speaking a staccato language I had never heard before, with a lot of vowels. *I thought Filipinos spoke Spanish? Was that Tagalog?*

Frank walked in with Ramone, the floor-lead at JCS. They walked up to me at the bar, and we all shook hands. Ramone ordered a Heinekin, Mauricio gave Frank his coffee without being asked. Ramone nodded at me in acknowledgment, went over to the pool tables, and picked up a cue stick.

Frank looked at me and said, "Are you hungry? Let's go see what Prez has for us tonight."

We walked through the bar, the guys all looking at me as I passed. As we entered the kitchen, the smells were overwhelming again.

Prez came over and gave me a long hug. Her eyes were watering. She looked deeply into my eyes and said, "You're a good boy, Stu. A *good boy*." She patted my cheek and turned to the stove to serve the three of us.

Dinner was filled with small talk about the history of the region, and the integration of the Filipinos and native Alaskans. The Filipino national language was Tagalog, which I heard at the

bar earlier. Prez spoke a few sentences in it to me so that I could listen to the cadence and pronunciation. It seemed like it would be a lot harder to learn than Spanish.

I got the feeling they were trying to make me feel more comfortable, and it was working. I was able to talk about the local native tribes somewhat intelligently since my bed stand was stacked high with a pile of history books.

The only difficult time came when I asked between bites, "Frank, I'm reading about Tlingit-Haida mythology, but I'm not sure of the significance of the legend of the half-man, half-otter creature. How do you pronounce it, *Kushtek-aa*?"

To my amazement, He reacted to my question in near terror. His head shot up, and his eyes widened. He turned almost white.

"Don't *ever* speak that name out loud again! Never say that word in my presence! *Not ever!*" He quickly looked around the room.

I was flabbergasted. Was Frank afraid of a children's fairy tale? This was the most intimidating human being I had ever seen, probably in his late forties, and he was acting like he was a kid listening to a scary campfire story. I looked at Prez, not believing what I was seeing. She was looking at Frank with concern, and then looked over at me apologetically.

"Stuart didn't mean anything by it. Did you Stuart? He was only asking about the legend of it. He wasn't trying to say anything."

Frank looked embarrassed by his reaction. "I'm sorry to raise my voice, Stu. There are a lot of different ideas about the...that particular...uh, creature. *Myth*. I was told stories from when I was a baby about them." He laughed a little. "I guess you really caught me by surprise with that one. Let's not talk about it right now." He brushed it off, but there was no denying his face was two shades paler.

What the hell did I just get into?

There was no talk about Jeannie during the entire dinner, so I didn't bring it up. Frank and Prez slowly worked me into telling them about my family. Marie and the Peace Corps, the violence

of Dad, and that precipitating my leaving home and coming up to Alaska. When I talked about the pipeline, and how I didn't seem to be getting up there to make my fame and fortune, they looked at each other.

Prez smiled. "Well, it seems like you were brought up here for other reasons, Stu. Maybe the riches you were seeking are not the ones you are receiving. You don't seem like the rest of the mercenary young men coming up here just looking for money. Perhaps you are looking for something else. I think that's why Frank wanted the three of us to get to know each other better. Did you know Frank's family has been the Shamanic leaders of the local Tlingit tribe here in the Juneau area for over five generations?"

My eyes widened. "Really? You mean the religious leaders of the whole tribe?"

These guys are what I'd been reading about for the last year! "I want to hear all about it!"

I wondered if he would tell me about the initiation ceremonies. I had so many questions about it, like what about sweat lodges, and what about the Amanita mushrooms? Is it true most of the Native American art comes from the vision-dreams of the Shamen? Is shape-shifting real? *Jesus, no wonder he didn't want to talk about Kushtek-aas, his ancestors must have done battles with them or something. Maybe vision quests. This was cool!*

"He looked at Prez, then at me. "We'll talk about it if you wish, Stu. Right now we'll eat dinner, then afterward, maybe I'll answer some of your questions.

We were eating dessert when someone knocked on the door. Frank opened it to see Ramone standing there.

"We have a problem, Frank. The nightwatchman just called. We might have a leak in one of the ammonia tanks. You better come look."

Frank didn't even say goodbye. He was out the door in two seconds flat.

"My. Ammonia leaks are very bad. Ammonia is one of the most flammable substances there is, very explosive." Prez looked worried. "I'm sure Frank can handle it."

She and I were alone. "Prez, would you tell me about your ex-husband, Frank's brother, If I may ask?"

She smiled at me, then her lips narrowed, and she nodded. Her eyes looked sad.

"Gordon. My husband's name was Gordon. I was his second wife. He married when he was only seventeen, before me. A local girl he went to high school with. Really a beauty, but mean—a real manipulator. I don't know what she expected from Gordon. He was a great athlete but came from a busted up family. Frank was kind of the dad to him.

"They got pregnant when she was a Junior. She was only 16. They both dropped out of high school, and moved in with Frank. He had a cabin over in North Douglas. No water, but electricity. They had to haul the water from the river every few days in jerry cans.

" Frank had been working at the Cold Storage by then. Three or four years. It didn't go well between them. The brothers really didn't get along too good, Gordon, was...well, kind of a hell-raiser back then. Frank had to get up at 5 to go to work, and Gordon wasn't even home by then sometimes. Out drinking and partying. He was only 17, you know.

"The baby was really colicky, kept the whole cabin up all night, sometimes. Frank was the steadiest guy I had ever seen. He had graduated five years before Gordon. I was in eighth grade then. I was so in love with Frank! Gord told me Frank would hold the baby, sometimes all night, just rocking and singing to it to make it go back to sleep. Then at 5, Frank would get dressed and just go to work. Twelve to sixteen hours. The mother wouldn't even bother with the boy. *Gordon Junior*.

"One day, the mother just took off. Gordon had been out screwing around, he really was wild back then, and Frank got home from work to the baby, all alone in its crib. No note, nothing. She just left. Somebody said she got on the boat to Seattle, but nobody ever saw her again.

125

"Gordon joined the Marines a month or so later. Didn't tell anyone, didn't talk to Frank or anyone. Just left Juneau. That was 1950. Frank had to raise his nephew alone. He had some help from the village, watching the boy when Frank was at work.

"You know in Native tradition; the uncle is an essential part of a boy's bringing up, especially with Frank's family members being the Shamans of the tribe for so many years. Frank just figured it was up to him to teach the boy all he knew and get him ready to take over that position in the village.

"Well, we heard a little about Gordon from another member of the village who served with him, Gordon never wrote his brother for years. The Korean War had just started to get into gear, and they needed tough, angry guys like Gordon. He was a perfect match for the Marines, as soon as they got the discipline thing out of the way. He was a tremendous athlete, a great shot. He had been hunting since he was nine! Tireless runner, and of course, all that anger. They made him a sniper. He still doesn't talk about it, but he was in the front lines for the whole war. He didn't even take many leaves. He really got involved.

"The Marines were his new family, his pride. He had never been a part of anything like that before. He lived Semper Fi every minute of his life after that, stayed a non-com, didn't much like officers, all the way to Master Sergeant. Trained other snipers and got into the Green Berets in 1964. Of course, Viet Nam started right after that. He was stationed in Japan and was sent right over as an "advisor" training the ARVN. He shipped out to Da Nang in March of 1965 with his regiment, the 9th. He led search-and-destroy missions all around the airbase. He didn't talk much about that either. In 1967 he was in Khe Sanh and lost almost everyone he served with. There was hand-to-hand fighting there. He was wounded pretty badly. They thought he was going to die, and he was sent home. The problem was, he didn't have a home. Not really."

"What happened to Frank and Gordon Jr.?"

She looked over her shoulder to check that we were still alone. She frowned, obviously deciding something, then told me

the rest of the story. "Frank raised little Gordon by himself. Teaching him the ways of the tribe, and a lot more things I'll never know, Shaman-stuff. Some people say that Frank could, well, never mind, weird stuff. Little Gordon went to High School here in Juneau, but right after graduation went to live out in Chignik. He wanted to learn to be a biologist studying sea mammals. I think Frank may hear from him sometimes.

"Anyway, Gordon. My husband. Gordon Senior." She laughed. "We met at the Cold Storage, Gordon was working in the freezers. I was an *'Alaskero.'* I had come over from the Philippines, ten years before, when I was only fifteen. I was so naïve! I had Mauricio when I was sixteen. The very next year.

"The father was an *'Inside Man'* at the cold storage, but he wasn't even there when the baby was born. He left to go back home as soon as he found out I was pregnant. He was from California. I was so naive. What can I say? The first time I saw Gordon! I was twenty-two, he was handsome and wild, and everyone was afraid of him because he had so much violence in his past. I was completely taken by him. I had only ever been with one man, the father of my baby. We went out in Gordon's Chevelle and would park, and drink vodka, and...well, we ended up getting married. I had Mauricio already, my little boy, but Gordon couldn't handle being a father. He wanted his freedom. He went away about a year after we got married. He went to Seattle. He got into some trouble. Bad trouble. Someone shot him. Killed him. It was about seven years ago. I took the money I made at the Cold Storage, and with Frank's help, I bought this place. Now I have lots of boys to call my own! You too, Stu. You are one of my boys now."

She reached out her arms and hugged me at the table. She smelled like cooking and warmth, and love.

I feel like I'm in Mom's arms.

Ice Palaces

October came. With it the end of the halibut and salmon fishing seasons. Lena broke up with Rod and went back to the Lower-48. I had to move into a little hotel in the Filipino Barrio, a block from the Estrella, to save rent. Just a bed, a dresser, and a nightstand. Gold polyester sheer curtains. Seventy dollars a week.

The halibut boats changed over to the smaller hooks and went out for Sablefish. Mo told me that Sablefish weren't really cod, but were called Black Cod anyway. They were only found in the deepest waters the boats could pull their lines up from, sometimes over one hundred fifty fathoms down. At six feet to a fathom, close to 1000 feet deep.

The first boat that unloaded with Sablefish at the cold storage looked like it had sprung a leak from its diesel tank. When it pumped its bilge out, an oily slick spread out around the boat and under the entire dock. I asked Mo if we should call the Coast Guard or something.

"It's the Black Cod, Stu. They carry so much oil in their meat that it looks like that when they pump. That's why the meat is so good for smoking. You go to any of the restaurants in town now, especially the Filipino ones, and they'll all have smoked Black Cod on their menus. It tastes like smoked butter when you steam it. You should try it."

They were stunningly beautiful fish too, with black bodies, huge heads, and gills bright crimson red in contrast. They averaged about eight pounds, but some were monsters, going to thirty pounds or more. The bigger ones faded to light gray, but still had the dramatic red slash of color at the gill openings.

The cold storage crew started to diminish. When school began in September, we lost Jeff to Michigan State, and a bunch more of the Slimers went back to their homes all over the world.

Jeannie had vanished. I asked Frank about her.

"She's gone," was all he would say.

It was clear she never did have any interest in me, anyway. She preferred the company of older men. Or at least men that had an aura of danger about them. It made my stomach hurt when I thought about it too much. *I just hope she's okay.* I remembered what she said to me on the dance floor, about being safe with me. I thought about that for a long time.

After Black Cod season came the cold, and the King Crabbers. With the doors open to the outside, the temperature of the main floor dropped into the mid-twenties. I bought more layers of clothes to wear, including my first pair of Sorel Caribou Boots. They were amazingly comfortable after my Ketchikan Reds. They were like wearing toasty-warm felt tennis shoes. I wanted Bunny Boots, but every pair was already accounted for by the Senior Inside-Men. Rumor had, you could get them at army surpluses in Seattle, for about three hundred dollars, but that was 2000 miles from here.

The crew was down to twenty or so. Frank had his 'Elite Inside Freezer Crew' of six or eight, and the rest of us processed the crab as it came in.

The crabbers would come out of the fog like ice-covered ghosts. They had unquestionably been out a long way, and for a very long time. The crews were all battle-hardened and looked at us condescendingly like we had an easy life compared to them. *They were probably right.*

The entire superstructure of the boat was deeply encrusted in ice, and there were always one or two guys chipping it off as they unloaded. I heard if they didn't do that, it would get top-heavy and rollover.

Hours at the cold storage started to diminish. We worked eight-hour days now, sometimes only four on Saturdays, and we had Sundays off. With no overtime, my paychecks were a third of what they were in summer, and things started to get tight.

I had blown all of my summer earnings on drinking and restaurants. It didn't occur to me to save anything for the long winter. When Thanksgiving came, I wanted to do something to celebrate and to try and get my mind off of being so lonely. I tried heating a Swanson's Turkey Pot-Pie on my white gas camp

stove on the nightstand next to the bed, but I accidentally caught the curtains on fire and got evicted.

I moved out of the hotel into a two-bedroom shack a few blocks from the cold storage, owned by the Filipino that ran the hotel. Rent was only two hundred seventy-five dollars a month. I soon found out why. There was no heat. The oil furnace only worked once a week, if ever, and the inside of the house would drop down into the teens at night sometimes. That froze the water pipes, so I had no running water either.

I got a roommate in my little ice castle, a guy that worked on the inside crew. He had moved out of his last place, too, for the same financial reasons. We split the rent, so I had at least a place to live. His last name was Corrigan, so we all called him Cory. We worked the same hours and would go to the swimming pool after work, to shower and work-out together.

Cory was a major-league dope smoker, and he was the town dealer, to supplement his income. He had girls over all the time, smoking pot with him, and they usually spent the night. It wasn't comfortable listening to them going at it in his bedroom, but it *was* nice to have girls around.

He fired up all the time. He even went to work stoned. I didn't mind. Every so often, after our shift, I would join him to try and forget how cold and hungry I was. It didn't work.

He kept pounds of his *'Matanuska Thunder-Fuck'* pot under my bed in a big plastic garbage bag. All night long, I could hear the mice gnawing through the bag and rooting through his supply, munching the seeds. Cory didn't mind the mice cleaning his stash for him, but he did say the downside was that they left a bazillion little mouse turds in return. We just smoked it anyway.

There was no way to cook or hang out in our house. It was simply too cold all the time, so we just slept there. I was glad for my good North Face goose-down sleeping bag. We had to eat in restaurants, and with the work hours being cut to the bone, I soon spent all my savings and totally ran out of money.

One February afternoon, the day before payday, I was walking down the icy sidewalk, the temperature was three

degrees. I reached into my pocket and pulled out a nickel. That was all there was left—*one single nickel.*

I was hungry all the time, and couldn't eat out. The grocery stores were just as expensive, and if I brought any produce, it froze solid, sitting on the apartment counter. We couldn't do the dishes. We had no running water. But...it was crab season, and we were processing thousands of pounds of King Crab a day.

We were *forbidden* to touch the crab. It was too expensive, the owner of JCS said in an announcement over the intercom. Over twelve bucks a pound, wholesale. We weren't even allowed to buy it for any price. *For who knew what reason.*

Going to work hungry, and pulling the big square baskets of fresh-cooked crab out of the boiling tanks was too much of a temptation to resist. The cooking baskets would sit on the concrete floor next to the boiling tanks until the crab cooled. Three or four baskets lined up next to each other, with eighty or a hundred pounds in each. The steam would be condensing on the windows, the smell of fresh-cooked crab filling the room. My stomach was doing back-flips. It was gnawing on my backbone.

Some of the Kings were unbelievably huge. They looked like giant, surreal, spiny red insects in the basket. Their bodies were nearly a foot across, and their legs gave them a span of close to three feet. The world's record, I was told, was twenty-four pounds. One day we got an eighteen-pounder. We measured its leg span at fifty-one inches.

The legs of the crab were in five segments. From sharp-pointed ones at the ends to thighs that were eight to twelve inches long and over two inches in diameter right next to the body. Those were my targets.

I developed a way to eat and not get caught. After I pulled the baskets out of the cooker with the chain and winch, setting them on the ground to cool, I would wait until Mo was at the other end of the building. I would go to the basket, turning my back to everyone.

Quick as a heron stabbing a fish, I'd break a leg off the crab, separate the thigh section, snap the thigh in half, shake out the meat, and stuff the entire steaming piece into my mouth. It took about five seconds. I got pretty good at it, too. I was eating about eight thighs a shift, about four pounds of meat. Enough to keep me from starving to death. *Or maybe I just really like King Crab.*

One day, I waited for Mo to leave the cooking room, watching him mosey casually away. When he was out of sight, I attacked the one I'd been drooling about all morning. I walked up to the basket, broke off the leg, removed the massive thigh, opened it up, and stuffed a piece of meat into my mouth that was close to a half-pound, and *way* too hot. I didn't wait long enough for it to cool off. I was trying not to gag as I turned around, sucking air in through my mouth, and Mo was standing right in front of me.

Shit. Busted.

He had his arms folded across his muscular chest, and was scowling down at me. It was all I could do to hold the damn crab in my mouth, tongue burning, cheeks bulging, eyes watering, so I couldn't very well pretend I wasn't eating it. He patiently waited until I finished chewing.

I was ready to be fired and knew I was in deep shit.

"*Mr. LeClercq,*" in that deep baritone voice.

I finished swallowing. "Yessir."

"You know our policy about not touching the crab."

"Yessir."

Long pause. "Will you be doing it again?"

I finally noticed the twinkle in his eye. I smiled. "No, Sir."

"Good." He walked away.

At closing that day, a new policy was initiated. Employees could now buy the crab at the wholesale price of twelve dollars a pound. Over two hours of our work for one pound of crab. That was about one whole leg.

The next day at closing, I brought Mo my bag of fat crab legs to purchase, each one hand-picked, and every single one as long

as my arm. He weighed it. Eight and a half pounds. *Over two day's wages. I'm becoming a junkie.*

Mo looked at me, deadpan. "One pound and a half. That'll be eighteen bucks."

I couldn't believe it. I was grinning from ear-to-ear as I slipped and slid through the icy streets to get home. I feasted on my fresh cooked and still steaming crab legs while sitting in our eighteen-degree living room. I was going to buy some mayonnaise the next day and make an enormous King Crab salad, spread it on toast with some Tillamook Cheddar Cheese, and make crab-melt sandwiches. *Not bad for a broke guy in a condemned house.*

At six o'clock the next morning, I awoke to a city worker pounding the walls, nailing a sign on the outside of our house:

CITY OF JUNEAU ORDINANCE
BUILDING CONDEMNED
NO OCCUPANCY

I went to my Filipino landlord and asked him about it.

He shrugged. "Okay. I lower your rent to one seventy-fi'. Mo' bettah?"

"Deal."

We stayed in the house for the rest of the winter. Nobody kicked us out. It was a little embarrassing when Cory brought girls home for the night, though.

When the crab season ended on January 18th, I got moved to the seven-man freezer crew, and everybody else working on the main floor got laid-off. I finally made it to the *'Elite Inside Crew.'* The only thing was, we were down to twenty-hour weeks now, and Cory and I still had no money for food.

In a fortuitous stroke of luck for us, Cory's resourceful, supposedly homosexual, and slightly dishonest younger brother Ed got a job working in the kitchen at the luxurious Empress Hotel. Every Friday, regular as clockwork, he would trudge up the hill through the snow and ice to our condemned house bearing armloads of gifts pilfered from the kitchen refrigerators.

133

Flats of eggs, three dozen to a cardboard container, two-gallon boxes of milk, three-pound butter cubes, and entire *cases* of frozen T-bone and Porterhouse steaks. All for free, just a gift for us. He saved our fucking asses that winter.

Sometimes Ed would hang out with us, eat steaks, and smoke dope. He seemed pretty normal to me. I had never met a homosexual before. As much as Dad hated *'Fags,'* I couldn't tell the difference. He was hilariously funny, smart, and loved Blues music as much as I did. *What's the big deal?*

I found a ponderously heavy, rusty, fourteen-inch cast-iron frying pan under the sink and fired up the cobweb-covered electric hot plate. Three meals a day, sometimes four. Eight eggs and a couple of inch-and-a-half thick steaks, fried in butter. Cory and I would eat right out of the frying pan. We never even washed it. Every day, for two months.

One day we were coming down in the elevator from the minus-thirty-degree blast freezers for our lunch break. We were sharing the elevator with Frank and the other four inside men.

"What's for lunch, Stu?" Cory asked.

I grimaced. "Steak and eggs."

"Fuck, again? I'm sick of that shit!"

The guys looked at us like we were crazy. The next day Ed got fired for stealing, and that was the end of that.

Frozen Frolics

I got to work at seven-thirty and put on my freezer clothes. It was sure nice not being covered in blood and guts all day long, though the intensity of the blast freezers wasn't a piece of cake either. Wool 'scratchy-itchy' one-piece union suit long underwear, with a sleeveless cotton t-shirt underneath to keep from itching to death. Woolrich halibut shirt, Woolrich wool pants, three pairs of socks under my very own pair of bunny boots, inherited from Ken, who went back to Boise, Idaho for the winter. 26-ounce C.C. Filson Double Mackinaw Cruiser coat over everything. Wool watch cap and an insulated pair of rubber gloves. Into the freezer, I go.

My job was always one of three things. Worst case scenario, I had the 'new-guy-on-the-freezer-crew' crap job of chipping the ice off the concrete floors of the main freezer hallways. I had to use a six-foot-long iron chipping bar, pointed at the end that weighed thirty or forty pounds. Eight solid hours of pounding on the floor and sweeping up the ice. That was my least favorite job and made being a part of the *'Elite Inside Crew'* not very glamorous.

My other responsibility was loading the stacked salmon in the freezers into carts, and loading semi-trailers with them to ship to the Lower-48. That was my favorite job. I always got to work with *'Freezer-Guy Tim,'* the Filipino. We liked each other a lot, and Mo said I was the only one who could keep up with him. Tim was an absolute *machine*. Massive shoulders on his five-nine frame, dark-skinned face, covered in acne scars.

He always wore a khaki-green long-sleeved t-shirt knotted around his head for insulation, with a camouflage Vietnam bush hat on top of it. We would race to load the carts together, and run them out to the crews loading the semis. By mid-day, we were stripped down to just our sleeveless t-shirts, wool pants, and bunny boots in the minus-five-degree main freezers, steam pouring off our heads and bodies. We worked without speaking,

both of us powering through until the breaks. We could load a thousand-pounds of fish in a freezer cart in six minutes flat. The loading crews thought we were crazy, but I loved the rhythm of the work, and how strong it made me feel. At breaks, Timbang and I would put our coats back on, sit together in the snow on the edge of the dock, and talk. It was thirty degrees warmer out on the pier, and the crew room was *way* too hot.

For twenty years, people said, he had hardly said anything to anybody, but after we had worked together for a couple of months, sometimes Tim would tell me stories. Stories of how, when he was only eight years old, he started working in the rice fields of the little village where he was born. Working in knee-deep water, bent over double, picking rice for sixteen to eighteen hours a day. *At eight-years-old.* No wonder the man was as strong as he was. He told me that in only three more years, he would go back home and buy a house, find himself a wife, have some children, and sit down for the rest of his life.

I asked him if he had any girlfriends here in Juneau.

He smiled at me with his perfect teeth and said, "Just for an hour."

I was proud that he trusted me. At lunch, he would run home to his dad's house, where he would eat fish and rice every single day, and run back to work. You could see him trotting up the street, with the sleeves of his t-shirt headgear flapping in the wind. People stared, and laughed at him, but I thought he was a wonderful man.

One day my roommate Cory and I were taking the frozen salmon off of the aluminum trays stacked on shelves in the minus-30 degree blast freezers. We loaded them into the carts, bringing them back out onto the warm 25-degree cold storage warehouse room. There we piled them in baskets attached to a winch and dipped them in a sugar-water solution.

Dip them three times, then put them back in the trucks. Wheel them back into the blast freezer and stack them like cord-wood. The sugar solution kept them from getting freezer-burned. A few days later, after the glaze froze solid, we moved

them to the main five-degree freezers, where they awaited shipment.

As I was stacking the freshly-sugared fish, I noticed that several of them that had been there for a few days were damaged. I asked Cory why half of the bodies on some of the bottom-row fish were missing. It looked like they had been chewed off. He pointed to a hole at the base of the freezer wall, about four inches in diameter.

"*Wharf rats*. They chew right through the foot-thick reinforced concrete walls to get to the salmon. Then they sit here, at minus-thirty degrees, and gnaw on the fish. We have to throw away anything they touch. Most of 'em have rabies. Some go to eight or ten pounds too, like a small dog. I had to kill one a coupla' weeks ago with a chipping bar. Fuckin' blood everywhere. With the tail, he was over two-feet long. *Mean motherfucker.*"

The winter raged on. I was living paycheck to paycheck, taking home about $190.00 a week. I had spent all my summer earnings on warm clothes, alcohol, marijuana, rent, restaurant food, and alcohol. It was surprising how quickly you got used to spending what you were making, no matter how much you were making. My savings account melted like butter in a red-hot cast-iron pan. I was going to bars every night after work and was getting a little too fond of Johnny Walker whiskey. There were some nights I didn't remember walking home to my fucked up condemned house and crawling in my sleeping bag.

February moseyed into March, and the snow turned to slush and then to rain. Pretty soon it would be fishing season again, and the enormous paychecks that went with it. I was not looking forward to the long hours, but I promised myself I would put aside enough to live in a real apartment next winter. With a stove to cook real meals, and a real heater, and everything. Maybe I could even find a cute little Slimer to share my bed. I felt so alone I was *aching* for the touch of a woman. I flashed back on Jeannie's golden eyes, and my chest started to hurt a little.

I was in Cadman's one Saturday morning buying a new pair of Woolrich pants, when I ran into Frank, talking with this other mean-looking guy. I waved at him and went about my business, not wanting to bother him.

The next Monday, Frank sat down next to me on the dock at lunch. "Can we talk, Stu?" Cory got up and left in a hurry.

"Sure, Frank. What's up? How's Prez?"

"Just fine. Say, Stu, that guy I was talking to in Cadman's Saturday asked me about you."

I raised my eyebrows. "Good or bad?"

"He is looking for someone who will be the First Mate on his halibut boat this Spring. He asked me if I knew of a hard worker that could follow orders. I mentioned your name to him. Do you think that's anything you'd want to do?"

"Fish halibut? What does 'First Mate' mean? As opposed to what?"

"I tell you what. Let's meet at the Northern Star tonight, you'll get to see Prez, she's been asking about you, and we'll talk. OK?"

"Sure! I would love to! And I get to eat Prez' cooking! See you at seven!"

The Eagle Flies with the Dove

The Northern Star only had a few people in it when I got there, Frank and Prez were sitting at their table, talking. I walked up to them, and Prez gave me a big hug. It feels good to be someone's son again.

Dinner's ready! Let's go eat!" Prez was still wearing her apron.

We went into the kitchen and sat down at the dining room table. Prez had made adobo again, and I was in heaven once more. We ate quietly, just some small talk about the weather changing. Prez wanted to know about my wanting to be a fisherman.

"Jeez, Prez. I have no idea. Frank, do you think I could do it? Doesn't Mo need me to work at JCS this summer?"

"Mo and I have talked about it, Stu. He will miss you but thinks it would be a great opportunity for you to get into another line of work. You might really like it. Phil is one of the top fishermen in all of Alaska, and he doesn't choose his helpers lightly. If you fish with him and do well, you could fish with anyone, anywhere. You could travel around some more if you wish. Phil's last First Mate is fishing tuna boats in San Francisco."

"San Francisco, for real?"

Prez nodded. "It would be a wonderful experience, Stu. It would get you away from the monotony of the cold storage work, as well. You will see much of Southeast Alaska fishing. You would learn a lot from that man."

"Speaking of learning. Frank, tell me about your family, please."

"We have been here for many generations, Stu. My great-great-great-grandfather was the Shaman of the Haida-Gwaii down in the Queen Charlotte Islands in Canada. His tribe migrated here looking for better fishing grounds, and some say for women." He winked at Prez. "I know you have studied the ways of the *Real People* in your books, and are aware of some

of the rituals and beliefs we hold to be true. I would not be sharing any of this with you if I thought you would ridicule it.

"We are 'Of The Earth.' We believe that She is our Mother, just as the Christians have their Father-God. Every creature on this planet is our brother or sister, and even the fish that we work with every day are a part of the circle-wheel. The Native fishermen say a prayer to every fish they catch, thanking it for giving up its physical body to feed us. We believe the spiritual existence of an animal continues on, even after the body dies.

"When we hunt a moose, or a deer, or an elk, we ask its forgiveness, then pray over its body after we kill it, knowing its energy will continue to live in us. We also believe that some animals are the go-betweens between the spirit world and the physical world. Like the Great Eagle. It is like a god to us. It carries the power back and forth between the two worlds. It is a line of communication to the Spirit World."

"Is your religion just for Natives? Do Whites," I nodded to Prez, "or Filipinos believe as well? Could I become a Shaman, for instance?"

"Many of the supporters of the Real People have similar beliefs as we do. Phil, the man you are going to meet, is considered a Shaman by our people. He has great power spiritually. He will teach you much. If you can get him to say anything."

"How am I going to meet him? What if he doesn't want me?"

"He will hire you. Meet him tomorrow morning at six, at the cafe. I already cleared it with Mo. This is important, Stu. You will not do better than this. I believe you are already moving away from your Christian God, becoming a man, and becoming one of Us. Your work ethic, your lack of arrogance, the way you treat people, that is your true spirit. You weren't sent here to Alaska simply to get rich."

"I wasn't sent here. I hitchhiked."

"You were sent here." He smiled at me, one of the only times I had ever seen him smile.

Prez had tears in her eyes when we hugged goodbye.

Encounter with the Devil

I walked into the Ritz Cafe at six o'clock sharp. There were a dozen people scattered throughout the little diner at that hour, sitting in groups of twos and threes. Phil was sitting alone in the corner, just quietly drinking his coffee and smoking. I walked over to him. We shook hands and introduced ourselves. He nodded at me to sit down at the chipped yellow-marbled Formica table.

There was an aged, tattered-brown lithograph of the old Juneau-Douglas Treadwell Gold Miners on the wall next to him, barely visible through the fog of cigarette smoke. They were standing next to a mining cart, holding picks and shovels, staring at the camera, grim and unsmiling. I looked at the picture, then at his face, and thought he must be a real throw-back to those days. When men were men, and you did what you had to do to survive in Alaska.

I was able to take a closer look at him when Shirley came over to refill his cup and take our orders. He looked in his fifties, but Frank had said he was only about thirty-four. Oil-stained black Greek fisherman's cap over curly long gray-streaked hair. Face weathered and tanned from a lifetime outdoors. Gray-black moustache and a full beard. Soiled Ragg-wool sweater, sleeves pulled up over tanned, thickly-muscled forearms. Part of a smeared tattoo showing. Ice-gray eyes, surrounded by crow's feet from squinting into the sun, no doubt. I guessed he must be about five-ten or so, and one eighty-five. Broad shoulders, but not weight-lifters' shoulders. Hard-work shoulders.

His left hand holding the cigarette was half gone. It was cut in half, lengthwise. I tried not to stare at it as he gave his order. The little finger and ring finger were gone, along with the whole outside part of his hand. Now just a three-fingered claw.

Shirley left with our orders, and I found myself in the focus of his unwavering stare. He was appraising me without any

expression like I was a steer on an auction block. His jaw was working slightly.

I just sat there, not sure what to do, but willing to do whatever I had to in order for this to work. I wanted this job, but this was shaping up to be the strangest interview I had ever experienced.

"You're not very big, are you."

Good start. A real confidence builder.

"Both Frank and Mo tell me you are one of the hardest workers they have ever seen at JCS. Even able to keep up with the Filipinos. They have seen a lot of men go through there in the last forty years, and that's saying a lot.

"Do you think you have what it takes to fish? I'm not talking about a factory warehouse job. I am talking about being the First Mate on a *'Highliner,'* one of the most productive boats in the fleet. Just the two of us. Working sometimes twenty-two hours a day, and not being able to make a single mistake or bad judgment call, or it could get one of us killed. We work no matter what the weather. I am talking about keeping your mouth shut, your head down, and working harder than you have ever dreamed of working in your entire life. Doing exactly *what* I tell you exactly *when* I tell you.

"This is an *enormous* responsibility, Stu. Not one man in fifty could last out there for a week. I am asking you to do it for months at a time. Twelve or fifteen days at sea, then three or four days ashore for rest. Then back out. From April first to November fifteenth. You will be doing the work of two men, out on the back deck. Without a Second Mate, your share will be substantially larger. If you pan out, you will be the highest-paid *'First'* in the entire halibut fleet, but it will take a couple of seasons to get there. In the winter, you can go back to JCS and work in the freezers with Frank, or take your money and live in Mexico, like I do."

That's pretty fucking cool.

"Have you ever worked on a boat before? Ever been out at sea?"

"Just pleasure boats and little fishing boats with my dad, Sir. Nothing like a commercial boat."

"Call me Phil. OK, I can teach you all that, I'd rather you start from scratch, anyway. When can you start? Do you want to think about it first?"

"Why don't you take a First Mate, or Second Mate, or Third Mate, or whatever you call them, from another boat? There have to be other guys out there that could do it better than me."

"They're all talk, the whole bunch of them—swaggering, over-educated wannabes. I wouldn't trust any single one of them to keep up with me for even a single trip. Besides, they're all whiners. Braggers. All hat and no cattle. They all talk too much. I heard you keep your mouth shut and work."

"I don't want to leave Mo and Frank hanging, sir. But they did say not to turn you down if you offered me a job. Today. I can start today if you want."

He nodded, just looking at me. "My last First was with me for over eight years. You have some big shoes to fill. You were a gymnast, is that right? In college?"

Shirley came up with our breakfasts. As soon as she set it in front of him, he started shoveling it in, as if we only had five minutes to eat. I picked up my fork.

"Yes and no. West Coast Invitational Champion on the Rings. I competed against the college athletes as a Senior in High School. No college, though. I kinda missed out on that whole part. I came up here, instead."

"Well, that explains the handshake, then." Between bites. "You're stronger than you look. The D.A. is in Harris, Dock J-10. I want you there tomorrow morning at six. It will take us about two weeks to get the boat ready to go out. Sanding, varnishing, tying gangions, and loading gear. The season opens April third. I will provide a bunk and three squares a day, but you don't get paid until I get paid. After our first trip. You in?"

"The D.A.?" *No pay for a month?*

The *'Devil's Advocate.'* Your new boat. She's 46-feet, black and red. You can't miss her.

Moon Toast

"Yes. Yes, I'm in. I will see you tomorrow morning!"

We finished our food; he threw a twenty on the table, we shook hands again and went our separate ways.

I was going to be an honest-to-God halibut fisherman!

The Devil's Advocate

Cory and I parted company at 5:30 the next morning. I figured he could live in the condemned house all by himself for a while. My pack was packed, I had a duffle bag full of my cold storage gear, and I walked the mile to Harris Harbor.

Harris was tucked in behind two breakwaters to shelter it from the brutal S.E. Alaskan storms. Most of the docks were filled with charter fishing boats for the many tourists visiting Juneau. There were two long docks filled with little wood and fiberglass pleasure boats for the residents to fish out of, and that left only two floats for the commercial fishermen. Since Juneau was so far from the fishing grounds out on the Pacific Coast, Kevin had told me, Harris was not that popular for the Salmon, Halibut, and Black Cod fleets.

"Besides, all the State workers would have a fit if anybody got a fish scale on their fancy new white fiberglass pussy boats." Kevin *really* hated State Workers. As far as I could tell, except for Mo and me, Kevin hated *everybody*.

I walked down the long wooden gangway to the docks and started looking for 'J' dock. It was the very last one, of course. My pack and duffle felt like they were filled with concrete, by the time I found it.

There she was, the Devil's Advocate. Black painted hull, black cabin, with red trim around the windows and the top of the hull. Black smokestack with a red stripe. The bow of the boat down to the waterline was covered in this beautifully varnished wood that looked like teak. The same type of wood trimmed out the short gunwales that surrounded the deck. Her name was written in yellow on the bow of the boat above the teak, and on the stern. Her port of call, Petersburg, Alaska. She was the beamiest boat I had ever seen for her size. Phil said 46-feet long, so she must be at least twelve wide. A six-foot diameter spool filled with thin green rope on her back deck, and dozens of bright pink and orange buoys 36-inches across, tied to every

spot available. Upside-down anchors were lining the pipe-rails around the spool. Two enormous wooden poles attached to the deck, rising above the cabin twenty feet. White Decca radar and six antennas attached to the top of the cabin.

I walked up to her, completely intimidated by all the equipment and hardware. How was I going to learn how to do this?

This wasn't Dad's old Glastron runabout or one of the skiffs from Fatty's Bait Dock. This was The Show. The Big Leagues. The Pros. I have made a terrible mistake.

Phil came out of the cabin, holding a cup of coffee. "Come aboard. We have a lot to go over."

I stepped on board, almost tripping over the high sides. Phil went back into the cabin, and I followed.

My new Skipper was talking, in his barely audible tone, "The D.A. was built in '28 on the East Coast of Canada. She is Yellow Oak, the strongest wood in the world. Three-inch thick planks over six-inch beams. She draws eight and a half feet. Her hold carries 38,000 pounds. She is the finest heavy-weather boat in the fleet."

The cabin was ten-feet wide and sixteen long—a small oil-burning stove on the left, with a one-gallon blue speckled coffee pot on it. Dining table to the right, seats four, with a chart unfurled on it. A narrow wooden door to the left of the table, going down to the engine room, probably. Wheelhouse in the front, large wooden spoked wheel, surrounded by electronics. Door to the left of the wheel, slightly ajar, showing a bunk and nightstand.

"That door there is down to the engine room and fo'c'sle. That's where you sleep. There's a bunk down by the engine. Your oilskins hang outside. There're hooks next to the ladder on deck that goes up on top of the cabin. Your clothes will stay in your backpack down next to the engine. There's coffee on the stove. Grab a cup, and let's go back on deck."

"What's a fo'c'sle?"

"Short for *'forecastle.'* It means *'before the mast.'* It's where the sailors quartered on the big sailing schooners last century. We all use it to mean 'sleeping quarters.'

I pulled a metal mug from the hooks over the stove and poured a cup of coffee so black and thick it looked like asphalt. "Coffee-Mate and sugar?"

He looked at me like I was asking for a chocolate eclair. "No. If you need it, we'll add it to the shopping list."

I took a sip of the coffee and tasted something hard in it. I pulled a piece of eggshell out of my mouth. Eggs in coffee? *Maybe that was breakfast.*

We went out on the afterdeck. "OK, I will try and make this simple. That's the ground-line." Phil pointed at the spool of rope. "You work from the trolling hatch, back there in the stern. The end of the ground-line gets attached to a buoy." He touched one of the three-foot pink floats. "Depending on how deep we are fishing, we let out enough line to give room for drift, then attach an anchor." he pointed to the row of anchors lining the rail. "Once the anchor goes overboard, we start attaching the *snaps*. This method of halibut fishing is called *'Snap-On.'* The *'Conventional Boats'* have the gangions attached already to the ground-line, but that takes up a lot more room, and you need a bigger boat."

He held up a clothes-pin contraption made out of stainless steel, with a 30-inch nylon cord attached to it, and an enormous hook. "This is what the *'gangion-assembly'* looks like. We will have the hooks baited already, and lined up in the tubs over there." *Three galvanized washtubs.* "I drive the boat. You snap on a snap every three fathoms. About every ten seconds. Six feet to a fathom, right? You keep going until you get to the end of the set. I say when. It will be about four hundred yards long. Then we tie on another anchor, let out buoy line, attach another float, let it go. You understand? The ground-line sits on the bottom of the ocean, anchored on each end, with buoys marking each end of the set. We do that three times. We let the bait work for five or six hours, and then we pull the sets.

"OK, now. Pulling the sets." He walked to the right-rear corner of the cabin. "We gaff the buoy off the side of the boat, right here next to this davit. This is the *'pulling davit.'* The ground-line threads through this pulley, over the davit, through that pulley attached to the back of the cabin, and then to the drum. Once we hook everything up, you throw this hydraulic lever next to your left knee, and the drum starts to turn, speed indicated by how far you throw the lever. First, the buoy line, then the anchor will come up. You stop the drum and untie the anchor. It goes back on the anchor-rail, over there with the rest of them.

When you re-start the drum, the hooks will start to appear. If they have fish on them, you gaff the fish with that gaff over there hanging on the ladder, and then you unsnap the snap, throw the fish into the bin at your feet, and keep going. The drum never stops. You will learn to do it in one smooth motion. No fish, the snap gets thrown in the bucket.

This is called *'Running the Rail.'* The gunnels are the rails of the boat, the man on the pulling davit with the gaff, is the *'Railman.'* You should be able to pull an entire set without stopping the drum once. Try not to stop the drum. It might tear the hooks out of the fishes' mouths. Questions?"

"About ten thousand. How about if I drive the boat, and you do this?"

He nodded. "I did the entire thing myself, on my last boat. She was smaller, only thirty-four feet. The 'Lisa H.' I had a steering wheel right here at the davit, and another in the trolling hatch. I set and pulled all by myself. One day, the ground-line got caught under a rock down there, it must've been one hell of a big rock. I was too tired to notice how hard the drum was straining to pull the gear. It stretched the ground-line so tight, it was like a piano wire before I realized it.

"Suddenly it broke free, and line started shooting out of the water, there were hooks flying past my face, one grazed my eye socket, then one hooked me right here." He showed me the scar in the palm of his maimed left hand. "My arm went right through the davit-pulley, and my hand was chewed right off. I

was finally able to shut down the hydraulics with one foot. I'm lucky I didn't lose my whole arm. After that, I bought the D.A. and hired a Railman. I drive the boat, and find the fish."

I just looked at him. I pictured the pain, the terror of being alone out at sea, and having something that horrible happen to you.

He was studying my face carefully. "This is dangerous work, Stu. But you'll see it's the most gratifying job you will ever know. Being out on the ocean, the magnificent scenery, the weather in your face, the honor of being able to feed thousands of people with the highest quality food there is on the whole planet. We are a dying breed, no pun intended, there are only 300 boats in the entire Alaskan halibut fleet. We are respected by everyone who knows who we are and what we do. I think you were born for this work."

I thought about it, what we were in for, what might happen, what it meant to me. *There were no cowards out here, that was for sure.* "I'm in. Let's get to work."

Glacier Bay

When April 3rd dawned, we were anchored up in a little cove in Glacier Bay. We started there for a couple of reasons, it was as calm as a bathtub, and it was so full of fish, we knew we would start our first shake-down trip with success. We only set two sets the first day, everything went smoothly, if a little slowly, and we were anchored back up in our protected cove for three hours, letting the bait do its thing. While we were waiting, we were baiting. Three more tubs of hooks baited and ready for tomorrow's sets. Phil proclaimed me to be an *'Official Master-Baiter.'* We both chuckled at the joke, though from the sound of it, green deckhands had heard it since the dawn of fishing.

Glacier Bay was a wonderland. Milky powder-blue water, from all the glaciers feeding into the 1300-square-mile bay. Mountains were rising right out of the water, and glaciers were coming off every mountain. Trees, and silence, and wildlife like I have never seen before. Grizzly bears on the feeder streams, a lone wolf, trotting along the shore. Herds of sea lions, packs of seals, two gray whales rolled along a few hundred yards away.

As we were chugging out to pick up our gear, something was swimming next to our seven-foot-tall marker flag, marking the set. We got closer, to see it was the dorsal fin of a Killer Whale, the fin the same height as our marking flag! *There were Killer Whales all around our gear!*

Phil just shrugged. "They'll leave."

We hooked up, and my first set as a Railman was underway. Phil steered the boat, looking out the starboard cabin window at me, to keep us close to the gear coming up out of the water and to watch me work. I pulled the buoy on board, coiled the buoy line, untied the anchor, and my first hook came in sight. Visibility was only about six feet into the milky bay, so I didn't have much warning when the first fish came into view. It was a codfish. I missed the head with the gaff hook and speared it in the side, but Phil said it didn't matter, since we were going to cut it up into bait, anyway. Six hooks later, my first halibut! I

150

gaffed it in the head, like I was supposed to, and pulled it on board. It flopped and jack-knifed like crazy until I hit it with our fish club, and it went still. I remembered what Frank had told me, and I said a 'thank-you-prayer' quietly, to the fish. Phil said my first halibut was about forty-five pounds.

We worked until the two sets had been pulled, all the fish had been cleaned and thrown in the hold on ice, and the deck was hosed off. As we sat down to dinner, the ship's clock said '2220'. We had started that morning at four. It was ten twenty at night.

While I was icing fish and cleaning the deck, Phil had filleted one of the rockfish we had caught and served it to me pan-fried with rice for dinner.

"Good work, Stu. You're getting the hang of it already. We'll stay in Glacier Bay for the next couple of trips and see how the fishing is."

That was three years ago.

A Spot of Cappuccino

I never did make it to Mexico in the winter. Phil invited me down to the Yucatan, much to my surprise, to join him in his usual winter hangout. I opted out to save money, and every winter stayed in Juneau, living in Harris Harbor aboard the D.A.

When it snowed, I swept off the decks and cabin so that she wouldn't freeze and rollover. Saving on rent, I was able to conserve most of my earnings. The first winter in Juneau had taught me a valuable lesson about protecting yourself from unseen calamities.

I worked for Frank and Mo in the freezers part-time, when they needed an extra guy. Somebody would call in sick, or they had an unusually large order and had to load more semis than usual.

Timbang had left for his little village in the Philippines. I never got a chance to say goodbye. I loved and missed that gentle, hard-working man. Cory had taken off, back to Portland, Oregon. No one knew if he would return. I didn't know hardly anybody at JCS anymore, and my heart just wasn't in it.

I couldn't tell Mo and Frank enough how much I appreciated them getting me out of there and onto a fishing boat. Some days I would go in even if there wasn't any work and just sit in the warm crew-room. I would watch them play crib, and we would talk.

Every Saturday night, I had a standing date at the Northern Star for dinner with Prez and Frank. They were married now, and I never saw Frank smile so much. Mauricio treated me like an equal, almost like a relative, and was even teaching me a little Tagalog. "Tagal na ah!" meant, "Long time, no see!" and "Magandang gabi" meant, "Good evening!"

I never saw or heard of Jeannie, or any of her 'Sheilas' again, although there were some single women who were regulars there that I got to know pretty well.

I occasionally had a guest on the boat. Some of the local women thought it was romantic to have a one-or-two-or-three-night-stand with a seasoned halibut long-liner, I guess.

One of my frequent cuddle-buddies was a beautiful diminutive Italian girl, Donatella. She was a regular at the Northern Star. From New Jersey, of all places. We all called her, 'Donut.' She was a tiny little thing. Big dark-brown eyes, and thick black hair, down past her waist. Tiny little feet enveloped in giant Sorel boots. She was about four-foot-ten and not even 90 pounds. She was constantly in the company of a beautiful black dog that outweighed her by thirty pounds. He was two-years-old. His mother was a Golden Retriever, and his father a Rottweiler. He had a big white spot on his otherwise coal-black body, covering his chest. At night, all you could see of him was that white spot. She named him 'Cappuccino.'

"See?", she exclaimed, "He's all black, with a white spot on him, just like coffee with steamed milk!"

We called him Cappers, or Cappy, or Cap, depending on what he was doing, or who or what he was trying to eat at the time.

I adored that dog and adored that precious, passionate, affectionate girl. We spent many nights on the D.A., with it snowing a blizzard outside, but with the oil stove keeping us toasty warm in Phil's cabin. Cap was curled-up at the foot of Phil's bunk, and Donut's nude warm body spooned tightly against me, her thick black hair on my pillow.

I finally got my Doctorate Degree that winter. Stuart Franklin LeClercq-DS. A Doctorate in Snuggling. I was going to write my Thesis on 'Sub-Zero Spooning.'

One late-February evening, Donut came into the bar, looking upset. I hadn't seen her for a few days, assuming she had been staying with her girlfriends. Instead of telling me about her time away from me, she blurted out she was moving back to Camden, New Jersey, and couldn't take Cappers with her. I was heart-broken.

"I am so sorry, Baby. I am running out of money, and my parents have sent me a ticket home. I couldn't *possibly* bring

Cappy, he's way too big for their house, and Mamma hates dogs, anyway. Stu, Sweetie, could you take him? Didn't you say Phil might let you have a ship's dog? Baby? Please? I don't trust him with anyone else. He loves you so much!"

She started crying right there in the bar, and I got a little sad, too. She spent the next three nights with me, refusing all my offers to stay and let me support her for the winter. One morning, I put her in a cab for the airport, and she was gone. Forever. I never heard from her again.

Cappuccino stayed with me. Phil was coming home from the Yucatan in two weeks, and I was going to have to sell him on the idea. I was worried sick Phil would say, *"Absolutely not!"*

My worries were unfounded. When Phil got back to the boat the first week of March, all tanned and rested, he looked at Cappy, looked at me, nodded, and just said, "We could use a ship's dog. Nothing wrong with a little company." *And that was that.*

Becky

It was a beautiful spring day on the docks north of downtown. I was working on the gear between trips, tying new gangions, and sharpening what seemed like ten-thousand hooks. Phil insisted I sharpen every single hook we had, even the brand-new ones, right out of the box. I had my shirt off and was tan and horny. Cappuccino was tied to the dock with a short piece of old buoy line, sound asleep in the sun.

I spotted her from three docks away, my radar working flawlessly after nineteen days at sea. Cut-offs, muscular legs, embroidered Mexican gauze peasant blouse, no bra. Shoulders back, and a confident strut. Her pendulous breasts were swaying gently under her shirt as she walked, and as she got closer, I could see the darkness of her nipples through the thin cotton. She was eating a granola bar, dipping it in a little tub of pink yogurt. She was looking around for someone; it seemed. *Me, I hope.*

I stayed intent on my work. *Casual-like. Indifferent.* I looked up as she went by and gave her a million-watt smile that would have knocked the average woman right into the water. She smiled at me and just kept right on walking.

Shit. Okay, the dock was a dead end. She'd have to return sooner or later. I slid my butt around, so I could watch for her coming back.

There were a dozen or more halibut boats in town that day along with purse-seiners, trollers, and gill-netters. The dock was packed. As she rounded the corner, coming back, I could hear the wolf-whistles and cat-calls from the other crews. The testosterone level in a fishing harbor could power the average Third-World country. *No need for nuclear energy boys, simply strap the old dicks to a generator.*

Her smile had faded away to a hard line, and she had a tight, stressed look. Her yogurt was gone, and her arms were folded across her chest. She had to go slow around me; there was stuff

155

all across the dock where I was working. *Now, how did that happen?*

I wanted to say something that would endear her to me forever, but at the same time not appear threatening. Put me instantly above the macho animals she so despised, but still, turn her on sexually.

"Hi," I said.

She glanced down at me with a frown.

My voice woke Cappers, and he raised his head, looking for trouble. I put my hand on him to let him know it was ok.

I tried it again. "Don't mind the animals, most of them are house-trained." She stopped and let out a little burst of laughter.

"My name is Stu. I'm the zookeeper in this monkey-house." I got to my knees and stuck out my paw.

She leaned over and took it in a firm handshake.

"Becky. May I pet your dog?"

"Pleased to make your acquaintance. Sure. He won't bite. Much."

She pulled her hand from mine, and very gently, let Cappers smell it. I didn't want to let her hand go. It felt like heaven to touch a woman again. Cap licked her hand, and she scratched his ears. The electricity was flowing out of her. Her sexuality was almost more than I could handle. Her heavy breasts were swaying gently under the gauze peasant blouse, and I was finding it hard to breathe.

"Live here, or touristing?" I asked. *Suave. Debonair.*

"I live here. *South Douglas.*"

"Except for the constant staring, do you enjoy the docks?"

She looked at me and smiled. "Yes."

A real talker. "Whatcha doing down here, may I ask?"

"Looking for a friend's boat. He was supposed to arrive today from Sitka. He's got the *'Requiem'*?"

"No luck?"

"No. Maybe he's at the city guest dock, Downtown."

"May I escort you to safety?"

"Who's going to escort us?" She replied with a smirk.

I took that as a yes and stood up. "Stay here, Cap." He was tied, but I wanted to let her know I was in complete control of a ferocious animal.

She was two inches taller than me in her leather sandals, maybe three. Long brown hair, curly-frizzy. Huge hazel-green eyes. *Scandinavian heritage, probably.* I guessed she was in her mid to late twenties. Suntanned face and arms. *Outdoor-type, I bet.* Gorgeous, muscled thighs. Cute feet. No make-up, polish, or frills.

We walked down the docks silently for a while. I had no idea what to say, now that I had her undivided attention. She was enjoying my discomfort, I could tell. She was smirking. I was becoming self-conscious without a shirt on. I folded my arms over my chest, flexing my gymnast biceps. It didn't help. She never even looked.

We got to the end of the dock: Cars, civilization, people. Now I felt plain naked. I put out my hand to shake hers again. If I was never going to see her again, I wanted to touch her at least one more time.

She gave me a slow smile. "Thank you, that was very gallant."

"Oh, no problem, I'm a white-knight-in-training."

She smiled again. "Do you ever get to the '*Empress Bar*,' Sir Stu?"

It was a hang-out for State Workers and Legislators. Stuffy atmosphere, lousy music, watered drinks. I'd looked in the door once a year or so ago, and walked away.

"Sure, all the time!"

"If you get done with your work, come on down. I'll buy you a drink for all your trouble."

Yee-fuckin'-ha! "Okay! That would be great. About nine-ish. Okay?"

"See you there." She turned and walked away with long strides. Square shoulders, great ass. Good calves, too. I saw a tattoo on her back through the gauze blouse, a dreamcatcher with feathers. *I love women with tattoos.*

I looked up to heaven, *"Thank you, Jesus!"* I turned and walked back to the boat.

One of the crewmembers on the purse-seiner *'Mary Jane'* yelled over at me, "Go get her, Dude!"

I smiled at him but thought he was an unsophisticated pig.

Meeting the Empress

I finished work about six-thirty. The last hooks sharpened, the ground-line checked for frays, and the deck spotless. There was no sign of the Old Man; he was probably at his Old Lady's house or playing pool at the Shamrock.

I took my clean clothes up to the swimming pool, where they had lockers and showers. I paid my extra two bucks admission fee to get into the workout area, too.

Changing into my workout stuff, I made my way to the meager cable equipment they called a gym. It was just enough to work up a good sweat, mostly just warm-ups and upper-body stuff. I sure missed the gym at my old school. I'd kill for a set of rings to work out with.

Rumor had it the high-school had a full setup in their gymnasium, but I wondered if their insurance would allow me to work out on it. Maybe I could teach the students? I liked the idea and promised myself I would look into it in the fall.

I sat down at the cable leg-press machine, pegging it at seven hundred and fifty pounds. Guys were watching, so I didn't even warm up. I did a set of ten, then ten more.

One of the guys walked over and looked at the stack. "Jesus, I'd hate to be kicked by you!"

I smiled at him and did ten more just for show. I reached up for the lat-pull-down bar after setting it at two hundred. I did ten reps real slow with heavy negatives to work my lats. I could get them to spread like eagle's wings. In my prime, the year I took the Westco Gold Medal with a score of 9.85 in Rings, I could do reps with two-sixty-five at a bodyweight of one-twenty-eight.

I farted around with some sit-ups, then hooked my legs over the chin-up bar and did inverted sit-ups. Slow, completely controlled, just like Coach taught me. I unhooked and dropped down. Five or six people were looking at me, so I flexed my traps at them. Grinning, I went in to change into my Speedo.

I swam a few laps to loosen up, but I *hate* swimming, I sink like a stone. I could, in fact, sit motionlessly on the bottom of a swimming pool. I cannot float, no matter how hard I try. The refreshing water felt good, though.

Next stop the dry sauna and the smell of hot cedar. I always loved that smell, but the two-hundred-degree heat was too much for me. I took a ten-minute shower and felt like a million bucks. When I looked at the clock on the wall, it showed 7:40. *I'm starving.*

We had had a reasonably good trip, about twenty-one thousand pounds. My share was twenty percent after expenses. I got the highest share of the whole fleet. No other deckhand got over fifteen per-cent. Halibut was selling for a dollar-fifteen a pound. After fuel, groceries, lost gear, boat payment, docking fees, boat share, Skipper's share, etc., etc., my share came to $2960.00. Cold, hard cash. For nineteen days at twenty hours a day. $7.78 an hour. *All mine, baby.* After $65.00 a week and $1.55 an hour in my old job in Seattle, I was in heaven.

I threw two grand in my dresser drawer, next to my handgun. Then, I folded the nine one-hundred-dollar bills and three twenties in my front-right jeans pocket, loving the feel of the weight of it. *One big old bulge of money. No education, no future, but a pocket full of hundreds will make you feel like a king.*

I sauntered into town, walking through the antique carved double doors of the lavish turn-of-the-century Empress Hotel and made my way through the lobby into the restaurant. I got a few looks from some of the guests checking in.

I stood at the entry door to the restaurant and checked things over. The Legislature was in session, so I saw a whole passel of suits there. Mucky-mucks. Big shots. Lobbyists. Lawmakers. *Kiss my ass Boys, the fleet's in town.*

I was wearing my off-the-boat uniform. Adidas Stan Smiths, white and green. They were my favorite dancin' shoes. Tight, faded jeans. Red t-shirt, skin-tight. Black wool halibut shirt, the good Woolrich one, with the sleeves cut off halfway up my forearms. I was flyin' the Devil's Advocate's colors, red and

black. I was the same color as my boat. Razor-sharp freshly oiled Gerber knife in a woven leather sheath, hanging from a woven leather belt. *Just in case there was trouble.*

I walked in, real cool-like, and surveyed the room. Suits everywhere. Some secretary-types were hanging out with the immaculately dressed men. *I wonder if well-dressed women are better in bed? I'll probably never find out.*

I smirked at the closest table full of pansy-ass state workers and waited for the hostess to seat me. She looked me up and down and suppressed a scowl. Not many of the fleet boys came in here to eat.

"Table for one?"

I nodded. Slow, John Wayne-like. I followed her slowly across the room to a table next to the kitchen door. I ignored the slight and sat down.

She gave me a menu. "Your waitress will be here in a moment, sir."

She smiled, kind of stiff. *I'll give you stiff, you working-class babe.* I watched her ass in the starched blue uniform as she moved away. *Wonder if she's gettin' any.* I was unbelievably horny after nineteen days without even seeing a woman.

My waitress was a cute little brunette named Michelle. I flashed my perfect teeth at her, a five-hundred-watt smile.

"Drink, sir?"

"Cuervo Tequila, double shot, lime, salt." *Bad-ass mother-fucker.*

She was back in a flash with the first of my four basic food groups. Tequila, Guacamole, T-bone steaks, Key Lime Pie.

I shot the glassful down after the salt ritual. My eyes were really watering by the time I got the lime between my teeth. Jesus. I glanced around to see if any of the secretaries were getting horny watching me. The whole restaurant steadfastly ignored me.

I read the menu through watering eyes. Steaks, T-bone. 16 oz.- $28.00, 28 oz.- $49.00, 34 oz.- $61.00. I had no choice, really; I had the fleet to defend.

Moon Toast

"I'll take the largest T-bone you have, Michelle. Blood-rare, warm in the middle. Make sure to tell the cook I want the one with the biggest tenderloin on it he's got. Baked potato. Double everything, especially the bacon. No vegetables, I'm allergic. Do you have any dinner rolls? I'm starving. One more of these, they're going down fast." I motioned to my empty glass.

She widened her eyes a little as she was writing and nodded. *Not used to a man's appetite, I see.* These office prissies probably eat lettuce for dinner with their martinis to keep from getting fat asses.

The table next to me got up and headed for the door— businessmen in navy suits. I watched the way they moved. *It'll take more than lettuce to get that butt in shape, pal. "Does this suit make me look fat?" "No, your lard-ass makes you look fat, you pansy asshole."* I chuckled at my own humor and felt the glow of the tequila doing its work.

I looked up at my adorable waitress. "May I buy you a drink in the bar tonight?"

She smiled. "Sure, Okay. That would be great! I have to close-out, but I'll be done about 1:45."

Jesus. That's three hours before I usually get up. "I'm Stu. You are positively yummy delicious."

She laughed and blushed deeper. "I have to go."

"Okay. See you later." I was smiling into my drink. *Alcohol makes me irresistible.*

I shot down old Number Two. Not so many tears, this time. *Two doubles make me invincible. Three make me invisible. How does that joke go? I was going to have to pace myself.*

I glanced at my watch as my new love delivered my dinner, 8:35. Lazy-susan of chives, butter, sour cream, and bacon bits in one hand, the dinner tray balanced in the other.

She set the platter in front of me. *Fred Flintstone, beware.* This piece of meat looked like fuckin' dinosaur road-kill. It hung over the plate on all sides. Blood was dripping on the tablecloth. *Sacrifice a virgin lately?*

Michelle looked at me, worried. "You gonna' really eat that thing?"

162

I winked at her. "I have fantastic, limitless, and insatiable physical appetites."

She blushed again and hurried away to her Legislators.

The potato was a pound at least, and the steak two. The steak won. I started with the tenderloin. I cut into the room temperature meat, two and a half inches thick, and took a bite. Another. Another. *Good meat, Michelle.* I ate slowly and deliberately. The third double wasn't looking nearly as good as the first two. It's funny how food can ruin a perfectly good drunk. I finished the steak and a quarter of the potato. I was sipping at the syrupy cactus juice when Michelle came by to clean the mess.

"Dessert?" She was daring me.

"Let me see the choices, Love."

I scanned the menu. I had the whirlies from so much food. *Key Lime Pie! I'll just have me a slab of that-there pie, little Missy.* I just pointed at the selection.

She looked at me like I was nuts. "Are you *sure*?"

"You bet. *Four Basic Food Groups.*"

She was convinced I was totally whacked now. She was shaking her head as she took my dishes away.

I ate the pie and drank three cups of coffee. *Fuller than a tick on a coon dog's dick. Yessir.* The honest truth was, on a sixteen-day trip, I would lose ten to twelve pounds, about nine percent of my entire body weight. Twenty-hour workdays, not much more than fish and rice to eat, combined with the sleep deprivation, it was brutal. On the short layovers, I would eat maybe six times a day. I was constantly starving. I would gain it all back again, in just three or four days, to go back out and do it all over.

I looked at my watch again, 9:25. Time to mosey on over to the nightclub. I could hear the band playing the *'Dinner Set.'* I *hated* that kind of music. *Musak-crap.* Lawrence Welk. Might as well be chamber music. A string quartet. *Give me the Blues, and some hard Rock and Roll, Baby!*

Bar Belles

I sucked in my bloated twenty-seven-and-a half-inch gut and walked through the door, surveying the crowd. In case anyone was looking, I adjusted my knife on my belt.
I'm a dangerous man, don't mess with me. Half French-Basque, half Sicilian, and all male. LeClercq, Stu LeClercq.

There weren't many people in the place yet. Juneau bars closed at three a.m., so the dedicated partiers wouldn't arrive for a couple of hours.

I bellied up to the bar. *Literally.*

"What'll it be, pal?"

"Cuervo Gold, lime, salt." *This is my seventh shot. I'm not an alcoholic. I'm a drunk. Alcoholics go to meetings.*

I spun around with the drink in my hand and studied the place. The Legislators from the restaurant were sitting at a table near the stage. The band was one of the sucker bands that get booked into Juneau nightclubs from Seattle booking agents. I can only imagine their thrill to be booked into a nightclub in this place. Not what they fantasize about in front of the mirror when they're practicing their guitar licks.

The name of the band was the *'Sweet-Cats.'* The curvaceous female lead singer was attired in a one-piece skintight leopard-spotted leotard and four-inch black, strappy high-heels. The drummer, not to be left out, was wearing a pair of Winnie-the-Pooh *'Tiggr'* ears from Disneyland. The bass player had a tiger tail hanging from the head of his ax. They were going into a rousing rendition of *"Kansas City,"* one of my least favorite songs. I watched the lead singer strut around the stage and bet myself she wasn't wearing anything under the catsuit.

I sipped my drink and surveyed the crowd. I was getting to be a pro at detached observation: *No commitment, no friends, a solitary man.*

The band took a break and came down off the stage to meander through the early night crowd. The lead singer worked her way up to the bar. Up close, she was older than I thought.

Late thirties, maybe even forty. I could see her soft breasts, compressed by the catsuit, and the dark circles of her nipples through the thin fabric. She nodded to the bartender, and he silently poured her a double shot of Crown Royal over rocks.

The singer took a long drink, then sighed. Turning her head, she looked over at me. I smiled at her, a hundred-watter—nothing special, just friendly-like.

"Howdy. *Love* the outfit."

"Hello there. Thanks." Her heavily made-up eyes traveled up and down me like I was a curio in a back-alley antique shop. She took in the knife and the cut-off sleeves of my shirt. She smiled and gave me a look like we were prisoners in the same cell. "You've *got* to be a local."

"Well, actually I'm a District of Columbia lobbyist from the National Rifle Association. Can't you tell?"

She smiled at me with white entertainer teeth and slowly licked her glossy red lips, making them slippery-wet. *Little wrinkle lines around her mouth.* "You want to try and *buy* my vote?"

She was very close now, smelling of Crown Royal and perfume and pot.

The tall, skinny lead guitarist came up to us and wedged himself between us. Shaggy mullet hairdo. He looked down at me with daggers in his eyes.

"Monica, are you ready to start the next set?"

She grimaced and rolled her eyes at me. "Stick around?"

"Sure. I'm here 'til closing. I'm Stu."

"Stu, huh? I think I like '*Stud*' better. I'll see you next break, Stud. I've got *plans* for you." She winked at me with her painted eyelids.

As she walked away, I won the bet with myself. *Nothing underneath the catsuit.*

Becky showed up during the next set, with a small group of friends. Three women and another guy. All dressed casually, jeans and sweaters. I wasn't sure what to expect. Dresses, maybe. They sat at a table next to my duly elected Legislators. I wanted to watch them for a while, see what was what. She

hadn't spotted me yet. They were talking and joking together. Body language showed the guy wasn't really with any of them, just out for a drink, maybe. They were all drinking some girly drink; he had an umbrella and a monkey swinging from his.

They settled down to quiet talking, and I watched the woman next to Becky, checking out the bar. Her eyes swept over me then came back again to check me out. She laughed at something the guy said, still looking at me, then said something to the other two girls. They both looked over. When Becki made eye contact with me, I waved at her, waggling my fingers. She motioned me over. They were talking among themselves quietly when I approached the table, holding my drink.

"Hello, Stu!"

"Howdy Becky. Howdy Becky's friends." That got a chuckle. *Cool as a cucumber.*

"This is Amber, Sarah, Susie, and Randy. This is Stu. White-Knight-in-Training."

That got a few raised eyebrows. I pulled out a chair, thought about sitting in it backward, decided against it.

"I owe you a drink, Big Fella." Becky was measuring me, as were her friends.

"Done. I'll have another tequila. Lime. Salt."

"Oh God, here we go again!" This from Randy. "The last time we started with tequila, I slept in Becky's bathtub. Miserable night. Had to work the next day, too."

I looked at him, then at Becky. "In the bathtub? How many were already in the bed?"

They all laughed again.

"Just Sarah and I." Becky was shaking her head. "Amber actually drove home that night across the Douglas Bridge."

Amber winced. "I didn't remember doing it either."

I looked at Sarah, then back to Becky. I didn't say a thing, but I was thinking a bunch. Becky's eyes were laughing at me.

Randy finally clarified it. "Sarah and I flipped for the bed, I lost. I was supposed to sleep on the couch, but I never cleared the bathroom. I was so drunk I couldn't walk. I still can hardly smell the stuff without my stomach doing flips."

"Well, there's only one way to find out, isn't there." Becky signaled for the waitress. "Five tequilas, please. Lots of limes."

I was going to like this woman. She was fun.

We talked for a while, drank some more, drank some more still. The band was finally warming up and playing stuff I could dance to. When Monica started the opening lines to "Proud Mary," I stood up and held my hand out to Becky.

"Dance?"

"You bet!"

We sauntered out with all the fat-ass Legislators. I was a pretty good dancer. Good body control, pretty good rhythm. The knife kept slapping me in the thigh. *Sacrifices you had to make.*

I had always heard that a woman made love the same way she danced. Becky danced with her eyes shut, following the music. She had some Modern Dance training it appeared and made some really cool moves. *I wonder if that's where she got those legs?* She seemed to be enjoying our company.

I did some James Brown steps, and some spins, just horsing around. She started to do the *'Frug'* or something, I followed suit, waving my arms around. Then the *'Funky Chicken.'* I glanced over at Monica. She was watching me make an idiot of myself. The song ended, and Monica said something to the drummer. They immediately went into *"Twist and Shout."* I guess Monica liked to have someone in the crowd that wasn't dead yet. Becky and I twisted our asses off, laughing and sweating up a storm. We were still laughing and dancing when we got back to the table.

Amber had been dancing with a suit; Randy and Sarah were just hanging out. We settled down and ordered some more drinks. I needed water. My mouth tasted like cotton balls. I was so dehydrated. I dipped my napkin in the water and rubbed my neck with it.

I looked over at Randy. He was looking at me really intensely. I smiled at him, and he smiled back. He winked at me. I kept smiling; this guy was a lot of fun, too. The next song started, a butchered-up version of *'Jumping Jack Flash.'*

I held my hand out to Becky.

"Not this time. I'm sittin' one out."

I turned to Sarah. "Dance?"

She jumped up and was halfway to the dance-floor before I caught her. She was cute, kind of plump, but a pretty face. She danced with a nervous sort of smirk on her face. The music abruptly went into a slow dance. *I hate dancing slow.* I led her off the floor, and she looked disappointed. I sat down and polished off my ice water, and all the other ones at the table that hadn't been touched. *Whew! I was dry.*

The party continued for several more hours, Monica was standing at the bar between sets. She kept looking over at me, clearly pissed off I wasn't still over there. Our table was talking about their work, mostly. A lot of stuff I had no interest in concerning people I didn't know. They all had Masters' Degrees from all over the country. A whole bunch of education sitting at that table getting drunker than shit.

Randy scooted over closer to me. "Stu, why are your sleeves cut off? Is that a style up here?"

"Actually, it's how you can tell a long-liner. You know, halibut and black cod fishermen? We have to wear the wool shirts for the rain, but if there's an accident, and a hook grabs you in the sleeve when you're setting gear, if the cuffs are still attached, the hook will grab the cuff, and pull you right overboard, straight to the bottom. We cut off the cuffs to let the hook just tear the shirt, instead."

His eyes widened. "Wow! It's actually that dangerous?"

"One foot in the grave, and one foot on a banana peel, we like to say."

He put his hand on my thigh and just looked at me. I guess he needed steadying. He looked pretty damn drunk. He was breathing tequila in my face.

I looked over at Becky. She was watching us with a little smirk on her face. I was feeling over-heated with this guy's nicety, and all the alcohol. The room seemed surface-of-the-sun hot all of a sudden. I extricated myself out from Randy's camaraderie and stood up.

"Where you goin' handsome?" He was swaying slightly, looking up at me. I enjoy bonding as much as the next guy, but this one was a little too much in my face.

"To the can."

I walked past Monica sitting at the bar, talking to a duly-appointed asshole. She glanced more daggers at me. This night was not shaping up well at all. I staggered into the men's room and checked my watch. 1:45. What was I supposed to be doing at 1:45? *I can't remember.* I held myself against the stall to pee. The room was spinning. I had lost track of drinks after eleven. The dinner was sitting like a bowling ball in my gut. I walked out of the restroom and ran into Randy coming in.

"I thought you'd got lost." His eyes were looking at me peculiarly.

"Nope, I'm comin'."

"I wish!"

"What the fuck are you talking about?"

He giggled and staggered into the men's room. I was shaking my head when I arrived back at the table. My head was a little clearer. The girls were all smiling at me.

"You OK?" Becky said.

"Yeah, sure."

"We thought Randy might be a little much for a country boy like you."

"Country boy?" *What the fuck was going on?* "What are you talking about?"

"Never mind, let's dance, my naive little knight."

Becky took me by the hand and led me towards the dance floor. Monica and company were trying to do some Creedence, and I could actually dance to it. When we got back to the table, Randy was back and was laughing hard with the other girls about something.

I sat down and drank some more water. Through hazy eyes, I looked around the bar, which was completely packed by now. Every table was filled, and some people were standing by the bar. It was getting hotter and hotter in there.

Something in me just snapped. I stood up. "See you all later, gang. I'm out."

"What are you talking about?" Randy said, "We're just getting started!"

"Come on, Stu, stick around."

"Yeah, Stu, we have to dance some more."

"Sorry guys, I turn into a grizzly bear after 2:00."

I shook hands with Becky, who looked at me with a puzzled look, then the girls, then Randy. He looked disappointed.

"I'll catch you all later, see ya'."

I thought I might be something special to her, and all I was, was another drinking buddy. I didn't want to be just her friend. I was lonely and aching for a woman's touch. I wanted her to want me. *She's not going to fall for some uneducated fisherman.*

I broke out into the night air, gulping it down and smelling the stink of cigarettes on my wool shirt. I was angry at myself for getting suckered into that bar, chasing after some woman I knew I wouldn't have a chance to have. I didn't understand why I was so angry, but I was seething.

I walked fast towards the docks, breathing deeply and feeling completely humiliated. *What the hell had happened in there? What did I expect?*

I arrived at the D.A. The boat was completely dark. I tripped over the gunnel getting on board and sprawled on the deck. I staggered into the cabin, turned on the light, and turned up the oil stove a few drops. I went below and stripped off my clothes and crawled into my bunk. I was drunk and tired and felt like absolute shit. I had never felt so lonely in my whole life. Cappuccino tried to put his head on the bunk, but I shoved him away.

I choked back a sob and fell into a black sleep. I dreamed I was late for class, and couldn't find my locker, then I couldn't remember my combination, then I ran into the classroom after the bell rang, in front of the teacher and all the students, and I didn't have any pants on. Everybody was laughing at me.

Becky's Journey

The next morning, I went back to work, sharpening hooks and tying the snap, gangion, and hook assemblies together. My mission was to tie three hundred a day. It took about six hours or so. I was somewhere into the two-hundreds when I spotted Becky walking up the dock towards me. I never thought I'd see her again. I felt like an idiot after last night. *Why did I drink so goddamn much?*

She walked over to the side of the boat and smiled. "Sorry, you couldn't stay last night, Stu. We truly enjoyed your company."

"Well, I guess I had a little too much to drink."

"It happens. Don't worry about it. Whatcha' doing after work today? I'd like to take you out to Douglas Island and show you the cabin, maybe meet a few friends. Can I fix you dinner?"

"Really? Dinner? That would be wonderful!"

"Sure! Why don't I come to get you about seven, it gives us plenty of daylight, and you can meet everybody out there.

"That would be perfect. It gives me time for a quick shower."

"See you at seven!"

She turned and walked away. I watched her walk up the dock, strong strides, shoulders back, not looking at the rest of the boats, just confident in her own self. I was impressed. *Self-sufficient Alaska girl. Maybe I misjudged her last night and shouldn't try so fucking hard to impress people and try to get laid. It's been months since I've been with a woman, though.*

I finished up at five and sat on the deck with my back against the hatch reading until six-fifteen. Cappers was quietly hanging out, chewing on a knuckle-bone. I had found a used copy of Jack Kerouac's 'On the Road' at the bookstore. What a wild time that was. I really liked Neil Cassady. He was crazy.

I went up to the Laundromat, showered, and was sitting back on the boat reading when Becky pulled up to the top of the gangway in her truck. It was an old white Chevy pickup from

the early fifties. *What a character this woman was!* I locked Cap in the cabin and walked up to the parking lot.

I hopped in, and she ground into gear, and we headed off across the Douglas Bridge to Douglas Island. We turned left and headed south a couple of miles, coming across a group of little cabins on the right, scattered through the woods, and spaced fifty or seventy yards apart.

Becky turned down a steep dirt driveway and pulled up in front of one. A doll-house-sized hut covered in wood shingles, with a cedar-planked porch across the front. I saw smoke coming out of the chimney. We approached it over a wooden boardwalk, elevated above the huckleberry and salal, past the outhouse, and went in.

The cabin had two rooms, separated by a short wall with a door-less opening. The main room was a kitchen and sitting area. The kitchen was dominated by an antique wood-burning stove with a big oven. The smokestack was coming out of that. I could hear the wood crackling, and the unmistakable smell of burning alder and cooking lasagna.

I peeked through the opening into the other room and saw a dresser and a waterbed, a bookshelf with hundreds of books on it, and a little stereo and turntable with a stack of records. The top record was *'Jimi Hendrix-Are You Experienced?'* The bed was elevated on a platform of two-by-twelves and cinderblocks.

I came back around the corner to find Becky peeking in the oven.

"Almost done. We've only got my friend Jannice coming tonight. I wanted you to meet her. She'll be here in a half-hour or so. She lives over there, in that cabin. She nodded to another gray cedar shack, barely visible through the Alder trees.

We sat on the porch facing the sun as she talked. The worn wood was smooth and weathered gray from years of wear. Her voice was heaven to listen to, husky and honest.

"My story? Well, where do I start? I was raised by my grandparents. My Mom and Dad split up when I was seven, and neither got custody because the courts said they were incompetent. He was a hard-drinking carpenter; she was just

172

too young and naive to know how to raise a kid. She had me when she was only 16.

Grams and Gramps lived on an old cotton farm north of Dallas near the Oklahoma border. The farm had been settled by Gramps' father before the turn of the century. Somewhere in the 1890s.

He was Dutch-Norwegian. He and his wife, do you know she was only 13? came over to the U.S. on a freighter and just headed west. They settled there for who-knows-what-reason. What a god-forsaken place it must have been then! There weren't any Indians left anymore, but what a terrible combination of climates!

There were winters that the weather would be in the mid-'60s, and the next day a *'Blue-Norther'* would come ripping down from the plains, and the temperature would drop 50 degrees in only a couple of hours.

Grams said there was nothing between their farm and the Arctic Circle except a few barbed-wire fences, and most of them had blown down!"

I thought that was hysterical and exploded laughing.

She looked at me with fierce defiance. "I'm serious! It was very hard on them, even while I lived with them, they still were trying to grow cotton. It's a brutal, hand to mouth existence."

"No, no! I understand the harshness! I was only laughing at the colloquialism, that's all! Really!"

She looked at me sharply, trying to see if I was telling the truth. She must have seen something because she relaxed a little. There was still this deep crease between her eyes that wouldn't go away. I reached up to touch it. She pulled back at first, then saw I was gentle and let me touch her softly there. I rubbed it gently, looking into her huge brown eyes. She looked back, not afraid one bit, just studying me.

I softly massaged between her eyes with the thumb of my right hand. Finally, her questioning eyes closed and let me continue. Every time after that, I got her to close her eyes; it was a victory.

"About nine years ago, we had a summer that was hotter than a camp skillet on a mesquite fire. The entire cotton crop was just burned alive in the field. I lived with my grandparents until I was eighteen and went to college at North Texas University in Denton, studying to be a schoolteacher."

Just like Sis! I always gravitate towards the noble ones.

"In college, I had my first true love affair with a professor of Philosophy. He was married, though."

I guess he philosophized himself right into her panties.

"I was as naive as they come, and he completely took advantage of me. But he was a father figure to me, and he was a skilled, passionate lover, too. He listened to me when I said something and made me feel like I was a real woman."

So go back to Texas, already. Why am I listening to you tell me what a great fuck this guy was?

"We still write back and forth. Gary just got his third doctorate! He finally got divorced. I might go down and see him someday. His wife just never understood how brilliant he was."

Brilliant and a good fuck. What are you doing talking to an uneducated fisherman for?

I was really getting mad and was jealous as hell, picturing this old bastard getting head from her, and philosophizing as they lay in bed together afterward. I forced myself to pay closer attention.

"I received my Master's Degree in Teaching, and just had to get out of North Texas. Gary wanted me to go immediately for my Doctorate; he was going to help me a lot with my thesis,"

I bet.

"But I needed a chance to clear my head. I left for a three-month trip to India. It was so beautiful but savage, you know? Dead bodies were floating in the Ganges River, right where the people were bathing!"

She had an affair with another older guy she met on a trek in northern India near Tibet. Single, handsome, another college grad.

"His family was from Anchorage. Richard was sent to India by his parents for a hiatus after graduation."

Hiatus my ass. Get a job, you deadbeat faggot.

So they did it under the stars looking at the Himalayan Mountains wrapped in yak blankets or some such thing. Why in God's name she told me this stuff, I had no idea. I think it was her way of 'bonding' with me, but it made me feel like shit.

"After my return to the States, I found Gramps in the hospital, and Grams had to sell the farm and move in with her sister in Tulsa.

"There was no place for me there, of course, and I had nowhere else to go. I thought of Richard in Anchorage. I had the little bit of money that Grams could give me for the sale of the farm; it was like an early inheritance. So, I flew to Anchorage.

"Richard, unfortunately, had a fiancé in Anchorage. He had been engaged to her the whole time we were in India together. Why would he do that?"

Because yak-boy wanted to get into your panties, Darlin'.

"I looked for work in Anchorage, but my heart wasn't in it, I didn't want to run into Richard again. I heard that Juneau had an opening in the Native Alaskan Studies Program, and flew here. I got the job right away because of my degree. Now I get to do what I love, and travel all over the state, seeing all the little villages.

So, education works for some people, I guess. I thought of Stanford, and 'what if.' *Fuck it.*

I looked at her talking, and her beautiful, strong face. Brown Scandinavian eyes. Nordic jawline. Full mouth, soft lips, perfect teeth. She wasn't model beautiful, or Playboy beautiful, but she had an earthy, honest beauty that I could look at for hours and hours. *I could be with a woman like this forever. Beautiful, strong, honest, smarter than shit. Independent. Why not?*

Red Gravy

Jannice showed up for dinner forty-five minutes later. We ate lasagna, drank Chianti, and talked, and laughed together. I was relaxed and happy. My body was getting rested; life was good.

Jann worked with Becky at the Research Center. She was a Marine Biologist, studying the possibility of global warming seas, and the effect on starfish. She was interested in my work, asking me about halibut and what they ate, and if I thought they were being over-fished.

I said I didn't think so, there were only 300 boats in the entire fleet, and the only threat might be the Japanese trawlers, dredging the bottom and killing all the juveniles, before they had a chance to breed. I hated the greed and hated the waste. The difference between asking forgiveness and praying to every fish we caught, compared to that kind of 'fishing' made me sick to my stomach. *I hated those damn Japs—mercenary motherfuckers. I wish every one of their boats would sink.*

It was nice to talk to intelligent human beings, Phil was no dummy, but he didn't say much, and I spent most of my free time just reading.

We talked about food and my mom's recipe for spaghetti sauce. Becky got hers in a bottle at the grocery store to make the lasagna. It was pretty marginal, but I was in 'lay-over-eating-mode' and would have gladly eaten Styrofoam plastic if it had sauce and parmesan cheese on it.

"OK, smarty-pants, tell me how you make yours! Actually, I would love to know how to make red gravy. My grandmother was a terrible cook."

"Red gravy?"

"Spaghetti sauce."

"OK, first, it definitely ain't 'gravy.' It's called pasta sauce, marinara, or in Sicily, *'Sugo,'* or *'Succo.'* My mom always called it *'Soo-goo.'* It must have been a family thing. OK, got a pen? Paper?

"Get a big pot, put a quarter cup of olive oil in it, and heat it up. Add ten cloves crushed, peeled garlic. Brown the garlic. Add six big cans of Hunt's tomato sauce, and three little cans of Hunt's tomato paste. Use Hunt's. My mom's family has been using it since, like the Depression, or something. OK, add three tablespoons of granulated sugar, a tablespoon of ground pepper, two tablespoons of dried parsley, two tablespoons of sweet basil, bring to a simmer. Take the empty tomato sauce can, and add four cans of water. That's it. Let it simmer for a few hours, stir to get the thick stuff off the sides of the pan, and off the bottom. Serve with pasta. Cover it with parmesan and a good grind of black pepper. We like Rigatoni or Penne pasta. No self-respecting Sicilian eats long spaghetti."

"But it's so simple!"

"Remember, this comes from a family of peasants. It's an *'Old Country'* recipe. Enjoy!"

The night went on, Jann went home to get some sleep, the wine was gone, Becky and I were alone. We sat on her couch, in front of her toasty-warm wood stove, and she took my hand in hers.

"Thank you for the wonderful evening, Stu. You are not at all like most of the men I know here. You're deeply sensitive."

"Thank you for the wonderful dinner."

She laughed. "I bet you were rolling your eyes when you saw bottled red gravy! Oops! *Soo-goo.*"

"Not at all. I appreciate home-cooked meals. I miss good cooking. I miss a well-stocked kitchen."

"Do you miss a warm bed, too?" She leaned over and kissed me hard. She put her tongue in my mouth and started making soft, urgent noises. In a moment, she reached down and brushed her fingertips over my hardening cock, which was straining to get out through my jeans. I reached into her shirt and held the weight of her soft, naked breast, running my thumb over her hard nipple.

Her brown eyes were gleaming with lust. "Let me close down the stove, Lover. Then *you're* coming to bed."

Ringo

I spent a lot of time at Becky's after that. Every non-working moment. We went on hikes together, along with Cappers, and to the little movie theater in Juneau, to eat popcorn and hold hands. A few times, we took the ferry to Petersburg, or Ketchikan, or Sitka, and explored those little S.E. Alaska towns, too.

Lots of time, we just sat in her cabin together and read, or just talked. Cap loved her wood-burning stove and slept right next to it. I was falling deeply in love with her, and I think she was getting used to having my dog and me around. She had lived alone for five years, with 'a few boyfriends', but no one special. I ended up moving right into her cabin. I took over all the cooking, and we became an *'Official Couple'* in the Juneau-Douglas Community, *"Beck-'n'-Stu."*

We stayed to ourselves mostly, but sometimes we had friends over. Usually, right before I left town on a trip, I ended up making dinner for anybody who was around at the time. It was becoming a tradition.

Tonight, our Main Guest would be Gary, her old friend from Sitka, who owned the *'Requiem'* fishing boat. They had been a *'couple'* a few years ago. He was around every few weeks, and he and I had become pretty good friends, in spite of the fact he was once lovers with my girl.

The attitude at that time was, everybody was friends, no matter what the past relationships were. People just kind of traded partners around every once in a while, it seemed. Break up in the Spring, and date other people, then hook-up in the Fall with someone else to stay warm during the Winter. I liked a more traditional approach to relationships and even fantasized about Becky and I getting married. I kept that to myself, though. Nobody had anything good to say about traditional marriage.

Gary was in town waiting for his boat to get fixed again, so Becky invited him and some people from her work at the Capitol Building. A couple of other researchers, and two Associated

Press reporters that were here covering the Governor's office. There would be seven of us.

I went out to the big wood-shed next to the driveway, unlocked the padlock, and opened the plywood door. Inside lived my pride and joy, sitting in front of six or eight cords of split and stacked drying alder wood.

I stood there for a minute, just looking and getting that indescribable feeling I always got when the weather was warm, and it was time to ride.

My love was a 1969 Triumph Daytona 500 motorcycle, in Lincoln Green. The most beautiful bike I had ever seen. *Except for that black and gold Norton 750 sitting next to it on the showroom floor, that was twice as much money.*

I was in Seattle two winters ago, with seven hundred dollars burning a hole in my pocket, checking all the used-motorcycle shops. I was looking for a Honda CL350, in blue or red, the high-piped kind, the scrambler model. I thought they were seriously cool-looking, but couldn't find any but the low-piped CB's, which I had already owned in a 175, and didn't like nearly as much. I searched all over the city until I walked into this little shop on Capitol Hill, *'Tom's Brit Bikes-New-Used and Repair.'* There was an enormous British flag hanging in the window.

As soon as I walked in, I was in heaven. *There's nothing like the smell of a motorcycle shop.* Oil and gas, and leather jackets, and something else that smelled of freedom and joy and the exhilaration of being out on the road. Side-by-side, crowded together in the tiny storefront, were dozens of the most beautiful motorcycles I had ever seen. Triumphs and B.S.A.s, Nortons, Matchless', and even one I had never heard of, a hulking, black thing with a weird looking motor. The sign on it said, *'1959 Vincent Black Lightning'*. It was almost five thousand dollars!

The sizeable British bikes had lines and curves and engines that put the Japanese bikes to shame. It felt like tradition and heritage, and thirty years of café racing and pubs and racing on the Isle of Man. All that mystique and glory was sitting right in front of me.

I was looking at this magnificent, towering bike in the most beautiful black with gold pinstripes, *'Norton'* in gold scrollwork on the huge teardrop-shaped gas tank. On the side cover, it said *'Commando 750'*.

A 750, my God, this thing must do a hundred and fifty miles an hour!

I looked around to see if anyone would mind me sitting on it. There was no one in the showroom area, but I could hear voices through the door to the workshop. I squeezed the front brake to keep it from rolling and swung my leg over. The bike immediately started to tip over, and I was nearly too short to stop its momentum. I caught it just in time, standing there on tippy-toes keeping it balanced. The problem was, I couldn't get my leg back over it to get off without losing my balance. I was stuck. *Crap!*

I was looking around for help when a guy came out of the back and saw me.

"Can I do something for you, son?"

I smiled, all embarrassed, and nodded my head. He came over and held the bike steady while I awkwardly got back off.

As he was putting the kickstand back into place, he said, "Looking for a bike?"

"Yeah."

"Maybe this is a little tall for you." He looked me up and down. "How about this one?"

He brought me over to a little single-cylinder dirt bike. *'Triumph Cub 250'*. It came up to my knees.

"Um, no thanks. I was looking for something with a little more power."

He frowned.

"Really. I've been riding since I was thirteen."

"How old are you?"

"Twenty."

He shrugged. "Oh, okay, let's look at this one. It just came in on trade."

He walked me over to a medium-sized bike wedged in between two of the bigger ones. As soon as I saw it, I fell in love.

The side cover said, *'Daytona 500'*. It was olive green, with rubber dust covers over the forks, perfect smooth lines, twin-cylinder engine. *500cc's!*

Little rubber knee guards on the fuel tank. *Petrol tank.* Whatever the British called it. The most beautiful exhaust pipes I had ever seen, swoopy and graceful, ending in the coolest mufflers that tapered into a kind of bee stinger at the rear. I was utterly and totally in love.

The salesman was talking. "This one's a '69, Lincoln Green, Amal Concentric carbs. Quick and light should fit you perfectly. Nice low seat-height. It has seven hundred thirty miles on it. I'll sell it to you for eight hundred ninety-nine dollars, plus five percent tax." He pulled a calculator out of his breast pocket and started tapping on the keys. "That's nine hundred forty-three dollars and ninety-five cents."

He looked at me, daring me to take his offer, sure I was going to walk out the door.

"I'm from Juneau," I explained. "I have seven hundred in cash right now. I can get the rest out of my bank account at the Bank of Alaska. Is there one around here?"

His eyes widened with surprise. "I'm sure we can look in the yellow pages and find one."

He went behind the desk and pulled out the big book. "Second and Yesler, that'd be right downtown. You gotta' car, or anything?"

"No, I'm taking the bus."

"OK, there's a stop across the street that goes downtown every few minutes."

I said I would see him in an hour or so and walked out the door. As soon as I hit the street, I got a queasy feeling in my stomach. *What have I done? I'm going to need that extra money to get through the winter!*

I strolled across the street to the bus stop, arguing with myself. I looked back at the British flag hanging in the window.

"Fuck it! I am buying that bike. Right now, today!"

I was grinning like an idiot when I got on the bus and made my way to the bank. I got an additional three hundred bucks out

of my account and hustled back to the bus stop to get back to my new bike. I was in the little motorcycle shop forty minutes after I had left.

We finished the transaction, I showed him my motorcycle endorsement to prove I was legal, and he threw in a full tank of gas and a thirty-dollar helmet. In less than an hour, I was pulling out of Tom's shop, grinning so wide I fogged up the faceguard.

That was two and a half years ago. I was still crazy about my bike, the only Triumph in Juneau. It smoked a little from needing some new piston rings, so I called it '*Ringo,*' after the Beatles drummer. *A spot of British humor, that.*

Dinner Party

I moseyed 'Ring' down to the harbor to see who had just arrived in town. This afternoon the thirty-six foot *'Julie B'* was in, her two hands washing her down after a trip probably down Chatham Straits.

I knew George the skipper personally, and his deckhand by sight. They sometimes drank at the Lucky Shamrock. I was hoping they could help me out with my shopping list.

"Howdy, boys!"

"Hey, L.D."

He must have forgotten my name. Who's Eldee? Oh well. "How'd you do, George?"

"Ah, Okay, I guess. 3400 pounds."

"Sweet! Say you don't happen to have any *'chickens'* on board, do you? I'm making dinner at Becky's tonight. I need four or five pounds."

Chickens were halibut under 10 pounds. It was completely illegal to have them in your possession. A huge fine and possible confiscation of the boat being the penalty. The problem was, they were usually brought up from the bottom dead, choked to death by the colossal halibut hooks we used.

Halibut fishermen, as a rule, were either Norwegians or frugal, or frugal Norwegians, and never wasted a thing. Typically, the undersized fish got filleted immediately. It disguised their size in case of a surprise inspection, and it would be a ridiculous waste to throw them overboard dead.

George and his deckhand exchanged looks, then George nodded to him. The deckhand disappeared into the hold.

"You didn't get these from us, right?"

"Get what from you?" I winked.

The 'hand came up with two gallon-sized baggies secured with twist-ties, each with at least three or four pounds of white fillets. He handed them over the side to me. I hefted it in appreciation.

"Thanks a bunch, guys, this should feed everybody with plenty to spare!"

"I couldn't believe how many of the goddamn things we caught this trip!" George said with disgust. "It was as though that's all there were out there. I tell you, we are gonna' fish ourselves right out of business if we're not careful!"

"You two don't want to join us, do you?" I asked. It would have been rude to offer them money.

They both laughed. "Sure, if you've got a couple of T-bones! We are sick of fish!"

"Yeah, no kidding. Well, see ya' at the Shamrock!"

"Say 'Hi' to The Old Man for me!" This from Gene.

"Good fishin', L.D.!" from the deckhand. *I never did get his name.*

I waved goodbye to them and walked up the dock to my Triumph. I had stuffed a garbage sack in my tank bag just in case and put the big baggies into it. I was hoping they wouldn't leak all over the place. I kicked the Triumph started and zipped over to the grocery store and the Douglas Bakery to finish my list.

Seven people filled Becky's two-room cabin to the limit. I had to kick everybody outside so I could finish cooking on the hot little alder wood-fired oven.

I baked the six pounds of halibut fillets in two cans of concentrated orange juice, the juice of four fresh lemons, and several shots of Cuervo Gold. Some even made it into the marinade. Twelve cloves of fresh garlic chopped real fine, a handful of dried parsley, ground black pepper until my hand cramped.

I made up the recipe a few years ago when I got a craving for Duck a L'Orange, and couldn't find a handy duck. I loved duck. It drove my dad crazy when we went out to fancy dinners.

"Theresa, he's 12 years old! He can't have Orange Duck!"

"Oh, come on dear, I think it's wonderful he's trying new things! Why he's such a big help in the kitchen these days with dinner! Let him have it this time!"

"It's seven dollars! He can eat a cheeseburger!"

Mom always won, of course. I was the youngest and really did help her a lot in the kitchen. I loved to cook. And eat.

The halibut baked carefully in the tiny oven, next to the fresh Douglas Bakery French bread I made into garlic bread, with a paste of olive oil, butter, minced fresh garlic, and Parmesan Cheese. Green salad, white wine (everybody had been instructed to bring a bottle), and Granny Smith apples sliced up and covered with vanilla ice cream and caramel sauce for dessert finished the feast.

"Buuuurrp!" Gary put his hands over his prodigious belly, looking proud as a new poppa.

I looked over at him. "Get enough to eat, Big Guy?"

The table groaned in unison. Becky's best friend Sarah shook her head in awe. "Becks, you gotta hang on to this guy, at least until next Spring anyways. We need a good cook around this winter!"

Becky smiled at her longtime friend. "Oh, I guess I can tolerate his youth and exuberance for a few more months!" Her eyes were sparkling.

Sarah knew Becky's preference for older men. Her last serious fling was almost thirty years older than me.

Gary leaned back in his chair and put his long arms behind his head.

"Stuie, my boy, you're gonna' make some lucky guy a great little wifey! Come over here and gimme a big kiss!" He started smooching at me across the table.

Becky's newswire friends chuckled a little nervously.

I was a little miffed at Sarah's comment, even though I knew it was mostly in jest. I was a bit sensitive about being the youngest at the table by nearly ten years, and I wanted to liven the place up a little bit anyway.

I jumped up and went over to Gary, and before he could react, kissed him full on the lips, squeezing him so he couldn't get away from me.

He fell straight backward, all six-four, 259 pounds of him, breaking the chair and crashing to the floor. The whole cabin shook.

"Why you son-of-a-bitch-faggot-loving....!" He jumped up and ran straight towards me.

He tackled me with his full weight and pushed me across the cabin and into the wall next to the screen door. I was laughing so hard I almost pissed in my pants. Gary was madder than a hornet, trying to poke me in the nose.

I grabbed him just above the knees with both arms and lifted him, turning his back to the door. I pushed him through it, across the porch and right through the rotten cedar deck rail. Over the side of the deck, we went and fell three feet into the huckleberry bushes. I landed on top of him, knocking the air completely out of him with a loud "*Gunnhh!*"

We lay there in the bushes, with the rest of the dinner party looking over the broken rail at us. Becky and Sarah were laughing. The other guests looked worried that we had hurt ourselves.

Gary was lying there, trying to catch his breath. I rolled off of him and climbed back on the porch, watching him warily, in case he was just faking it. He finally shook his head and slowly stood up. I reached over the deck to give him a hand.

Sarah's eyes opened wide. "I wouldn't do that if I were you!" she warned me.

"Nah, old Gar wouldn't really hurt his buddy, would you Gar?"

He looked up at me and slowly extended his hand. I grabbed it and pulled. He put one foot up on the deck and heaved himself towards me. When he stood up straight, he was chuckling. "I can't believe this little gnat-fart could lift me up!" He gave me a pat on the head. "C'mon Stuie, let's have some tequila!" He put his arm over my shoulder and led me inside.

The dinner party was shaking their heads and smiling. '*Crazy fishermen!*' one of them muttered.

During the farewell goodbyes, I watched Gary and Becky hug goodbye. She whispered something in his ear, which instantly gave me a flash of jealousy. It seemed Becky was getting a lot more demonstrative with her affections lately. They held their hug about four beats longer than I was comfortable with, then

parted with kisses on the lips. It was something we all did among friends, but for some reason, it still gave me a pang to see her kiss anyone else.

After everyone had left, Becky and I went inside to do the dishes and clean up. I washed, she dried.

I turned to her and asked, "What did you say to Gary tonight when he was leaving?"

Her eyebrow lifted. "Did that bother you?"

"No. Well, kinda'. You two make a pretty nasty pair."

"Nasty! What does that mean?"

"You know, he's a huge guy, you're slim and tall, you know what I mean."

"Stu, I no longer have any attraction to Gary!" She looked away quickly.

"Then what did you whisper in his ear just now?"

She looked at me, face filled with exasperation. "I told him that he was the best friend you would ever have, and I loved him for it!"

I felt like an asshole. "You did? Really?"

"Yes, really, goddammit."

The rest of the clean-up was done in silence. We got changed, and I climbed into the waterbed. It had been rough-framed out of used two-by-twelves and elevated three feet off the floor with concrete cinderblocks.

Becky turned her back and roughly put on her full-length cotton nightdress I had nicknamed 'not tonight,' then climbed up and curled into a ball way over on her side of the bed, the water sloshing.

I was sleeping nude as usual, always hoping she would find me irresistible. *Fat chance.* She was absolutely pissed, I could tell. She had that crease going between her eyes.

The single candle next to the bed illuminated her frustration. I rose up on one elbow and faced her, bobbing slightly. "I'm sorry, baby. I didn't mean to ruin the mood. I just say things without thinking sometimes."

She sat up in bed and faced me. "I wish you would have a little more self-esteem sometimes! You act like such a fucking

victim all the time! I'm tired of feeling like I'm the baby-sitter or the mom every fucking minute!" She choked back a sob. "You're such a child sometimes! Dammit! You drive me crazy! You've ruined a perfectly good evening!"

"Does this mean I can't tie you up and do the rubber ducky and monkey bars thingy tonight? We can put Don Ho on the stereo, and I've got a fresh bottle of coconut syrup..."

She looked at me like I was crazy, then burst out laughing.

I grabbed her roughly and swung her on top of me. We were nose to nose. I kissed her quickly. Her eyes, I tasted tears. Her nose, her cheeks, her mouth. She kissed me back, fiercely. Shifting position, she straddled me and pulled the nightgown off in one motion. Her soft, heavy breasts were rising and falling in the dim light.

"Looks like I have to rename your nightie."

"What?"

"Never mind." I entered her in one thrust.

She was unrelenting in her control. Insatiable in her passion, vocal, and insistent that I fulfill her every desire. We made love for hours, doing everything imaginable. I lost count after her eighth orgasm. Our glistening bodies covered the sheets in coconut oil.

After she passed out in exhaustion, I lay there uncovered, letting my sweat dry in the soft night breeze coming in through the open window. I was watching her slow breathing. She had rolled over with her back to me, and the covers had fallen away.

Turning towards her, I traced my fingertips over the lines of her ribs, the deep-set dimples at the base of her spine, and the dreamcatcher tattoo on her right shoulder-blade. Her tan, oiled skin glowed in the flickering light of the single candle.

I heard Phil's voice from yesterday. "We sail with the tide change tomorrow morning at 3:10. We'll be gone for sixteen to twenty days, or as long as the ice holds." *Almost three weeks without the taste of this body.*

I shook off black thoughts and fell into a restless sleep. I dreamed of running through a dark forest, of hiding under stinking, rotting logs, with unseen creatures trying to find me.

Bugs

We started the trip about three miles northwest of Cape Spencer, farther offshore than usual, but Phil said he thought it was the place that he thought had looked promising last season.

As soon as we set, the wind picked up. Our ammeter showed gusts over forty. We had to run for cover, a long straight next to Chicagof Island named Lisianski Inlet. At the head of the long inlet was the little fishing village of Pelican. In the old days, Phil was telling me, as we jockeyed around to set the hook, Lisianski was a secret spot for the monster 'Whale' halibut over 100 pounds. "Now, you just get the chickens and maybe one or two to 25 pounds or so."

I remembered dinner at Becky's and was thankful someone was still catching the little fish.

Lisianski was a narrow slash, cut deep into the north side of Chichagof Island that afforded a lee anchorage from the prevailing southeast storms and was only about an hour from our gear. The little fishing village of Pelican was farther up the straight, but we were staying on the hook tonight to get to our gear faster in the morning.

We had two sets in the water, two skates each, each skate was fifteen hundred feet long. I wasn't too worried that the winds would blow away our marking buoys, I had double tied the knots, and it wasn't enough weather to break the 5/16" nylon ground-line.

We sat and listened to the wind pick-up. It was a more significant storm than we anticipated. It wasn't going to blow over before dark, so we settled in.

I went down to the hold and redistributed the ice over our catch. Fresh ice on flatfish meant they stayed hydrated, less water loss meant heavier fish, heavier fish meant more dough-re-mi.

I left Phil listening to Crosby, Stills, and Nash on the little cassette deck and pouring over the charts looking for

tomorrow's sets, scowling at the fact that this year his golden fishing areas were turning out to be not so golden after all.

I came up out of the hold with lunchmeat and cheese for sandwiches. We kept one bin open for groceries. It gave us more room in the little icebox for everyday stuff.

Phil was on the CB radio. "Uh, Roger Milo. Yeah, Area 11B, yeah." A pause while he listened.

The voice came through clear and loud like he was just a few miles away. "Isn't that where we found the bugs, Scratch?"

"Crap. I forgot that from last year. Thanks, MM, over, out." He hung the mike back on the radio. "*Shit.*"

"What?"

"I forgot the place we set this morning is full of bugs. We had some trouble with that two years ago, why I didn't mark the chart is beyond me. We may have lost the entire catch if we can't pull tonight."

"*Bugs?*"

"Fleas. Sand fleas. They live in pockets on the bottom. Billions of them, they must be a foot thick in places."

"Jeez, are you kidding? That's disgusting."

"Wait 'til you see our fish tomorrow. Fuck."

"Who's 'Milo'? MM?"

"What?"

"Milo? Who's that?"

"Agnar Larsson. He and I fished together out of Petersburg."

"If his name's Agnar, why 'Milo'?"

"Milo Minderbinder. A character from Heller's book, '*Catch-22*'? That's the name of his boat. '*Catch-22*'. Damned if you do and damned if you don't. He's laying over in Pelican, getting some repairs done."

"Does he fish halibut, too?"

"Used to, a coupla' years ago, now he's a troller. That's all he's ever wanted to do. He thinks halibut fishermen are all dumb Norwegians."

"I thought you *were* Norwegian."

"We both are."

What? "Why is your handle '*Scratch*'?"

"Old Scratch. The Devil? Satan? Devil's Advocate? Get it? It's kind of code, so the other fishermen won't know we're talking."

Curiouser and curiouser.

It turned out the weather got worse, and we didn't get to head out to pull gear for two days. We pulled anchor at four a.m. Phil was in a crappy mood, he hadn't found any place better to set gear yet, and he was worried that we had lost two days catch to the 'Bugs.' I thought it was a bit of an exaggeration, I had seen sand fleas, and they gave a nasty bite if you were sitting on the sand in cut-offs, but they were hardly anything to worry about.

We got to the set. I boat-hooked the big pink buoy onto the deck and tied off the ground-line to the loose end coming off the drum for retrieval. The drum started turning, and we were hauling gear. This was my favorite part. You just never knew what you might pull up from all those hooks lying on the bottom. I always wanted to go out to one of the seamounts, maybe a hundred miles off-shore and drop down a big old hook with a baby sheep or something on it. *I wonder what I'd catch?*

The first thirty or so hooks were empty, not even a gray cod or anything. I saw a small flash of white down fifty feet or so. It was my indicator we had something, though not very big, maybe twenty or thirty pounds.

"*Fish on!*" I called over to Phil.

He was driving the D.A. as usual, with his head out the big starboard porthole to watch me at the rail in case I got into trouble.

The halibut got closer to the boat, and I slowed down the drum to avoid jerking the hook out of the fish's mouth. As soon as its nose broke the surface, I gaffed its head and pulled it over the side and stopped the drum. It was flopping pretty good in the bin, so I gave it a whack on the head with the club and killed it.

I looked closer at the fish. All around the fins, where they met the body, were a bajillion white spots like the brown pigmentation had worn off. Phil came out on deck. He saw the markings and shook his head.

"*Bugs. Shit.* Well, maybe we missed the main bunch of them. Let's pull this set as fast as we can, OK?"

I shrugged. "Sure, Phil, whatever you say."

The rest of the set was routine, four more smallish fish, fifteen to 30 pounds, all with varying degrees of flea bites, but none scarred so severely they couldn't be sold. We moved on to the next set, a thousand yards to the west.

Right away, we had trouble. The sixth hook had a thirty-pounder on it, it was still barely alive, and it was eaten deep all around the fin-line, showing pink flesh.

"We can't sell it that way," Phil said. "Too scarred for the cold storages to buy. *Shit*! Turn up the drum speed, Stu. Pull as fast as you can."

Four hooks later, a bigger fish, maybe forty or forty-five, came into sight. I noticed it wasn't moving at all as it came up, which was odd. The forties-to-sixties were the toughest fighters usually. Really difficult to gaff in the heads, and they absolutely went *crazy* when they hit the deck.

I reached over to gaff it, keeping the drum on high speed as requested, but mistimed my stroke. The needle-sharp gaff hit the fish in the side. To my amazement, the gaff ripped the whole side of the fish open. It was only a skin casing over a skeleton. There was no meat left at all. Thousands and thousands and thousands of half-inch long, fat white sandfleas poured out of the gash clouding the water like milk all around the side of the boat. I stopped the drum and looked on in horror.

Phil came out and looked at the spectacle. "*Shit.* Don't bring her on board, Stu. Shake her over the side, or we'll get the bastards all over the deck."

As I shook the hook, I noticed the eyes of the fish were gone, and the fish had been eaten from the inside out. The skin was completely intact without a sign of a single bite.

"Yeah, the fleas crawl up the asshole and start eating from the inside. I don't even know if the fish is dead before they attack." He looked disgusted at the waste of a good catch, and at our inability to get out two days ago.

I was ready to puke. "The asshole?" I reflexively tightened up my buttocks. "It might still be *alive* when it happens? They eat it *alive*?" I was never going to sit on the beach again. "Are you shitting me?"

"Just take a look, Amigo." The dead carcass was drifting down to the bottom, surrounded by a vast cloud of fleas. "We'd better finish this."

The next fish was simply a head. No eyes and a skeleton where a twenty-pounder had once been. As I shook it over the side, a few fleas fell out of the empty eye sockets. *I was never going to take a shit again.* My asshole was clenched so tight my thighs were cramping.

There were no more fish on the skate and no more goddamn bugs. As we motored away from the nightmare, Phil took a red felt pen, wrote a big "B" where we were on the chart and circled it. We headed back to Lisianski and the anchorage in silence.

That night I dreamed I fell overboard and sank to the bottom of the ocean, carpeted in ten feet of fleas. They completely covered me, getting in my eyes, in my ears, and crawling in my mouth. I could feel them squirming up my butt when I awakened. I jumped out of the bunk and stood there in the dark, shaking, and sweating.

Bugs, my ass.

Making Waves in Lituya Bay

The storm died down that night, and Phil made a decision. "We're going to try and fish a little farther Outside, Stu. You game for it?"

"Sure. How far 'Outside' is that gonna' be?"

"I want to try the Fairweathers. I used to troll for salmon out there, maybe ten years ago, and it was full of fish. It's right on the edge of a big canyon, the Fairweather fault line, and the Humboldt Current brings the baitfish up from the bottom there. We used to kill it fishing for Kings. I have a hunch there will be halibut out there too."

"How far out?"

"We'll still see land. Twelve to sixteen miles."

"Where do we anchor at night? That's four-hours running roundtrip every day."

"If the weather's good, we can just set the sea anchor and drift all night. If it looks too rough, we can make it for Lituya Bay."

"When do we leave?"

"Let's run into Pelican, sell what's onboard, get fresh ice, and head out. You ok without a layover for a while?"

"We're here to fish. Let's go do it."

And we did. A one-night layover in Pelican, fresh ice, and a few drinks at the local bar. I flirted like crazy with the adorable little bartender Lori, from Cleveland, Ohio, but it was all for fun. I was Becky's, and she was mine. The next morning, we began the five-hour run out to The Fairweathers. We got there in time to set three sets of gear. With the absolute assurances from Phil that there were no fleas in the Fairweathers and another moderate storm approaching, we made it for Lituya Bay and our snug little anchorage, letting the gear soak overnight.

We had to time the arrival into the bay to coincide with the slack tide, the narrow channel going into the bay was impassable during strong incoming tide surges. We waited for a

half-hour or so outside the opening until Phil gave the go-ahead to go in.

Lituya is a beautiful 'T'-shaped fjord cut into the Alaskan shoreline. Seven miles long and two miles wide, it was scoured out by glaciers to a depth of over seven hundred feet deep. Two of the glaciers are still feeding into it. It is completely sheltered from the storms that sweep the coastlines and is a traditional anchorage for all the fishing boats working the Fairweather Grounds. Tonight there was only one other boat in sight, the salmon troller 'Julie C.' By the time we set the hook and made dinner, it was ten p.m. We had time to play a couple of hands of Cribbage before bedtime, neither of us was too tired after such a short sixteen-hour day.

The next morning we headed out at four, and we were picking gear by six-thirty. We had terrific success, with every sixth or eighth hook holding a money fish. We caught some monstrous bright-orange Yellow-Eye rockfish and the most enormous Gray Cod I had ever seen at least twenty pounds. The Yellow-Eye got filleted for our dinner, and the gray cod chopped up for bait. Sixteen halibut over forty pounds, one over two-hundred, and we were back in the money. We rolled out three more sets for their overnight soak and powered in. The engine was smoking a little more than usual and sounded a bit rough by the time we anchored up, but Phil didn't seem too worried.

After dinner, we sat out on the back deck and had a shot of Cuervo to celebrate a good day. Phil pointed over at the opposite shoreline.

"You see that line over there on the cliffside? Where the vegetation looks different? See, the old green fir trees are way up high, and everything below that line looks brand new? Alder and huckleberry and brush, but no big trees? Look all the way over to where the glaciers come in. It's the same all the way to the head of the bay. See it?"

About a thousand feet above sea level was a clear difference in the vegetation, just as he described. All the trees were gone below that—nothing but bare rock, huckleberries, and scrub alder.

"I see it, but I don't get it. You couldn't clear-cut those cliffs with logging equipment. They're straight up. And everything is gone in some places, right down to bare rock. What am I looking at?" I had never seen anything like it before.

"Get this. Back in 1958, there were three fishing boats tied up in here, just like we are now. So, eighteen years ago. A massive earthquake hit the coast about twenty-five miles south of here, in the middle of the night. Like an 8.3, or something. The entire head of the bay, see that mountain way over there? See how oddly it's shaped? The entire side of the mountain peels off and collapses into the head of the bay. They think it was actually *two* landslides, one after the other. Over *thirty million cubic yards* of mountain crashes into the bay. It created the largest wave ever recorded in history. They can tell by the vegetation destruction that the wave was initially, get this, *one thousand seven hundred feet high.* A wave. Two-hundred-and-fifty feet taller than the Empire State Building. By the time it got out here, it was still three hundred feet high, can you imagine? It sank two of the boats instantly. One boat got insanely lucky, broke off its anchor chain, and rode the wave five miles out to sea. The crew lived to tell about it. Father and Son. Pretty amazing, huh?"

"Are you completely fucking with me, or what?"

"Look for yourself. That tree-line, way up there, was the crest of the wave. That's why it scoured everything down to bare rock. Pretty cool, huh?'

I did not sleep for the first two nights we were in that damned bay and dreamed of landslides and tidal waves for the next week.

Fairweather Friends

The Fairweather grounds were everything Phil had promised. We were really knockin' 'em dead, having a great trip with over 14,000 pounds on board, and we had a good chance of 'plugging' the DA. That's what you called it when you open up the hatch cover, and the hold is so full, the fish come right up to the very top. The problem was, the DA was just not acting right. Her twenty-year-old Caterpillar Diesel was not running correctly, and sixteen miles offshore, it became a real concern.

"What're we gonna' do Skip'?"

The Old Man looked at me, disgust was written all over his face. "I've done everything but tear the bastard completely apart, and I can't figure it out! It's not the injectors or the filters, but she won't make revs! I can only get four knots out of her. I was planning to stay out here three or four more days, 'til the ice was gone, but we don't dare fish out here when she's running like this. *Shit!*"

I could feel his anger go clear through me. "I guess I should have taken that diesel mechanic's class we talked about last winter instead of going to Seattle, huh?"

Phil was staring down at the engine. "What's that? Mechanics...no Stu! This isn't anybody's fault, goddammit! I should've upgraded this old bastard engine two years ago." He looked at me with concern. "This isn't about you, Stu. I'm just mad as shit we have to go in."

"Go in? Already?"

"Hell, yes! You think I wanna' break down out here? And call the Coasties to tow us in? I'd be a laughingstock! Let's cut our losses and pull the gear. Shit! The worst part is we have to run all the way back to Juneau and order parts. That will cost us two more weeks! *Shit!*"

We arrived back in Juneau thirty-two hours later just before JCS closed for the day. That meant we didn't have to wait until the next morning to unload. It also meant I could sleep in my own, well, Becky's bed that night, instead of the smelly fo'c'sle.

We unloaded at Juneau Cold Storage quickly and efficiently. I was working even harder than usual in the presence of my old workmates. There were lots of new faces, especially this really cute redhead pushing loaded carts. Normie, the Header, was running the crane today and pitching me a major ration of shit. I knew he was proud of me, though. He always treated me like his own adopted son. He continuously took the credit that I did so well. Even Big Mo came out of his office to peer over the dock, his ubiquitous cigarette in hand.

I was proud as a peacock, especially when everyone on the dock "oohed" and "aahed" at the colossal 218-pounder we had caught the first day out. Big Mo gave me a thumbs-up and went back inside.

We chugged over to the mechanic's dock. It was around the point three-quarters of a mile or so down the road from our usual berth at Harris. I washed the D.A. down with the little hose they had there, rinsing and scrubbing the entire boat.

Especially tedious was climbing into the hold and taking out every wooden bin-board that separated the hold into six separate bins. The board edges were rounded and smooth from almost seventy years of ice and fish. I loved the smell of our hold. It smelled like money. After I scrubbed them with soapy disinfectant and stacked the forty-two boards on deck to dry, I was finally done.

Phil must have seen how antsy I was getting. "Not often you get back this soon, huh Stu?"

"Well, if you need me to stay on board tonight, I can. I know we have to get the engine ready to pull first thing tomorrow morning."

"Yeah, that's a good idea. Why don't we stay aboard tonight, then we can start the work at six when old Charlie opens up."

He saw the dismay written all over my face. "Just kidding, you little horned toad. Give my love to Becky. I'll be on board tonight in case you need any help. See you at six." He winked at me.

I stuffed my duffel in twenty seconds flat and jumped onto the dock. I didn't even look back, just waved over my shoulder. I double-timed it down the road to Harris Harbor and the 'Masters office.

The little green Triumph was padlocked as usual to the Harbormasters chain-link fence, covered with a plastic tarp. He let me keep it there, as long as I kept it out of the way. The big Coca-Cola clock on the wall said 9:45.

I didn't wait long for the bike to warm up; the memory of our last love-making was firmly on my mind. I slung the duffle strap over my head and one shoulder and made record time down the deserted highway.

When I got to the turn-off, I shut off the motor, coasted down the steep driveway, and then tiptoed into the two-room cabin quietly, in case Becky was asleep.

She wasn't. And neither was the guy she was with. I heard the little moans she made right before she came, as I walked around the corner into the bedroom. I stood in the doorway, watching. The single candle lit up her back. She was on top, grinding her hips like she did to help her come. The waterbed was sloshing with their efforts. Her taut back muscles were glistening with sweat and coconut oil in the dim light. My heart was pounding with the intensity of the sight.

She quickened her pace, then started making that delicious growling sound she made when she climaxed. It was a good one; it lasted for a couple of minutes. I thought it was the most exciting and most terrible sound I had ever heard.

The guy beneath her was thrusting hard up against her, climaxing in unison and groaning as he came, *"Oh, Baby. Oh, Baby."* The voice was unmistakably Gary's.

I turned and bolted from the cabin. I heard the screen door slam behind me. I was on my bike and had it kick-started in moments, duffle bag slung over my shoulder, fish-tailing up the dirt and gravel driveway to the main highway. I got back to the mechanics dock, my ears ringing and eyes blurry with emotion, not remembering the ride at all.

I entered the dark, cold cabin, and felt my way down the narrow ladder to my bunk, locking the dog in the galley. I sat there in the darkness, crying, shoulders shaking. That voice started talking. *You hate your life; you hate your pathetic smelly job. Uneducated bastard, you'll never amount to anything. Do you think you're going to fish the rest of your life? Your bitch girlfriend, laughing at you. Your so-called best friend. Cock Sucker! They were probably shaking their heads and telling each other what a fucking sucker you are. You're a loser, just like Dad said. You have no family left, no friends, You are absolutely and completely alone. There is nothing for you here—less than nothing.*

I felt like I was an alien creature on a strange planet. *What was I supposed to be doing here? Who did I think I was?*

I turned on my bunk light. I found myself looking at the picture of my Sis, and I propped up on the little chest of drawers. I picked it up and looked at it closer. We were so happy then. *Had I ever been happy since she left for South America? Have I ever been happy?* I couldn't remember. *Why did she leave me too? I feel so alone.* A terrible thought entered my head. I pushed it away. It came back, louder. *What if my life was so hard because I wasn't supposed to be here?*

How could it be that I wasn't supposed to be here? Frank said the universe loves me and wants me to be happy. *Happy? This is supposed to be happy?* I didn't believe him when he said it, and I didn't believe him now. *What was it that guy said in the bar to me that night? You come into this world alone, and you leave it alone, and that's all there is.*

I reached into the top drawer of the wooden dresser and pulled out the weighty bundle I kept there, wrapped in an old grease-stained t-shirt. I smelled the ripe-banana smell of gun oil.

I unwrapped the heavy stainless-steel magnum and set it in my lap, then folded the t-shirt and put it next to me on the bunk. I flipped open the cartridge. All six chambers were full. Hollow-point .41 Magnum rounds. *Enough to stop a thousand-pound shark. Enough to send me where I needed to go.*

The gun lay passive in my hands, ready to be used for the only purpose it was created for. A perfect tool. I thought it might even have anticipated its role, a single shot that would change my destiny forever and for all eternity.

I raised the barrel and looked into it through blurred eyes. I could see the ends of the lead hollow points in the cylinder. I was crying again. I didn't want my life to go away, but it had to. *I wasn't supposed to be here.*

I had completely failed at everything I had ever tried. My dad was right. I was a failure. I would show him I wasn't a coward. I would do this. Right now. That will show him. That will teach them all a lesson.

I put the barrel into my mouth, placing my thumb on the trigger. I set Sis' picture on the nightstand and held the heavy weapon with two hands. The barrel was cold and hard and oily.

This is what Gary felt like between Becky's lips. His hard oiled cock in her mouth. I'll show both of you what I think of you. You'll be sorry now. I looked into Sis' eyes, laughing at me. *I'm so sorry, my Sweet Darling.* My thumb tightened on the trigger.

Rebirth

The barrel was hard and slippery with oil and tasted like shit. I looked at Sis' picture through my tears, at the two of us laughing. I took the barrel out of my mouth.

I thought of all the bad things in my life, the things I hated about myself, the things that I was ashamed and humiliated about. I was a little, skinny, uneducated coward. I had nothing to live for: no money, no friends, no family, no future. I had no hope that it would change, and no faith that I deserved anything else.

I pictured Gary ramming his cock into her and got sick to my stomach. I dropped the gun on the bed and stumbled to the head. I got the toilet seat up just in time to heave into it, vomit stinking of banana oil and gun grease. I threw up again, and it splattered onto my clothes.

I sat down on the floor of the tiny compartment and started sobbing, smelling of vomit and gun oil. I was there for what seemed like a long time, then got up on my knees. I cleaned myself up with toilet paper, got to my feet, and pulled myself back to my bunk. I took the gun in my hands and laid back. I set it on my chest and lay there thinking about how everything had turned to crap.

I must have fallen asleep. The next thing I remembered was Phil shaking me awake. He looked really worried. My table lamp was on. I looked around for the gun. He had it in his hand, holding it by the trigger guard.

"You wanna' tell me about it?" he said quietly.

"I found Becky and Gary..." I shook my head.

"And you thought it was over."

"Yeah. I did. I couldn't think of any reasons left to be alive, Phil. I just wanted it to be over."

"But something stopped you."

"Something stopped me. I don't know if it was the thought of leaving my Sis without saying goodbye, or...what."

"Let me tell you something, Stu." He sat down on the edge of my bunk, the lamp putting his face in shadow. I could make out the concern and intensity in his face. "I told you I was a *'Tunnel Rat'* in Vietnam, but I never told you this. Never told *anyone* this.

"We were exploring a big maze of tunnels on the Laos border that we thought Charlie was using to bring guns and supplies in. I was the point man, the Commanding Sergeant. Our orders were to clean out and map this system that was bigger than anything we had ever seen before.

"I had a knife in one hand, and my .45 in the other, crawling through this system that might have been ten miles long. We were in and out of it for days. Rat, and spider, centipede and snake-infested, but we couldn't use any lights, we were trying to find the source."

His voice was hypnotizing, and somehow calming to me. "I came around this corner down there and ran straight into an NVA grunt coming the other way. We fought for a while in the dark, he was vicious and quick, but I outweighed him, by quite a lot, and got on top of him. I pinned him to the ground, took my .45, and emptied it right into his face. The whole clip. All seven rounds. When I crawled out, I couldn't hear anymore. I still can't, to some degree. My ears were ringing, I was covered in brains, and blood, and pieces of his skull. None of my platoon would even look at me. Like I had a choice. Like it was my fault.

"I went back to my bunk and just sat there, covered in gore. After a while, I reloaded the .45 and put the bloody barrel against my head. But I didn't pull the trigger. Just like you didn't pull the trigger. Hell, we had guys blowing their brains out over there every day—better men than me. Smart, educated men. They couldn't handle the shit, the pure hell that we went through every day. But for some reason, I couldn't do it. I walked into the C.O.'s office, still covered in blood and brains, and handed him my piece. I told him I was done. They shipped me back to Saigon for the rest of my tour, then home with an Honorable Discharge.

203

"I think the same thing happened to you, Stu. You realized that none of it was your fault. Horrible things happen to good people sometimes, and it isn't their fault. Don't blame yourself, Stu. You're a really good man who just stepped into some shit in this lifetime."

I started sobbing and put my head on his shoulder. He just held me like that for a long time, waiting for me to finish.

"This will stay between us, Stu. Don't ever worry about that." He set the gun on the nightstand, then went back up the stairs to his cabin.

I sat there alone for a long time. I was completely numb. I couldn't even move. Maybe an hour later, I looked at the clock next to my bunk, it was almost 3:00. *We have to be ready for the mechanics this morning at six.* I put the gun away, wrapped in its t-shirt, turned out my light, and tried to fall asleep. Phil needed my help, and I had work to do.

You can do this. You are going to need some sleep if you're going to face another day.

Brokedown

I awoke with the diesel chugging away. I hadn't even heard it start. I had been dreaming again. Something black. Something awful. I remembered last night, then. *Something awful, alright.*

I went up on deck, and Phil was at the wheel steering, smoking and staring at the water ahead. I rubbed my eyes, "What's up?"

"We have to take the D.A. to Ketchikan. They've got to put a whole new engine in her, and they have a better yard down there. We'll be there this evening. We're probably done for the season, Stu. Parts and install will take a month or more."

"No! What are we going to do without any work? How are we going to make it through the winter?"

He shook his head, "I don't know. We might make a few trips later in the season. Maybe we can re-rig for black cod. Maybe you can get out on another boat down in Ketchikan, but there're not many long-liners down there."

"Do you need help with the new install?"

"Not right away. I won't get the parts for at least three weeks from Seattle. You're kinda' on your own 'til then. I'll watch the dog. I can loan you a couple hundred to keep you going, but you won't be able to stay down below, the engine room's going to be tore to shit. I can still feed you, of course."

Crap. Fifteen to twenty thousand a year, my ass. Then the cost of the new engine would come right off the top of my shares. Shit!

"Okay, Phil. I'll do whatever you need. Maybe I can deck on another boat for a trip or two."

At least we were out of Juneau, and away from that bitch Becky. I pictured her frantically searching the docks for me to apologize, and felt smug about that. Then I thought of her riding Gary's huge cock, and my stomach flipped over again. *I will never trust another woman for as long as I live. Never.*

I instantly saw my sister Maria's face in front of me, and how we used to talk for hours about how important the love and respect of women was. Hell, I *worshipped* women. I was instantly filled with an overwhelming pang of guilt. *I'm sorry for talking like that, Mar. I am just so angry. I am so goddamn angry.* I pictured Becky's face. *I loved her so much. I loved her so much.*

We limped into Ketchikan sometime after 8 p.m., tying up at a huge commercial dock with a giant *'Caterpillar Diesel'* sign hanging on the warehouse. We made the boat fast, mooring it in between, and getting dwarfed by a couple of massive packers.

Phil talked as he cooked us some burgers on the stove. "I'd head out first thing tomorrow to look for work, Stu. You should pack your duffle tonight, or early tomorrow. Besides, you never know, someone might have just lost their First and really need you. I need you back to the boat in three weeks, though. I'll watch the dog. He'll be fine."

I nodded. "Okay, Phil. Maybe I'll get lucky."

He reached into his wallet and pulled out two hundred-dollar bills and two twenties.

"This is all I've got on me, Stu. I'll get you some more in a few weeks. We'll advance it off the next trip, Okay?"

"Sure, Phil."

I went below into the hot engine room and sat on the bunk without turning on the light. The diesel was ticking with heat. I was exhausted. I fell over onto the pillow and shut my eyes against the tears. *My beautiful girl. I've lost my beautiful girl.*

Sleep was filled with watching Becky's oiled and glistening upper body in the candlelight. In my dream, I was watching her on top, riding her man, while I was standing naked on the docks, in front of everybody, jerking off. All the people were pointing at me and laughing.

The Seeker

I said goodbye to Phil and Cappers and spent most of the morning walking up and down the docks of Ketchikan, looking for work. I wanted to keep long-lining, but I was checking everything. The gill-netters, purse seiners, cargo boats, packers, everything. It was in the back of my mind I was going to have to walk into town and get a job in a grocery store or something.

I was carrying my duffle bag full of gear, and my Ithaca '*Deerslayer*' 12-gauge shotgun slung over my shoulder. I wanted to be prepared for whatever I might run into.

No sign of halibut boats anywhere. Up and down, down and up, asking maybe two hundred boats if they needed work. I even asked a big white fiberglass cabin cruiser if they needed a deckhand. The rich-looking owner looked at my shotgun, and said '*no thanks.*'

At the end of the next-to-last dock, I finally found a little long-liner, rigged for snap-on. *Tiny boat*. Maybe twenty-eight feet, with a beam of eight or nine. Dirty, flaking white paint on the hull and cabin that hadn't seen either cleaning or touch-up paint in ten years. Hand-painted purple smokestack and an Indian spirit-eye painted on the bow. Her name was scratched under the eye in black, palsied longhand, *'Seeker.'* Two men were sitting on the hatch-cover, drinking beer. One was soft and 70-pounds overweight, the other one stood up as I approached. He was tall and skinny as a gaff hook. *Mutt and Jeff.*

"Where's the Skipper?" I asked.

The one standing said, "That'd be me."

"I was wondering if you might need some help. My boat's in for repairs for a month or so. My name's Stu."

"We know who you are, Man." The chubby one said, matter-of-factly. He stood up, too. "We spotted you walking over there on the other dock. You're *Little Diesel*."

"I'm what? You know me?" *How could you possibly know me?*

"Sure, Man," the tall one said. "Everybody's heard of 'Little Diesel.' You're 'L.D.' You're The Old Man's First, on the Devil's Advocate. You work with 'The Legend,' man. The Numero-Uno boat in the fleet. We heard you get thirty percent of the catch, and can fish twenty-three hours a day. That's why they call you 'Little Diesel.' You know, heavy workload, never stops? Powerful for its size, but not very big? Is it true you get by on one hour of sleep a night?" He blathered on. "We heard the D.A. lost her engine out on the Fairweathers. Is that why you're here? Is it true The Old Man fired his last First for using a dull hook? I heard..." he looked around, "...he might have even threw him overboard, or worse. I can't pay you more than a coupla hundred bucks for the trip, but it sure beats standing on the dock, don' it? Plus, we get to say L.D. was our Second!" he looked happily at the other guy.

I couldn't tell if he was fucking with me or not. He talked like he was as high as a kite. *'Little Diesel'? That was a first. I kinda' liked it.* I looked around at the harbor. "How long you guys gonna be gone?"

"Six or eight days. We're going down Lower Clarence. It's just the two of us, plus you. If you want."

Oh crap. Better than nothing. "Count me in, boys."

The Skipper waved me on board with a flourish. "Is that a shotgun?" he asked, as though he had just noticed it there under my arm.

"Yeah. Ithaca Deerslayer Model 37. 12 gauge."

"Well, I guess that's ok. Put your stuff in the fo'c'sle. There's an extra bunk in the bow. You'll fit just fine."

By the time I came back up on deck from the filthy, stinking engine room, we were chugging out of the bay. A cloud of black smoke pouring out of the purple stack. The Skipper used a two-by-four wedged against the helm to keep the gearshift from jumping out of gear.

The Mate introduced himself as 'Starbird.' I noticed he was wearing a peach-colored long-sleeved dress shirt with a button-down collar, as though he was going to work as an accountant in an office building. The shirt had not been washed for perhaps

four months. *If ever.* It was stained black around the collar and cuffs and had another mottled-brown discoloration on the part attempting to cover the man's stomach. Holes everywhere. Large and small.

"Is that your last name, Starbird? I went to school with a John Starbird."

He scratched his swollen pink belly through a hole right above his navel. "No, Man. *Star Bird.* I'm a *'Seeker,'* you dig? The Skip's name is *'Rubber Duck.'* Get it? 'Cause he floats on the water?"

I looked back at the dock receding in the distance, wondering if I could make the swim with my full duffle and the shotgun. I don't think so. *I am rather fond of that Ithaca.*

We made anchorage at twilight, after chugging down Clarence Strait with the massive Prince of Wales Island to our right. A continent unto itself. The fourth-largest island in the United States, the 97th largest in the world, 135 miles long. It took us perhaps two weeks to get past it. It seemed like. We may have been making five knots. Downhill. It seemed to be watching our passage. Silent, looming, and omnipotent, judging us by our deeds and actions and probably wondering what kind of Gong Show comedy act this was supposed to be. All we needed was Chuck Barris jumping around the boat with his red pants on.

We made the turn into Cholmondeley Sound and found a little cove to set the hook. For dinner, Bird made us peanut butter and strawberry jam sandwiches with potato chips.

"L.D., get some beers for us from the hold, would 'ya?"

No problem. I would play along for a while. I was, after all, the lowest-ranked on the totem pole.

I pulled off the little plywood hatch cover, with its peeling white paint, the edges frayed and chipping. Chips of rotten plywood fell into the opening, and down three feet to the bottom of the hold. Warm air rose out of the hatchway, smelling of rotten fish and oily, stinking bilge water. There were probably two hundred pounds of ice in the little three-bin hold, perhaps two-weeks-old, melted into solid chunks. Most of the

ice was concentrated in the port-side bin, covering our only cargo, twenty-six cases of canned Columbia Beer, I counted. *I'm starting to get a stomach ache.*

I opened up one of the soggy cardboard cases and pulled out three cans. I brought the two theirs, then resignedly open the third for myself, there being absolutely nothing else on board to drink. I didn't dare drink the water out of the galley. I was still hungry after the sandwich but didn't dare to ask if there was any more food. We drank our beers in silence.

When I finished mine, my watch read ten o'clock. I thanked the boys for dinner and turned in for the night. Four a.m. comes up awful early. My bunk stunk of mildew and had a menacing greenish-black stain on the entire lower half. It was so damp I had to spread my Helly oilskins under my sleeping bag to keep it dry. *I've camped in worse conditions, but I miss my snug little bunk on the D.A.*

At 3:56 the next morning, my internal alarm went off, and I got out of bed. The other V-bunk was unoccupied, so Bird must have his bunk somewhere else. I strapped on my blue-dialed Seiko dive watch and went into the galley to try and find the equipment to make coffee. Nothing is more awkward than going through someone else's kitchen to look for supplies. I wanted to make sure no one else was up before me. *Making a good impression on the first day was important.*

While pouring my first cup, I listened to the snoring coming from the two bunks in the wheelhouse. I went out on deck to enjoy my java. *I'm getting used to sugar and Coffee-Mate.*

The sun cleared the trees in the little cove just after five. Bright blue sky, without a cloud in view, and the bay warmed instantly. The water turned a clear olive-green when the sunlight hit it. I could look over the side and make out the rocky bottom in perfect definition, forty feet down. There were little Star Flounders and schools of minnows darting around the big rocks. The chunks of basalt were blanketed in giant orange sun stars, thirty inches in diameter, with twenty or more legs. There were cream-colored sea anemones two feet long, with heads a

foot in diameter covered in a creamy lion's mane of tentacles, looking for breakfast.

I took off my wool jacket and sat there in my t-shirt, gazing overboard into the water, teeming with life. It was always a good sign for me to see that much activity, there were rumors we were stripping the ocean of its inhabitants, but there was no sign of that here.

At six, I tiptoed into the galley and made a second pot of coffee. At 6:22, I glanced at my watch as I was peeing over the side. Over on the shore, amongst the barnacles and thick carpet of seaweed, a family of sea otters was making their morning ablutions. I could see two adults, twenty pounds or more, and a pup the size and shape of a foot-long hot dog, except furry and slippery. They dipped their front paws into the water and washed their faces with both hands, the mother (presumably) going over to check on the little one. In my experience, Dads didn't care much if you were clean or not.

They dove in and out of the water around the big rocks, fur gleaming the most beautiful dark brown. It didn't surprise me that the Russian fur traders made millions off the backs of those gentle, beautiful little creatures. They finally swam away, heads in the water, looking for whatever they ate for breakfast. They never even noticed me watching.

At seven, I walked heavily through the cabin and went below to get my book out of my duffle-bag. I was sitting on deck, my back to the gunnels, reading it when the skipper came out at 9:17.

I looked at him, and he must've seen something in my face.

"Hey, man. This isn't about some get-rich scheme." His voice sounded a little defensive. "We like to relax and let the world catch up with us, 'ya know?"

I smiled at him and didn't say what I was thinking. "Sure, Duck. Beautiful morning, huh?"

After a hearty breakfast of peanut butter pancakes, and another pot of coffee, we pulled anchor. The little boat chugged its way to the Lower Clarence Grounds, and by eleven, we began setting gear. The herring smelled a little off and was

warm to the touch. It had been on deck all night. Apparently, the beer took precedence for the ice. The small baitfish were bleeding brownish-blood, their eyes clouded and rust-colored. It reminded me of Bird's eyes after dinner last night.

The hooks were rusty and dull. They hadn't been sharpened this season, nor probably last. *But we were letting the world catch up with us, no? I hope some halibut will catch up with us. I want to make something on this trip.*

Acid Test

We finished setting two short sets around noon, and Bird immediately fired up a fat joint, offering it to me. *No thanks, I didn't want to let the world catch up to me hooked to the ground-line at the bottom of Clarence Strait.* We had a leisurely lunch of peanut butter sandwiches and potato chips and beer, while Duck ran us back to the anchorage. The boys took a little nap, presumably not together, and let me know that we would pick the gear around four. *Or five. Or six.*

I figured what the fuck. *When in Rome, right?* I fished out my book and sat on the hatch cover. I looked around. I had my book, a cold can of beer; my Hellys were off, I was sitting in the warm Alaskan sunshine. *Life wasn't so bad, was it? I was still making more money than my buddies in Seattle, and sure having a more exciting experience.* I sat in the sun and let the world catch up with me.

The boys showed up at 5:30, we pulled anchor and ran out to pick up our first set. Things went routinely if a little oddly. Duck ran the rail and steered, because *'it wasn't safe for me to learn how everything worked.'* Bird cut bait. I stood by waiting to clean fish or to assist wherever I could. I felt as useless as tits on a sea cucumber.

The drum kept stopping on its own accord, the ground-line was frayed in two thousand places, and we didn't catch a single fish. A complete *'water-haul.'* Not even a dogfish, a cod, a flounder, nothing. I wasn't shocked at the results. The herring was so soft, even the seagulls looked at me sideways, squawking at me like they were accusing me of scavenger abuse when I tried to throw them one of the rotten fish.

The second set started the same, just empty hooks. Duck went inside, and Bird was running the rail, one hand on the tiny, auxiliary steering wheel attached to the cabin. In his peach, long-sleeved dress shirt. *With the button-down collar.*

I went inside and found Duck sitting at the table, with a chart unrolled in front of him. The chart was covered in weird symbols and colored images, looking like hieroglyphics.

Duck nodded solemnly. "Yeah, man. It's like when the Natives paint the eyes on the front of their dugout canoes to help guide them through the spirit world. It keeps the bad halibut demons away and brings us good karma in fishing. We haven't even broke down this season, except for last week, and those two other times. It really works, Man."

At that, I finally opened my mouth to say what I actually thought about this freak show, when Bird suddenly appeared and staggered into the wheelhouse. Eyes as big as saucers, glassy and unfocused.

"I...I...Oh, shit!" he moaned

"What? What happened? Bird, are you hurt?" I was worried and guilty I wasn't back there helping him pull the set. *Did he have a concussion?*

"Bird?" Duck seemed more confused than worried.

Bird just stood there in the doorway, weaving back and forth, shaking his head. His long greasy orange hair swaying back and forth.

"Man. Oh, man, oh, man, oh, man." He moaned. "This is so far out. I...I...I caught...I caught...a...a...a...magic halibut!" He was gasping at the enormity of the situation.

I cocked my head and looked at Duck, who was starting to look more concerned than confused.

"I saw this big fish man! This huge fish coming up. Maybe one hundred or two hundred pounds! I was so excited! I wanted to surprise you two and bring it in all by myself, 'ya know? So I gaffed it and pulled it on board, and it started flopping like crazy, and then, and then, and then it started changing colors! It changed from white to blue to green to pink to red to yellow to red to green, and then it turned *purple*! Just like our smokestack! Then it stopped moving. It got real still, 'ya know? It got real still and quiet, and it looked at me with those two eyes. Those two eyes right next to each other on the same side

of its head, real close together, and...and...and it talked to me!!!"

"*It talked to you.*" I said.

"Yes! Yes!! It said it said, 'Bird', it called me by my name! It said, 'Bird if you let me go, I will grant you any wish you desire. I am the most powerful magic halibut in the sea, and I will grant you any wish. But you have to throw me back in the water'. So I did! I did! I threw it back!" he was beaming with joy.

"Let me get this right." Duck was speaking slowly and deliberately, "You threw back, you threw away, the only halibut we've caught in *three weeks*?"

"What?" Bird was baffled. "What? Of course, I did, Man. It was fuckin' *Magic*. I got to figure out what to wish..." He scrunched his face, concentrating with all his might.

Duck went into the wheelhouse and came back out, holding an open plastic film canister.

"Goddamn, you stupid fuck," he said. "Where's the big hit of acid? Where's the Windowpane? There's only blotter in here!"

"The what?" Bird was searching hard for short-term memory. "What did you say? Windowpane?" His eyes rolled towards the cabin ceiling, trying to find the slightest glimmer of lucidness. "Oh, shit." He backed up, tripping over the door threshold, and sat down on the hatch-cover.

"That was a fucking four-way hit, man. Tell me you didn't drop the whole thing."

"Duck, hey Man, don't be mad. I just wanted a little something after my nap. It was a four-way? Really? A four-way?"

I stood there, my head switching from one to the other like I was in a tennis match from hell.

"You threw away...you threw away the only halibut we've caught in three weeks?" Duck was screaming. "Because it was *Magic*? Three weeks of work gone? You ate half our stash in one drop?" His eyes were bulging, and he was as purple as the magic fish.

Suddenly, and to my complete surprise, I started laughing so hard I thought I was going to puke. I was in hysterics. I doubled

over, looking through tears of laughter at the two of them. Duck, purple with rage, Bird sitting on the hatch, so dismayed at what he had done. I couldn't stop.

Then Duck looked at me and started laughing, and finally, the terrified Bird started smiling, then laughing, then crying and laughing so hard he got the hiccups. I started to catch my breath, then looked over at Bird with his peach dress shirt on, hiccupping, talking to a magic halibut. I thought of The Old Man, and what if someone said that to him in the middle of hauling a set, and I completely lost it again.

I was going to recommend Bird as my replacement when I retired from the D.A.

Water Haul

The next morning, I slept in until six, and it felt like a vacation. I awoke refreshed and totally relaxed. I made a pot of coffee and settled in on the hatch to read, and to listen to the talking of the seagulls waking up in the Alaskan sunrise. My otter family was doing their thing on the shore. I watched them play and eat, and wash-up, and it felt like heaven. I chuckled at yesterday's antics, shaking my head and thinking about the look on Bird's face when he came into the cabin. I started laughing out loud at that, and couldn't stop for a while.

About 8:30, Duck came out of the cabin with a mug of coffee and sat down next to me. He looked a little embarrassed.

"Man, I feel really bad about yesterday," he spoke gravely, looking hard right at me.

I smiled and waved my hand like it was just a fly buzzing around my head. "Nah. No problem."

"No, man, I feel like you're going to hold this against Bird, and look down on him, or something. Y'know, he's, uh, he's not in real good shape. He was in 'Nam, and some really bad stuff happened to him over there." He saw my look, and said quickly, "I mean some *really* bad shit, and he's...well, he's not really all there. He's not *crazy*, Man. Not really. He just needs my help, ya' know, and I'd appreciate it if you wouldn't tell anyone about this. You're kinda' *famous*, and your opinion means a lot to him. He's really worried that you're going to tell everyone that he's *crazy*."

I held my hands up. "Don't worry about a thing, Duck. Shit happens, and we've all made mistakes in our lives. Let's just forget the whole thing, ok?"

He looked completely relieved. "Thanks so much, L.D. I *really* appreciate it."

He went back inside the cabin. I smiled to myself and went back to reading.

At 10:15, Bird came out of the cabin and sat down next to me.

"Good Morning Bird! Beautiful day!"

He looked at me out of the corner of his eye. "Gene said you wouldn't say anything to anyone about yesterday, is that true?"

Gene? Oh, right. Duck had a real name. "No, Bird. Everything's cool with me. Don't worry about a thing. I swear I will never tell *anyone* about what happened. I promise. Cross my heart. Now forget it, and let's have breakfast."

We went inside to peanut butter pancakes and coffee. *At least I didn't have to drink beer for breakfast.*

After we cleaned up, Gene made an announcement, looking at me out of the corner of his eye. "We're not fishing today. We're almost out of freshwater, and we are going ashore to fill our tank." He looked at me apologetically. "We only hold nine gallons of fresh water, and we've been drinking twice as much coffee as usual." *Like it was my fault. That's why we had 26 cases of beer on board.*

We weighed anchor and headed north towards Prince of Wales Island.

"There's a creek that comes out just beyond the next point." Duck was explaining. "We'll pull up close. You and Bird can jump off and get water. The jerry jugs are sitting on the bow. You're going to have to hike a coupla' hundred yards upstream, the creek's got a lot of saltwater in it until it gets some elevation, and the tide's flooding hard."

There were two red five-gallon plastic jugs perched on the bow hatch cover. Duck cut the engines and let us drift into shore, as Bird and I put on our Helly pants and our rubber boots.

I thought for a second, then went down to my bunk. When I came back up on deck, I was feeding shells into the shotgun.

"No! No way, man!' Bird said frantically, eyes wide and looking around in a panic.

"Calm down, Bird." I explained, "What island is this?"

"I dunno. Uh, Prince of Wales?"

"And what exactly is Prince of Wales Island famous for in the whole wide world?"

They both looked blank.

"Grizzlies, boys. Brown Bears. P-o-W has the largest concentration of Grizzly Bears on the entire planet. Hunters come from all over the world to hunt the biggest Brownies that live. Right here." I pointed to the shore.

They looked terrified at each other, eyes wide.

I kept feeding shells into the gun. "These are double-aught buckshot. I've taken out the plug, so I have five rounds, plus one..." I jacked a round up, "...in the chamber. They will tear the face right off a Grizz at twenty yards, which might give us a chance to get the fuck out of there. Bird, you carry the cans, I'll take point."

I had never *seen* an actual Grizzly Bear up close before, but I heard they were afraid of humans, and would just run away from you. They didn't seem so bad-ass to me. *Party time, baby. Lock and fuckin' load.*

We jumped off the bow into a foot of swampy, salt-encrusted mud. If this was a stream, it had stopped running ten years before. I poked around through the dense underbrush with the barrel of the shotgun, until I found the way. A sluggish, brackish, brown trickle about a foot across, surrounded by skunk cabbage and swamp: I had heard bears were supposed to love skunk cabbage.

We mucked our way farther upstream. The land was perfectly flat, with no vegetation except for the skunk cabbage, and some small alder trees. The cabbage plants were massive, with three-foot-long leaves, glossy green with yellow veins, and enormous yellow flowers looking like jaundiced Easter Lilies on steroids. The creek, what there was of it, was swirling with salt and fresh water mixing from the incoming tide. We slogged on, mud to the top of our boots, my eyes moving like a point-man in hostile territory. I kept checking the streambed. The water was still cloudy, chunks of seaweed visible floating upstream. *Was that a clamshell? What a fucking circus.* I shook my head and kept walking.

In ten minutes, we were starting to climb a little. There was gravel in the streambed now, and it looked like we might find some pure water, after all. The underbrush started to thicken.

Devil's Club, the stems and branches crowded with razor-sharp thorns, some Evergreen Huckleberry, with no visible fruit on it, just little waxy green leaves, and scrub Alder so thick, you couldn't see six feet. The stream seemed to be clearing up. Still some swirling, that heat-wave look when fresh and saltwater combine, but not as much. The underbrush was so thick and crowded so densely up against the stream; I couldn't even poke the barrel of the shotgun into it. I couldn't see a foot deep into it on either side of the stream.

I suddenly got a smell of Skunk Cabbage so strong it made my eyes water. It felt like someone had thrown a wet blanket of Skunk Cabbage over my head. *But the cabbage was way back there, maybe a hundred yards behind us?*

The underbrush opened up, revealing a swampy, muddy clearing ahead. I studied the water, trying to find a hole deep enough to drop the jerry jugs into to fill them. I stumbled in my concentration, and my eyes were diverted to the mud on the side of the stream.

In the hard, slimy surface of the reddish-brown clay-mud, a couple of feet from the stream, and sunk a foot deep, there was a single, perfect, oblong footprint. It was fourteen or sixteen inches long, with five, six-inch long claw marks cutting slits into the mud in the front of it. Water was slowly trickling into it, filling it up. It looked as if it had been emprinted perhaps fifteen seconds before.

I felt my bowels loosen. Bird was intently looking around us, not noticing I had stopped. He ran into me before he saw my frantic signaling to stop.

"What's up, Man?" he said loudly.

My eyes were frozen on the footprint. His eyes followed mine, and I could see realization start to creep into his consciousness. A slow, muddy electrical current, fighting upstream against every drug this man had ever taken. Then realization dawned. Uncompromising terror. I thought he was a goner. He absolutely freaked. He started looking around like a madman, making these little mewing noises from in his throat somewhere.

I grabbed his arm, and he jerked it away, terrified. Eyes bulging, head whipping from side to side, long hair flying.

I whispered fiercely, *"Knock it off! Shut the fuck up! Now listen to me! Listen! Fill the jugs quickly, right here! I'll stand guard. The bear's moving away from us. It probably heard us talking."*

Bird nodded his head jerkily and splashed the plastic jugs loudly into the stream. I grimaced and held tight to the shotgun, sweeping it from side to side. I might have well been carrying a fucking grape Pixie-Stick in my hands, for all the good it would do if that mother-fucker decided to charge. *Double-aught buck my ass. What the fuck was I thinking?*

Unbidden, I flashed to a bar-story I had heard last winter. An old Sourdough Alaskan trapper was talking to a Cheechako greenhorn he finds in the high country. The greenhorn is wearing a brand-new chrome-plated Colt Single Action Army .44 Magnum, in a tooled leather holster.

"What's the pop gun fer?" The Old-Timer asks.

"Grizzlies." The young man says, proudly.

"How many rounds you got in that thing?"

"Six!"

"You only need one, you know."

"I know, but I'm not that good of a shot."

"No, that's not the reason. It's because if Griz comes at you, and all you a-got is that pistol, you'd-a-better just put that shiny new barrel right into your mouth and-a pull the trigger. Fer sure it'll make things a whole lot quicker, and a lot less painful on yourself. Not to mention easier on the bear."

Very fucking funny.

I gripped the shotgun, my eyes searching ahead to where the track was pointing, praying the behemoth hadn't turned around.

Bird wasn't even watching the containers fill. He was looking around, his body twitching like it was being stung by wasps. I reached down and shoved the openings underwater. The stream was still swirling salt, but I didn't give one single rat's ass about that right now.

After what seemed like two hours, but was probably five or six minutes, we were turned downstream with the jugs filled and headed for the boat. I would have sworn Bird was throwing a rooster-tail behind him as he ran down the stream. He reminded me of the hydroplanes racing on Lake Washington during Seafair. *Miss Star-Bird U-13.* The forty-pound jerry jugs banging against his fat body and flying around at the ends of his arms looked like they weighed no more full than they did empty.

I took drag, walking backward carefully, but with haste, picking my way blindly in the streambed by feel. *How much did those bears weigh? Over twelve hundred pounds?*

We scrambled on board, and Bird was screaming at Duck. *"Go! Goddamnit! Go! Get us out of here! Right now!"*

Duck slammed the boat into reverse and hit the gas, throwing a huge wake into the underbrush, at which point the gearshift immediately jumped out of gear. He slammed it into reverse again, and held it there, shoving the throttle to its stops. He must have thought a bear was right on top of us. It was funny as hell, but I stood on the bow with the Ithaca pointed at the brush, waiting for that gargantuan head that must be coming for us.

We chugged out into the middle of the channel, and Duck cut the engine. I took the jerry jugs and filled the water tank through the filler hole next to the bow hatch-cover. We drifted for a while, just glad to be alive. Bird was sitting at the galley table, still shaking. His hands clasped on top of his bowed head. I reached into the pantry and got the bottle of Cuervo and handed it to him. He took a long drink, then another. He started to calm down. Duck was studying him carefully.

"Hey, Duck," I said. "Ever hear the story of the two fly-fishermen up on the Kenai, going after steelhead?"

He shook his head, still watching Bird.

"They're in chest-waders, fly fishing this remote stream in the Interior, and all of a sudden this huge Grizzly comes running downstream, right at the two of them, just like a freight train.

It's throwin' water left and right, spray flyin' everywhere, comin' after the both of 'em."

Bird lifted his head to hear the story.

"They both throw their one-hundred-dollar custom bamboo fly poles aside and start runnin' for the trees, their lives dependent on getting there. Suddenly one of 'em stops right there in the middle of the stream and starts taking off his waders. 'What are you doing?' his buddy screams, 'You can't outrun a Grizzly Bear!' The other guy says, 'I don't have to outrun the *bear*. I just have to outrun *you*.' "

Duck thought for a second, then burst out laughing. Bird sat there for a minute, brow furrowed, then his eyes got real wide. "You mean...no! You mean he...to let the other guy get caught...that's awful!!"

Duck and I grinned at each other.

What wasn't funny, for the rest of the trip, our coffee tasted like salt water.

Blessings

We chugged back to Ketchikan six days later, no peanut butter left, holds brimming with over five hundred pounds of fish, equivalent to one good set on the DA. I had nothing to ice them with except the beer-ice, so I shoved the ice and beer together into the cavities of the fish. *Two 'Birds' with one stone, so to speak.* We just had to wash the blood off the beer cans in a bucket of salt-water before we opened them.

Gene was ecstatic, "We got at least five hundred pounds of fish in there! We've never sold more than three hundred in a single trip! The cold storage guys are gonna be amazed! You are one lucky charm, L.D.! You are one lucky son-of-a-bitch to have around! I can't wait for the next trip!"

It helped that I found a rusty file in the toolbox, and one morning sharpened every goddamn hook. I was able to catch some Tom Cod off the boat afterward with an old busted fishing pole I found in the gear locker. I cut the cod into tiny little pieces for fresh bait, throwing away the box of rotten herring. We had a mish-mash of Numbers Five, Six, and Seven hooks, so it was a miracle we caught any halibut at all. The biggest was about sixty pounds. If we had the one Bird threw overboard...

We sold at the local cold storage. I hoped nobody recognized me. That boat was fucking embarrassing. Gene came down the ladder and jumped aboard with a flourish.

"Here's your share, L.D." He handed me a twenty-dollar bill and three ones.

"Um, Gene, didn't we gross about six hundred bucks?"

He looked flustered. "Well, you *are* the second, L.D. Bird gets ten percent after expenses, and you get eight. Besides, I'm fixing the gearshift out of this money, we drank almost twenty cases of beer, and the engine sounds kinda rough...'

"Fine. Fine. Forget it. It was a pleasure doing business with you two. I'll see you on the go-round."

"You're not staying? We're going out in a week or two..."

"Thanks, anyway, Guys." I held my hands up in submission. "Take care, be safe, good fishin'."

I stuffed my duffle, grabbed the shotgun, and climbed the ladder up to the cold storage. Looking down on the pathetic scene, I just waved and walked out of sight. I heard one of them say, "...*overrated*" as I walked away. I just shook my head.

I finally found the D.A. Phil had had it moved to one of the guest docks, towed over, probably. No one was on board her, Phil was undoubtedly having a beer in town. I unlocked the cabin padlock and was mugged by my beautiful mutt.

"Cappers! I missed you, big boy! How have you been!" he covered me in slobbers and tried to jump up on me. We wrestled for a while, then I filled his bowl, and stowed my gear on my bunk. The new engine block was in place, but the engine room, and my luxurious stateroom, were torn to shit. No place to sleep here, except on deck. Or in the hold. Maybe in the galley, with Cap.

Rummaging through the icebox, I found enough for a ham and cheese sandwich, and an ice-cold cream soda. I grabbed a bag of Fritos and sat on the back deck of the D.A., dinner spread out on the hatch-cover. Cap at my feet. I ate my dinner in peace, eating, and counting my blessings.

Twenty-three bucks. For eight days of work. I reached down and petted my best friend. *Oh well. I was home. I'd rather be NOT working on this boat, than working on that one.*

Yakataga

It took another nine days to get the engine sorted out, make the run to Pelican, and get ready to go back out fishing. Phil was determined to make up for the lost time. I could see the stress he was carrying in his face. That evening at dinner, he broke the news.

"Stu, we have one chance to salvage the last two months of the season. It's going to be a real gamble with the weather. Usually, the boats don't go out that far this time of year, but I think we can make it work. We can't catch enough out on the Fairweathers, there're too many other boats there, this time of year. You'll have to tell me if you are willing to risk it." He reached down and scratched Cappy's head.

I sat up straighter. *Here it comes.* "Risk what?"

"When I was fishing out of Petersburg, on the big sixty and seventy-foot Norwegian high-liners, we would occasionally run out to Yakataga Reef to try our luck. It is the most prolific fishing area in the entire Gulf, but every time you go out there, it's a dice-roll on the weather. You can't anchor up at night. You just have to set a sea anchor and drift. We really don't have the right electronics on the D.A. We should have a good LORAN set to pinpoint exactly our position, but we don't. I was going to buy one until the engine blew up. But if we tie our flag poles with the reflectors on them to our buoys, we will be able to find them with just radar. The boats going out there are all big enough to weather a substantial storm, I have never even heard of a boat our size attempting it."

"Umm, how far out exactly are we talking?"

"Yakataga Reef is one hundred and ten miles off-shore. About a fifteen-hour run from Cape Spencer."

"Are you serious? You think that's the only choice?"

"If we can get there and set gear, we will plug the boat every trip. It's a pristine seamount, completely unfished, only discovered by accident maybe fifteen years ago. The problem is, nobody has the guts to go out there after them. The Japs can't

even get there with their otter trawlers, because it's in protected waters, or they'd have stripped it clean by now."

"How dangerous are we talking, really?"

"It should be fine. We are starting the storm season in a few weeks, but there haven't been any major events for five or six years. We have a brand-new engine. I wouldn't have even considered it with the old one. I think we can do it."

"And we would be completely alone out there?"

He nodded.

"Do you think the D.A. could handle it?"

"I do. We'll load an additional three thousand pounds of ice for ballast, but the extra horsepower in the new engine will still let us run at maybe nine knots. It will allow us to stay out there for sixteen days or so. We would have enough time left in the season for three trips, out and back.

"Stu, we would be fishing the richest grounds on the entire West Coast. What do you think? I won't make the decision to go out there without your input."

I looked at the determination in his face. "Why not?" I pointed to our sign over the door. "Whatever It Takes, right?"

He clapped me on the back. "Then, let's load up and get out there."

Run for the Reef

We motored over to the Pelican Cold Storage to load ice and herring, then to the fuel dock for diesel. The third stop was the guest dock downtown, where we left the D.A. with Cappy aboard and walked to the supermarket. We had to take a cab back to the boat. Two hundred dollars and sixteen bags of groceries later, we were on board.

Phil started the brand-new Detroit Diesel engine, and we were off. Departure time, according to the ship's clock, was 1810. I filled the icebox with the cream and milk, put the dry food in the storage lockers, the 50-pound bags of dog food, and rice under my seat at the galley table—fresh meat, eggs, and bacon in sealed plastic bags down in the hold on the ice. Once we got fishing, we would subsist on fresh fish and rice, almost exclusively.

"I'll take first watch, Stu. We'll get out of Lisianski and start running for the reef. You get some sleep. I will get you up about midnight for your watch. You go until four, then I will take the next shift. We should be there about nine tomorrow morning."

I didn't think I could sleep so early, but the lull of the diesel put me right out. Phil woke me at one, and it was my turn at the wheel.

The 'Midnight Sun' isn't a midnight sun at that latitude. It does set, but it just kind of lowers itself below the horizon for four or five hours, then skips back into view. The light at one in the morning was like twilight down in Seattle. You still had ten-mile visibility, but it was dim. The stars were halfway visible, and the moon was faded gray.

Phil was snoring in his bunk. I had the automatic pilot on, the 'Iron Mike', and was eating a peanut butter and butter sandwich, and eating potato chips. I was half-paying attention, looking for logs in our course, or any other issues. The engine sounded strong and steady. We were full of ice, and bait and food, our hooks and our gaffs were sharp, we were ready for the unknown.

About a mile ahead, I saw something out on the surface of the water. The Gulf at that time of the morning was as flat as a pane of glass. Not a single ripple, in what was reputed to be the potentially roughest body of water in the world.

As we got nearer, I was able to identify it. It was a shark fin. The shark was cruising up on the surface, swimming slowly, in a circle. Then I saw another one, then another, then perhaps twenty more. They were all going in slow-motion, some swimming in circles, some in straight lines. It occurred to me the sharks were asleep. I had heard they have to keep swimming to enable the flow of water over their gills, or they would suffocate. Reverse drowning is how I understood it.

One of the sharks was on a collision course with the boat, about a hundred yards ahead of us. I checked in on Phil. He was still sawing logs. I went out onto the back deck, then edged around the cabin, walking on the seven-inch-wide side-deck, holding onto the built-in handrail on top of the cabin. I went out on the bow and watched the shark approach. We were on a direct collision course. It just kept coming right for us. It was coal-black in the green gulf waters, tail moving slowly. I watched it get right upon us, it almost touched us, then without any discernable movement, it was gone. It must have woken up and dived, but I didn't see it even twitch. I stood on the bow watching, but no more were within range.

I looked around. There I was, on the bow of the boat, sharks all around us, the auto-pilot on, steaming along at nine knots in the middle of the Gulf of Alaska. Realization dawned. *Oh, My Dear Jesus. If I fell overboard right now, I would be alone in the forty-degree water, without a lifejacket or survival suit, surrounded by Salmon Sharks, watching the boat disappear. Phil sound asleep, and not going to wake up for two or three hours. Oh my Dear God, what have I done?*

I edged over to the cabin and grabbed the handrail like I was going to tear it off the boat. Slowly, I side-stepped along the narrow cat-walk the length of the cabin, and gingerly stepped down onto the after-deck. My hands were cramping from the

229

death-grip I had on the cabin rail. Cappers was sitting there, with his head cocked, looking at me.

You dumb fuck, that was the stupidest move you have ever made. I went back to the wheel and sat down. That's when I started to shake, and I didn't stop for ten minutes. The only good thing about it was, I was so jumpy after that, there was no risk of me falling asleep at the wheel and making a fool out of myself when Phil came out for his watch.

Hard Day's Night

We got out to Yakataga Reef the next morning and went to work. Two weeks of long days and short nights. We were filling up fast. It actually looked like we were going to plug the old girl. In my bunk at night, I fantasized about how I was going to spend all my money. *Maybe I would go back to Seattle and buy that Norton motorcycle!*

Now we're in the middle of this goddamn storm. I can't believe we didn't see this thing coming. Aren't there weather reports, for Christ's sake?

We put on our survival suits and ran for our lives to Icy Bay. The sky got darker and darker. It was harder to see the cresting of the waves, so it was nearly impossible to steer through them without some breaking right over the top of us.

Phil wouldn't give up control of the wheel. He insisted I didn't have the experience to handle weather like this, but he looked like hell. Pasty white face covered in sweat from the hot survival suit, his eyes were glassy from fatigue. I was standing next to him, holding on for dear life. Cappers was hiding under the galley table.

By the fourth hour, Phil couldn't do it anymore. I grabbed the wheel from his hands, and he staggered over to the table and collapsed. I had to steer by feel, trying to anticipate how the ponderous boat was going to be tossed by the mountainous waves. I didn't know what I was doing, but I was learning fast.

The waves were coming from behind us, off the starboard-rear-quarter. We would get overtaken by one, and start surfing on it. It would slide under us; then we were falling backward down into the trough until the next would catch us. At that point, the D.A. would pitch forward and rise fifty feet up on the front of the wave, where we would crest. The radar would catch one or two sweeps of land before we would be caught again in the sickening backward descent into the trough. The two sweeps of the radar were the only way I could tell which way to

go. I tried to hold a steady course, but we were being thrown around so viciously, it took all my strength to keep us on any course at all.

The winds were reading over eighty-five on the anemometer. Our guy-lines holding the mast were screaming with the tension. The waves kept building. One crested just as we slid into the trough, and broke right over the top of us. The courageous boat shuddered. We were completely underwater, then we broke up and out of the torment, and rose to the top of the next wave. *If one of those tore off the radar, we were going to die out here. Lost, and with no way to know which way to turn. If the hatch cover gets torn off, we would be driven straight to the bottom of the ocean.*

I knew the Lady Rae was behind us somewhere, but there was no way to tell where. Every six or eight radar readings, it looked like a blip back there, but the interference was too much to identify something that small. I hoped that if we did sink, she could find us out there, floating in our orange suits. There was no time for sea-sickness, not even time for fear. It was everything I could do to keep concentrating on the control of the wheel.

Phil had his arms crossed, his head down on his chest. Suddenly, he raised his head, and looking out the galley porthole, suddenly screamed at me, "Stu! Look out!"

I turned and looked behind us. There was a rogue wave bearing right down on top of us. I saw a wall of water that had to be sixty or seventy feet high. I instinctively spun the wheel hard into it, the boat turned right into the oncoming wave, and we glided right up and over the top of it. I spun the wheel back around, and we resumed our course for land. I had no idea how I knew what to do, but somehow I did, and it worked.

Hour after hour, it continued through the night and into the next day. We could barely tell it was daytime. The skies were black with the storm. Fatigue gave way to numb exhaustion. I kept forcing myself to keep my head moving, look over my shoulder for more rogue waves, but the sea seemed to be more consistent. Phil was slumped over the table, motionless. Every

tenth wave or so would break right over the top of us, but that became part of the sequence to deal with. Hanging on tight, waiting for the boat to recover. I had no idea how big the seas were. All I could see was black water when I looked out the cabin windows.

Finally, late the second day, after I had been at the wheel over twenty hours, the radar showed the entrance to the bay, about three miles ahead. I called out to Phil, and he staggered back over to me. The two of us held it together for a moment, his trembling hands next to mine. I could see all the scars on his hands when he squeezed the varnished wood.

He nodded at me. I checked to make sure he was ready, and I relinquished control back to him. The deep draft of the boat and the thousands of pounds of fish and ice we had down in the hold had saved our lives.

Icy Bay – Out of the Frying Pan

With the wind screaming hard from starboard and the seas still cresting over forty feet, Phil was having a hell of a time negotiating the narrow entrance to Icy Bay. The mouth of the bay was crowded with icebergs, some the size of our hatch-cover, some as big as our boat. As Phil threaded us through, I felt them bump and bounce off of us.

I looked ahead into calm waters, the icebergs finally becoming a solid ice pack at the foot of the glacier at Icy Cap, the head of the bay. Point Riou was on our starboard, covered with icebergs grotesquely misshapen by the mountainous wave action and thrown up on the beach like a pack of deformed albino whales.

The Lady Rae was about a quarter-mile to our stern, letting us have as much room as we needed to negotiate the maze of ice and to watch how we fared. I took off my survival suit, tossed it in the corner next to Phil's, and stood fidgeting in the wheelhouse, watching my Captain work. This was a one-man job.

Phil eased us further into the bay. The waves were calm in here, the breakwater arm of Point Riou protecting us now on the lee side, allowing him to pick his course between the more massive icebergs, letting the smaller ones carom as they would off of the Brazilian Cumaru ironwood cladding on the bow. I scrambled outside into the storm and edged my way to the anchor windlass to prepare to drop the hook.

In front of us was Moraine Island, and a flat calm place to set anchor in her lee, even though the wind was still howling through the trees above us at over 70 mph. The stainless-steel cable guy-lines holding the mast in place were singing, moaning an eerie tune with their piano-string tension. I held one for support as I passed by, and the vibration went all the way to the soles of my boots.

Phil nosed us in as close to the island as possible, making sure there was room for the Lady Rae to pull up next to us, and

gave me a nod to indicate I could drop the forty-pound Danforth. It hit bottom, and I played out some extra chain, making it fast for Phil to set the hook. He reversed slowly until the chain went tight and then put the D.A. in neutral. The boat immediately swung around, bow into the furious hurricane. A gust caught me unawares, if my foot hadn't been under the windlass for support, I would have gone overboard. I could feel the thumps of the icebergs hitting the sides of the boat. I let out twice as much scope, as usual, to allow for the wall of wind pushing at us, then pulled myself along the cabin to the stern to set our emergency anchor aft. With both hooks set, we were ready to receive the Lady Rae.

She came in slowly at half-a-knot, her high reinforced stainless-steel prow nudging aside the bergs, looming over us like an ocean liner. She went through the ministrations of setting her bow and stern hooks, two deckhands on her bow, and two astern, then one of the deckhands on the bow threw me a line. We pulled the two boats together, making both vessels fast at bow, stern and amidships. With four anchors out, and rafted together, we were set to ride out the remainder of the storm.

I noticed a crewman up on the poop-deck rigging a huge American flag. They must have struck the colors for the storm. It was interesting they would put that particular chore right at the top of the list. It fit the description Phil gave me of the Captain, though.

A man came striding out of the wheelhouse and looked over the side at us. He pulled off the hood of his faded red sweatshirt. *So, this was the hard-ass.* His white-blond hair, bright blue eyes, and red beard dusting his square jaw-line reminded me of a Viking longboat captain from the history books.

"Come on up for coffee, boys. I can't believe that the storm didn't drive you right to the bottom. There were times you were so far underwater; I thought you'd never come up. No wonder that little boat is a legend up here."

He shook his head and went into the cabin. The deckhand

who'd thrown me the line pulled off his hood too, and long blonde hair fell to his shoulders. *Her shoulders*. The same white-blonde hair, the same flashing blue eyes, square jaw, and lean, long neck muscles. Tall and graceful like a Nordic warrior. She smiled at us and shook her head too, a perfect mimic of her Captain.

"Wow. That was incredible. I can't believe you guys are still alive. My heart was in my throat every time you would go underwater, scared to death you'd never come up."

She was shaking her head in amazement. "You know my brother, and I timed you once at *eight seconds* underwater?"

I looked at Phil, eyes wide. He smiled back at me, white teeth showing through his gray-black beard. He looked positively joyful. I had never seen him like that before like he was a kid at Christmas. He looked ten years younger. His pride in the boat and our performance during the night eclipsed his usual matter-of-fact complacency. He was positively wiggling; he looked so proud.

His brown eyes gleaming, all he said in his typical way was, "Pretty wild ride, wasn't it?"

I reached out my hand to shake his in congratulations. To my amazement, he pulled me to him and gave me a huge bear-hug. He had never shown any emotion to me like that at all. Usually, it was just *'good work'* or *'that's just fine.'*

He held me at arm's length and said, "Stu, that was the finest seamanship I have ever seen. You saved the boat back there with your reflexes. Good job. You're a hell of a partner."

I was so proud I almost blew a gasket.

The woman was watching all this from up above, grinning from ear-to-ear. She motioned to her cabin door. "Come up! We've got hot food and coffee. You probably haven't eaten since yesterday."

"True," Phil replied. "Thanks. We need to clean up a little, and then we'll be over. Say twenty minutes." He knew we needed food and rest after our twenty-hour ordeal. He clapped me on the back and went into the cabin.

I watched her blonde hair whip in the wind as she turned toward the cabin. As wiped out as I was, I felt a little thrill at being able to see her again in twenty minutes.

I turned to appraise our damage. Surprisingly, nothing was in need of urgent repair. One of our eye-bolts holding the straps securing the hatch-cover had been torn loose, and the stainless-steel turnbuckle holding our flopper-stopper to the deck on the port side was bent, but it looked as though we had made it through nearly perfectly intact. A half-dozen of the marker buoys were gone, probably torn off during one of our many submariner moments, but they were easily replaced. The anchors were a little scrambled too. I'd have to straighten them out and retie a couple of them, but that would wait 'til later.

We went inside the cabin to straighten everything up. I was still in a daze from the lack of sleep, and the effort it took to get through the night.

Twenty-five minutes later, Phil, Cappy, and I scrambled over the side of the Lady Rae and onto her spacious deck. It was the largest ship I had been on since I'd unloaded the packers at JCS. There were close to a hundred coiled skates of Conventional halibut gear stacked all around the deck. The hatch-cover was twelve-feet square.

We entered the cabin, where the eight members of the crew were sitting around the big galley table. There was a nice spread of food--cold cuts and cheese, sliced bread, potato salad, green salad, bags of potato chips and pitchers of what looked like Kool-Aid.

We sat and ate for the first time in many hours. I made myself four sandwiches and chugged a couple of quarts of grape Kool-Aid. Cap was curled up at my feet under the table. I sneaked him a piece of a boiled ham sandwich and felt him take it from my hand and bolt it down. He hadn't eaten, either. I looked up and saw the woman watching. I shrugged and smiled. She handed me a fat sandwich from her plate and tilted her head in a 'give it to him' motion. I did.

As we were eating, we could hear the storm raging outside,

though the big ship showed minimal effect except for an occasional rocking when a more forceful gust hit.

Between bites, Phil and I got introductions from Lars, the Captain.

"Most of the boys don't speak much English, but they understand it just fine. This is Katrina, my sister."

She smiled and nodded at us, saying, "Call me, Kat."

"She's our First Mate. Don't let her looks fool you. She's tougher than her old man ever was, and doesn't tolerate slackers. Right, boys?"

The other men nodded hastily. One quietly muttered something in Scandinavian. The crew laughed.

"I am *not* a slave driver!" Katrina indignantly defended herself.

"Block's our Second," Lars nodded at the biggest guy in the crew, six-two and two-fifty. "Olaf's our Third. Deckhands; Sigurd, Henrik, and Arvid." Then he motioned to the man in the galley. "Nils the Cook. These boys have been with us since Petersburg."

They all nodded as their names were spoken; none of them said a word.

Lars looked at me. "So you're the famous 'Little Diesel.' I've wondered about you. You're for sure not Scandinavian. What's your blood?"

"My father is French-Basque, my mother, Sicilian."

"Basque! That explains a lot."

"How so?"

"Well, your size, for one. Basques aren't very big. The Basques were also the greatest seamen in the world once. Even more so than the Vikings. They were reputed to have discovered the New World two hundred years before Columbus, and the first to sail completely around the world."

"I thought Magellan was the first to sail around the world. He was Portuguese."

"Magellan was murdered in the Philippians. His Captain was Juan Elcano, a Basque. To be historically correct, he was the first man to circumnavigate. Magellan just got the credit."

I wonder if centuries of Basque bloodlines would have made me a better sailor. What if I knew what to do out there, because of my heritage? Because of hundreds of years of gene development? How strange that would be.

Calm Before the Storm

We finished eating in silence, then Kat stood and looked at Phil and me. "You two want a tour?"

Phil smiled and shook his head. "No, thanks, but I bet Stu is dying to see the wheelhouse."

"Yes, please!" I said to her, standing up. Cap immediately was under my feet.

"Cap! Stay!" I firmly commanded him. He immediately lay back down, looking depressed.

"No, Stu, he can come. There's plenty of room, and he's so beautiful!"

"OK, if you're sure. C'mon Cappers."

He jumped back up and followed us. Kat opened a varnished door and revealed a stairway leading below. She lead the two of us down into a wide carpeted hallway, with mahogany doors down both sides. The first door to the right had 'First Mate' engraved on a brass plaque. She opened the door, and we entered into the most lavish stateroom I had ever seen, like a luxury suite on a cruise ship, carpeted floor, eight-drawer dresser, big mirror over a wooden writing table. Its very own head with a shower, a queen-sized bed with a light-blue comforter on it and a stuffed Orca was sitting on the pillow. The amazement had to show on my face.

She laughed at my look and seemed very proud of herself. She gracefully swept back out into the hall and pointed to the other doors.

"Second Mate's cabin, main head, another smaller head, and the bunk room for the rest of the crew. She opened the door to a large room with eight bunks, four on each side. Every bed was spotlessly clean and made military-style. The room was the size of the D.A.'s entire cabin, and there was not a single loose object to be seen anywhere.

We went back above decks and into the wheelhouse past the door engraved with *'Captain.' I couldn't imagine what was in there, dancing girls and a swimming pool, maybe.*

The beam of the Lady Rae was over thirty-feet, and the wheelhouse stretched the full width. Huge oak wheel in the center. A countless array of gauges, switches, knobs, and buttons. Blue-lit screens were everywhere. I recognized a few of them as radar and LORAN.

Kat effortlessly stepped up into the helm's chair in front of the wheel and gestured to another nearby, on an elevated swivel stand, with armrests. "That's mine. Sit there, OK?"

I stepped up into the chair and swiveled around. We were at least thirty feet above the water. Although the storm was still howling outside, it felt as safe as a baby's crib. Cap curled up at my feet, watching me out of the corner of his eye.

"How long is she, Kat?"

Kat reached up and turned down the CB radio, now only broadcasting static. "The *'Lady'* is one hundred thirty-two feet, overall."

She looked at me for a moment, eyes twinkling, poised and beautiful in her blue ribbed-sleeveless top and tight jeans, blonde hair flowing to her shoulders. Her eyes shone as brightly as blue glass.

"So. You're *Little Diesel*. I've been waiting to meet you. You know they talk about you down on the docks in Seattle?"

I raised my eyebrows, not believing her, wondering what in the hell they *possibly* knew about me way down there. "Are you joking with me??"

She laughed. "It's a fact. You're truly a legend down there, you know. Everyone in Fisherman's Terminal has heard of you. Working *alone* with The Old Man, himself? There aren't any *three* men that could keep up with you, they say.

"That was a pretty remarkable show you and Phil put on the last two days. It's not going to hurt your reputation a bit. They'll say your boat was underwater for five minutes, and the seas were over a hundred feet, though." She laughed that beautiful husky laugh again.

"Will they find out the truth? I was curled up in the corner next to the dog, terrified and screaming like a little girl?" I said.

"You're funny. No, the fleet won't know that unless I tell them." She was smirking at me like she was playing with a trapped mouse.

"Sooo... tell me about Kat."

"OK, we'll change the subject. You really don't like talking about yourself, do you? Ok. There's not much. I was born in Petersburg, full-blooded Swedish, started fishing with Dad when I was nine, fished every summer through high school and college. I received my M.B.A. from Washington State University. I planned to run a fleet of boats someday. But you know, I missed being out on deck. *Missed running the rail.*" Kat looked at me, intently, "I'm a *hell* of a Railman, you know."

I nodded. I bet she was an *animal* with a gaff hook in her hands. She had *the Look.* You could sense her competence and courage. The bird-of-prey gunslinger-intensity in those blue eyes. I admired her ripped arms and delts—striated, muscled forearms and upper arms, with cut triceps, long and lean. Slim, muscular thighs, rippling under the tight jeans. *One strong, beautiful woman.*

"I came back home when Dad died and fished with Lars for a summer. We decided the old boat was too outdated and beat up, sold it and her license, and joined up with WestCo. We brought our whole crew with us from Petersburg to Seattle. Now we've got the Lady. That's it."

She finished her story, and we sat there for a while in silence, watching the storm rage. I looked over the side, way down at the D.A. I felt embarrassed for the old girl. She looked so old and bedraggled next to this majestic ship. I felt terrible about it, then shrugged to myself. *What would I do on a shiny new carpeted cruiser like this, anyway?*

I slid down off the stool and said, "Thanks for the tour, Kat. I think I'll grab something else to drink. I'm dehydrated from all that screaming."

She smiled back and stepped down from the helmsman's seat. We stood face-to-face, inches apart, for a few long seconds. I could feel her warmth.

"I'm so glad you made it, Stu. It's good to be alive, isn't it?" She reached out and hugged me with her strong arms.

I looked up into her ice-blue Scandinavian eyes and saw something I had never seen before. Confidence, and something more. *Fire*. I liked it a lot. She bent down and kissed me full on the lips, deeply and passionately. She slipped her tongue into my mouth and made a soft moaning sound. We held the kiss for a long time, our tongues dancing together. When we broke the embrace, she lightly kissed me again on the cheek and reached down to hold my hand.

Still holding hands, we went back into the galley, to rejoin the crew and our Captains. A couple of the deckhands leered at me, I thought. We sat back at the table, drinking and munching chips listening to the storm. Cap curled up at my feet and promptly fell asleep. He had been up for two days, too. The radio static coming from the wheelhouse was the only sound inside the ship. Clearly, these guys only spoke when spoken to, and probably only in Norwegian. Or Swedish. Or Danish. Some Scander-hoovian language. The only Swedish I knew was from the cook on Sesame Street. *"Hoonder-scoonder-foonder!"*

I wondered if they played poker? They'd be deadly with all that stony silence.

Death in the Air

Lars suddenly broke the quiet, saying to Phil, "Have you turned on the S.S.B. lately?"

The Single Side Band radios were used by the fishing fleet for short and medium-range communication--a couple hundred miles or less-- between each other and the Coast Guard. Most boats had stopped using them; they were heavily regulated and monitored every second by the Coast Guard. I heard you couldn't even cuss on them without losing your license. Phil always used his CB to talk to his fellow skippers anyway, and with us so far off-shore, it was usually turned off, too.

Phil shook his head 'no,' and Lars got up and went into the wheelhouse. I heard a lot of static, then faint voices crackling through the interference.

Lars walked back to the table. "There seems to be a strange atmospheric condition happening with this storm—some kind of a skip against the clouds. I have been listening all night to radio calls that must be over five-hundred miles away. One was from down by Cape Scott, which is closer to eleven-hundred miles away." He looked at me. "Brace yourselves; it's not pretty."

We tried to make out the radio-callers through the static, but the interference made the individual words nearly indistinguishable. The tones of the messages were unmistakable however; sheer panic and urgency.

Lars got up, and I could see him through the door fiddling with the controls. Suddenly the messages coming over the radio were clearer.

"*Mayday! Mayday! Mayday! This is the 'Ocean Harvester.' Man overboard! Man overboard! All vessels, please respond! Cannot turn in heavy seas! All vessels, please respond! Man overboard! We are ninety miles offshore of Cape Scott! Can anyone hear us? Mayday! Mayday!*"

We looked at each other, stunned. Then another static-filled call: "*Mayday, Mayday! Mayday! All boats, please*

respond! We are the 'Katherine G' sinking with all hands! Abandoning ship in heavy seas! Last known position 40 miles west of Jones Reef Lighthouse! All boats, please respond!"

Jones Reef Lighthouse was over 600 miles away.

Very faintly, then, *"Mayday! Mayday! Mayday! This is the 'Elaine Drew'...drifting without power... imminent danger of capsizing...all boats, please respond! We are forty miles NNW of Otter Point in extreme peril! Mayday! All boats, please respond!"*

I had never heard of Otter Point, so I assumed it was in Canadian waters, eight hundred or more miles away.

Another message then, reasonably clear of static, but cutting in and out, *"Pan...Pan...Pan...this is the Coast Guard at Kodiak Island. ... unable, I repeat, unable to scramble our ...scue helicopter or to launch our cutters... this storm. We predict the winds will lessen in six or ...hours to less than sixty miles an hour which is the point where ...launch the Air Rescue Teams. Any boats within reach of the Mayday calls ...lease respon... we will assist as soon as it is possible. All vessels monitor Channel Sixteen for rescue information."*

I looked around the table, horrified at what I was hearing. The two skippers were sitting together quietly, Phil's teeth clenched, his head shaking, listening to our comrades at sea dying in the storm as we listened, and us completely helpless to act. Chills ran up and down my back, my hair was standing on end, and my eyes clouded with tears at the hopelessness of the situation.

The radio calls continued for the next hour. Some too faint to understand, some filled with the gruesome messages. Boat after boat going down and deckhands being torn away and washed overboard. Several of the 'Lady's crewmembers had their heads down on the table, with their hands clasped tightly over them. Kat was crying openly, tears streaming down her face, shoulders shaking.

Out of the blue, crystal clear and loud enough to make me jump, another call came over the radio's speakers. It sounded like it was right on top of us. *"Mayday. Mayday. Mayday. This is*

the Japanese trawler 'Kyoto Maru Number Four.' We are disabled and sinking, drifting without power with all hands in immediate peril. Our location is twenty-three miles due west of Icy Bay, Alaska. We have lost one man overboard and are flooding rapidly. All vessels, please respond." The Mayday call was in perfect English.

They're right there! We can finally do something! I looked over at the two captains expectantly. They were looking at each other, silently debating their options.

Lars spoke firmly. He faced Phil but spoke to all of us. "No," he shook his head, emphatically. "We will *not* endanger this boat for a Japanese vessel illegally fishing within the 200-mile limit. They got caught with their pants down, tough shit. This boat is worth close to two million dollars. I will not jeopardize it, and my owners will not authorize it to rescue some yellow-slant Jap poachers. And that is my *final* say."

He got up and stalked into the wheelhouse, stopping to flick off the radio before disappearing through his cabin door, slamming it shut behind him. Kat watched him, mouth open, eyes blazing. She jumped from her chair to follow him, and then sat back down frustrated, obviously furious at his decision, but unable to countermand her Captain's order.

I looked over at Phil. He was sitting very still, just looking back into my eyes, his jaw working slightly. We sat like that for perhaps twenty seconds, eyes locked, unmindful of everything going on around us. He raised one eyebrow and cocked his head at me in question, and then he slowly started to nod his head. I followed suit, nodding my head, then faster, knowing precisely what we were going to do next and what it might mean to both of us.

We both stood up simultaneously and started moving towards the galley deck door. Cap jumped up, surprised from his sleep, hitting his head on the unfamiliar table.

Kat looked up at us. Then realization dawned on her face. She rose to her feet, swiping at her tear-streaked face. "You're going to do it, aren't you? You're going out there! I'm coming with you. You need another person to help. *Fuck Lars!* You have

to let me help! Please. You have to! *They'll die!*"

Phil looked at me.

I nodded, looking at the determination in her face. "We'll need another body once we get out there *if* we get out there. Do you understand what this is? This is everything. We're *all-in*. If we lose, there's nothing left. Phil and I *have* to go. It's the code of the D.A. *'Whatever it Takes'.* You aren't obligated."

"Obligated!" she spat. "What, you think I'm going to let them die without trying to help? You think I'm like my xenophobic goddamn flag-waving asshole brother? I am going out there. You need me. *You can't not let me go!*" She grabbed Phil's arm. "Phil, you'll need another experienced person out there! You can't..."

"Okay, okay! I didn't say you couldn't come. Stu just wanted to make sure you know what you're getting yourself into. He's the First, and you're his responsibility."

Her head snapped around to look at me. I saw the fierceness in her eyes. There was no mistaking her single-mindedness. I nodded. *Thank God for some help.*

"*Good! Enough talk! Now we go!*" Phil barked the order, and the four of us filed out of the galley, the dog squirming through the narrow door next to me as we made our way to prepare the Devil's Advocate to go back out into the storm.

Into the Fire

The three of us made preparations hurriedly, Phil talking urgently with the Coast Guard and the *'Kyoto Maru.'* The Coast Guard helicopter would arrive in approximately four to six hours from the Kodiak Air Station.

By that time, it would be all over but the eulogy.

The Kyoto did not have survival suits on board, but every man had donned a lifejacket and was furiously manning the hand-pumps awaiting the arrival of the Devil's Advocate.

As we untied from the Lady Rae, her crew looked silently at us working. One of the deckhands yelled, "Good luck!" as we pulled away from the towering ship. There was no sign of the skipper on deck. I looked over at Katrina's face. She was looking back at her former boat with a look of fierce defiance and determination.

We went into the cabin for last-minute orders. "Stu, you see if you can get that hatch cover better fastened! Katrina, you clear the cabin of everything that moves and throw it into the fo'c's'le. There may be injured survivors we'll have to tend to. We're going to clear the entrance of the bay in about ten minutes! Have your survival suits on by then!"

Phil was already pulling the bright orange neoprene suit over his clothes, having kicked off his boots.

I went on deck again, to make sure everything was secure, but everything had already been washed overboard that was not lashed down. The hatch cover was the biggest concern, so I double tied it with extra poly rope, threading it through the eye bolts that were still undamaged, cinching it down tight.

When I re-entered the cabin, Katrina was pulling on her suit she had brought over from her boat. It was the same bright orange as ours, but it had a huge *'Lady Rae'* emblazoned on the back.

I kicked off my boots and unzipped my suit. I stepped into the enclosed feet and pulled up the rubber monkey-suit. Every

time I had tried the suit on in practice drills, I felt like I was in a wet suit that was four times too big for me. It was clumsy and awkward, but if one of us got washed overboard, we could stay alive for over an hour in the icy waters. *In theory.* Without the suit, hypothermia would set in within five minutes. Death would occur in less than thirty.

Phil was anxiously looking out the cabin windows, looking for a clear path out of the bay. The wind was coming right at us, between seventy and eighty miles per hour. The monstrous seas were breaking on both sides of the narrow entrance, and the last remaining windshield wiper was fighting a losing battle against the fire-hose of rain hammering against the front glass. Phil was holding the wheel in a death-grip through the three-fingered mittens built into the suit. He had thrown back the constrictive hood for better visibility, and to lessen the sweat pouring down his face.

Kat and I were on each side of him, transfixed on the wall of water ahead of us. We cleared the entrance and were smashed by the first wave. It broke over the top of the boat and tried to drive us to the bottom. The D.A. staggered under the weight of it, then rose slowly upwards to clear the surface. Immediately the next wave hit us, nearly tearing the wheel from Phil's hands.

The three of us looked at each other, and the same look was on each of our faces. *We have made a terrible mistake. None of us were going to survive the second attempt at this nightmare.* After a few moments, the mouth of the bay was behind us, and the waves came at more regular intervals. Phil put the seas forty-five degrees to the port side to lessen the rolling effect.

He hurriedly explained our situation. "The Kyoto Maru is drifting, disabled. The winds have pushed her to about twenty miles west-northwest of the entrance. We don't have a good radar fix on her, but I am estimating how far the wind will push her over the next few hours. I can keep us on course. This wind will keep driving us North, so we'll have to make corrections every half-hour or so.

"She's an otter-trawler, one hundred forty-eight feet. The main hold is flooded, and her decks are nearly awash. She

doesn't have much time before she's driven to the bottom. We'll have to try to get close enough to her to run a bos'n line between the boats. With her size and the wave action, if we get too close, we'll be crushed instantly. There is actually an advantage to her being flooded. It will dramatically reduce her drift rate, and her rolling around."

I nodded at him, then staggered aft to get a line to rig. A 'bos'n line' was a thin line connecting the two boats, trailing through the water. A crewman would have to jump overboard, holding onto the rope, then pull himself over to the D.A., where he would be pulled on board. Easy enough in rescue drills, but the boats were moving up and down 60 feet and being blown all over the ocean. I had my doubts whether we could even *see* the crewman in the water, let alone fish him out.

How was I going to throw the line in this wind? In the olden days, they had an intricate knot called a 'monkey's fist' tied to the end of lines to give them weight for heaving. No monkey's around this boat, I thought, looking for anything I could use. My eyes fell onto the fish-club hiding behind the neat row of steel gaff hooks, with its iron pipe driven over the end. I brought it into the cabin and dug into the toolbox for a hammer. I drove the pipe back off the club and tied the end of the 100-foot line securely to it. It would make a perfect weight, as long as I didn't kill somebody with it when I threw it.

The next hours were filled with the constant heaving and rolling of the boat against the storm. The wind was screaming through the rigging sounding like the courageous vessel was vibrating apart. Nearly six hours from the safety of the bay, the radar finally registered the unmistakable blip of a large boat. It was eight miles away, West by Northwest.

Phil picked up his radio. "Kyoto Maru, this is the Devil's Advocate, do you read? Over."

"This is Captain Kaneshawa. I read you Devil's Advocate. We have lost most of our superstructure to a large wave. We have no electronics except for radio. We have lost two deckhands overboard and have lost sight of them in the water. Please approach carefully with all hands on the lookout."

ALL hands?

I looked at him. "Uh, Phil, do they know exactly how big we are here?"

Phil looked over at me and shrugged. "Well, I didn't think to tell them we were about as big as a large piece of sushi! I think we'll surprise them. I don't want them to lose faith now. Two men overboard! We'll be lucky to find the bodies!"

He spoke into the mike, "Roger 'Kyoto Maru' we'll come in slow from downwind. How long ago did you lose them?"

"Thirty-eight minutes ago, they were attempting to secure the forward hatch when they were swept overboard. They were last observed drifting North from our position."

"He sure sounds casual about the whole thing. Who cares about the electronics? Thirty-eight minutes in the water means they're dead." Katrina looked puzzled and angry.

"He's the Captain." Phil glanced over at her. "He has to remain detached from the whole thing. Besides, they're Japanese, remember? No emotion, no feeling, nothing personal. Losing the electronics may affect the rescue, the crewmen won't."

I scowled at him. "Come on, Phil, you mean to say he doesn't care if he's lost a couple of deckhands? Japanese or no, he's their Skipper, isn't he?"

"He may care, but he's not allowed to show it until this is all over. It would panic the crew if he were any other way."

An hour and a half later, the Japanese ship's superstructure was in sight. It was a tangle of cables and broken masts. The trawler was lying strangely low to the water, rolling dangerously in the beam sea. With no engine power, the vessel was utterly at the mercy of the storm.

Every fourth or fifth wave would break over the top of her, engulfing the ship in foam and fury. The decks were swept completely clean. We could see a couple of men huddled behind the cabin, waving.

"How many on board did he say, Phil?"

"Nine. Two lost, seven to fish out of the water. Get the line ready; we're coming up on her. Anybody see anything in the water?"

Kat and I pitched and zigzagged aft to look in the water around the boat. Outside, the wind was still shrieking, the chill cutting right through our suits. We were walking like moon men, clumsy and awkwardly in the ungainly rubber.

Kat was shading her eyes from the spray with one hand, and hanging on for dear life with her other hand, as she started to search around the boat.

I wedged myself against the gunnels and used both hands to shield my eyes against the driving rain. I could hardly see a thing. The waves were being whipped into a foam-blown frenzy. The rain felt like a perpetual attack of bee stings against my face.

I yelled out to her, "See anything?"

Kat shouted back, "Not a thing! I can't see more than a few feet!"

I was shaking my head with the hopelessness of the cause. *At least we can try to save the rest of them.* I readied the line for throwing. The three-eighths-inch poly buoy-line was slippery to hold, and I was fighting to keep it from getting tangled in the incredible wind.

Phil's voice came drifting back to us. "Are you ready to toss the line?"

"Ready!"

Phil turned the boat, so we were on the leeward side of the trawler, effectively blocking the wind for the throw.

The 'Kyoto' loomed up in front of us. There were two deckhands on deck waving. I grabbed the heavy pipe and threw it with everything I had. It splashed into the water ten feet from the other boat. Quickly coiling back up the rope, I tried again. Still five feet short. *The suit was making this impossible!*

I frantically unzipped and pulled down the upper half of the survival suit to give myself more freedom of movement. I tied the arms of the one-piece suit around my waist to keep it from falling around my ankles. This time I was able to circle the

awkward weight like a lasso over my head and launch it at the other boat. I let go of it just in time to see it sail over the gunwale of the other ship and land on its deck.

The crewmen on the Kyoto made it fast to a piece of twisted rigging. I fastened our end to the davit we used for pulling ground-line, leaving the remaining slack in the water. I was fairly confident the heavy stainless davit would handle the stress. The D.A. would drift faster than the flooded ship. It was up to Phil to keep the boats close enough for the rescue. Katrina's and my job was to pull the crewmen out of the heaving water before they were crushed to death.

The crewmen of the Kyoto were lining up on deck, ready to go into the frigid, churning water. I did not envy their next few minutes. The first hand grabbed the rope and jumped overboard. He was pulling with all his might against the waves. He must have been very athletic. He made it look easy and graceful. When he got to the side of the D.A., Kat and I timed the dropping of the boat to pull him in just as the gunnels went underwater. He slithered aboard like a prize catch. He lay there gasping and shaking against the cold.

We pulled him into the cabin for shelter and warmth. Kat wrapped him in one of the blankets from the bunk beds in the fo'c's'le.

He looked to be in his early thirties, white-lipped from the cold and shaking like a leaf. After a moment, he was able to speak.

"I speak Engrish. I was sent first to explain, and because I good swimmer. We have two men hurt, berry bad. One crushed by farring mast. Very bad. No swim. Captain, he stay until last to help him over."

"Devil's Advocate, do you read?" The radio boomed.

"Roger Captain, your man, is five-by-five, that is A-OK. Do you have injured, over?"

"The last men will be coming over in twos. We have to assist them. They are badly hurt. One has certain internal injuries. The other a broken leg. I will be coming last with the most seriously injured man."

Phil looked at Katrina and raised his eyebrows. *See? He cares.*

"Roger, Captain, let's continue with the operation."

"Uhh, Devil's Advocate, We were expecting a cutter or at least a trawler-sized vessel. Do you mean to tell me you came out for us in *that?*"

"We Americans have a saying, Captain. It ain't the size of the dog in the fight. It's the size of the fight in the dog. Over, out."
He winked at his crew. "Let's go get 'em! Stu, get that suit back on!"

We staggered back out into the storm, seemingly tearing at us even more viciously for having been cheated from another life. I could feel the wind tearing at my woolen coat, but I was going to leave the survival suit the way it was in case I needed more freedom of movement.

The next crewman wasn't nearly as easy. The tumultuous waves tore him away from the rope but he just managed to grab on again before he was swept away. He pulled so hard, he crashed into the side of the D.A. and was nearly knocked unconscious. Katrina grabbed him through a wall of water and yanked him onboard. She pulled him into the cabin to be tended by his other crewmate.

The next sailor was almost routine. The timing was getting better between Kat and me. Now there would be two coming over together, a man with a broken leg, and his helper. They both jumped in together, the disabled man holding on to the straps of his mate's lifejacket. The helper was a big, powerful man who pulled across the one hundred feet of open sea in less than a minute.

He timed the waves, then pushed with all his might at the hurt man, sending him onto the Devil's Advocate with a scream of pain, his leg twisted beneath him. I reached over for the burly deckhand and pulled him on board a second later. He gave me a huge smile and a pound on the back.

"Osoreirimasu! Arigatou! Arigatou!" He went into the crowded cabin to tend to his friend.

Now it was the Captain's turn. He had tied the other man to him with a rope around their waists, the injured man was either unconscious, already dead, or was just too exhausted to move. The Captain jumped over and began the laborious pulling of their deadweights through the water.

Suddenly, I saw something out of the corner of my eye. It was a black wall of water that blotted out all light in its immensity. A rogue wave more immense than any we had seen yet, it towered 60 or 80 feet over the tops of the two boats. Its crest was a mass of foam, and the water in it was black and ominous.

The monster wave surged between the two boats. The thin line snapped tight, and the end tied to the 'Kyoto' sheared away. The captain of the Japanese vessel rose up and up above us, eyes wide with terror, hanging on to the slippery poly-line for all he was worth.

Katrina and I grabbed our end of the rope and began pulling hand over hand as fast as we could.

Just as the two crewmen in the water came up to the side of the Devil's Advocate, the second wave in the set, unseen by all of us, and nearly as big as the first, smashed over the two boats.

I was torn away from the boat and was knocked overboard on top of the two men in the water. I crashed right on top of them, jarring the Captain loose from the line with a grunt.

We were in the water, being swept away from the Devil's Advocate as fast as the waves and current could take us.

I caught a flash of yellow lifejacket through the torment, grabbing it with all my strength. My survival suit was flooding from the top, filling the legs with ice water. I was sinking like a stone. The cold from the forty-degree water was paralyzing. My strength was fading quickly in the struggle. I felt like my brain was freezing. I held on to the other man's lifejacket with everything I had left and kicked the survival suit off of me. I couldn't see or breathe. Every time I tried to catch my breath, my mouth was filled with freezing saltwater. Drinking gulp after gulp of it.

I'm going to drown! I pictured the depth of a thousand feet of still, black water beneath me.

I was blacking out, my hand slipping from the life jacket when a black form came out of nowhere at me. *Salmon Shark! Oh my God, please no. Please!*

I reached out with my fist to strike at it but encountered wet fur, instead of the sandpaper skin I was expecting. *Cappers! Cappers came to save me!* I slid my hand over his head and grabbed his collar. He turned, and I could feel him pulling us back towards the D.A., as I tried to maintain consciousness.

I was slipping farther underwater, just aware my arms were being stretched as though I was being ripped apart. I began to swallow water again. My head cleared long enough for me to tighten my left hand around the lifejacket strap, then everything faded to nothing.

I've Got Dreams to Remember

"Pull my self together,
Put on a new face, climb down off the hilltop baby,
Oh, I get back in the race
Cause I've got dreams, yeah dreams to remember
....ahh help me baby, or this will surely be the end of me."
-Greg Allman

I was fighting a losing battle to stay conscious. There were waves and wind. My left hand was clamped onto something, but what was it? Something in my right hand was pulling me as well.

Too hard! I don't want to get out of bed! Stop pulling me! I wanted to sleep, and I was shaking with cold. *If I was in bed, why was I all wet?* I mumbled into the water, "Mom, bring me another blanket. I'm really cold. Mom?"

I drifted deeper into unconsciousness. *I was playing army with my buddies like I always did when I was little, except we were grown up like we are now. We were shooting our cap guns at each other, them against us, and all I had was this toy .38 Special single-shot pistol that every time I shot it, I had to reach into my back pocket and get the sheet of Greenie-Stickum-Caps out and peel off another one. Sometimes the sheet got a little damp, and the little round cap didn't even fire. Meanwhile, the other guys were shooting at us really fast, because they all had good dry roll caps, and there was a cloud of sulfurous cap-smoke all around them.*

Suddenly there were bullets whining around my head and splattering in the gravel at my feet because now the other guys were shooting at us with real bullets, and all I had was the cap gun.

I turned and ran. My teammates had disappeared, and I was all alone, and the shots were whining around my head. I ducked into this big brick building, like my old elementary school. I

257

looked back to see how far away they were and if they'd seen me go into the building, and in front of them was this huge, hairy guy that looked like a brown bear. He was yelling at the other guys in a hoarse roar, and then they all saw me and were chasing me into the building.

I ran into a little room that had a burning fireplace and books on the wall, and it was toasty warm and had a big, thick, carved wooden door that I latched behind me. I began searching desperately for a weapon of some kind, because I had dropped the toy pistol when I was running, and I didn't even have that. In the corner of the room was a rusty orange metal drum with a bunch of walking canes and brooms and umbrellas sticking out of it. I scrabbled through it for anything I could use to fight with, and to my amazement, I found a sword. A real sword, with a red and black handle and a three-foot-long steel blade, razor-sharp on both edges, and a needle point like a gaff hook.

The mob was at the door, and the big horrible guy was pounding on it, and the door began to give way. I put my shoulder against it, but the door disintegrated into splinters, and the monster was in the room. He grabbed me around my ribcage and lifted me off the floor. I got my right arm around his neck, and I struggled and twisted, expecting each moment that he was going to break me in half. Just as I began to see that I might have a chance against him, he started changing into something else. He turned into my father, I saw his face and how angry he was and how he wanted to kill me, just like that time driving home from the movies in the car, and then he turned back into the beast covered with greasy hair, his beard and teeth, and stinking breath were right in my face.

We were in a clinch, and I wasn't winning, but neither was he. His beard and hair and all the hair on his body started to grow long and soft and turned the most beautiful burgundy red color, and I began to relax because nothing that beautiful could hurt me. And then his teeth began to grow into sharp ivory fangs, and he snarled and snapped at me, and I knew he was going to kill me with his strength and his terrible teeth. I saw that he was a Kooshtek-aa, a terrible soul-stealing half-otter,

half-human demon from the Haida legends that would eat my soul and tear my body apart.

The beast suddenly bit me in my right shoulder. I could feel his fangs going into me, all the way to the bone, and the searing pain. I raised my left arm to try and pull its head away from me and discovered the sword, forgotten in my left hand. I raised the sword over my head and with all the strength I had left, plunged it down his throat. He gave a violent heave and tried to buck me off, but I was the strongest. He stared at me with his black soulless demon eyes as I shoved the sword all the way down his gullet. I could feel it going down his throat, and I could feel it pierce his stomach, and suddenly he turned into a man again, and he shuddered and heaved and died in my arms.

I opened my eyes. I was lying on the deck of the Devil's Advocate, safe in Icy Bay. I was covered in blankets, and the rain was falling on my face. There was a deafening noise above me, louder than the wind was during the storm. It was a helicopter, enormous and white, with an orange stripe on the side. *The Coast Guard had finally made it.* I moved my head and looked over to the cabin. Phil and Kat were talking to a Coastguardsman. He had an orange life jacket and a white helmet on. *He must have been lowered from the helicopter.*

Phil was looking over at me then. He came and knelt by me and put his hand on my arm, looking into my eyes.

"You're awake. How does the shoulder feel?"

Shoulder? Wasn't that a dream?

I lay there on the deck motionlessly, thinking about the dream. *So that's what it felt like to kill a man.*

I remembered the way he had jerked and tried to buck out of my arms, the way his black shark eyes had faded to a flat gray the moment of death, then how still he got. *How dead that dead really was, sometimes.*

I lay there thinking about how my life had changed in the last few years. To paraphrase Buddy Miles, my how them changes do occur.

I was shaking with cold, but there was something wrong with my shoulder. I couldn't move it without a searing pain down my arm.

But it was a dream, wasn't it?

Kat knelt beside me. She was crying. "I'm so sorry, baby. I had to. You were sinking, and you had hold of the other two guys. Cappy couldn't get you any closer to the boat. I had to, or you would have all died. I'm so sorry. *I'm so sorry.*"

"What happened? What's wrong with my shoulder?"

Phil was leaning over me, looking into my eyes. "Don't be alarmed Stu. The Coast Guard is here to get you all to a hospital. They've already given you a shot. You'll be just fine. Just fine."

My head cleared with terror. *"What happened to my shoulder??"*

"Well...she...aaah..."

"I *gaffed* you, Stu. I *had* to. You were sinking, and they were going down with you. I gaffed you and pulled you on board."

"What? Gaff...but, my God, I could die from blood poisoning!"

I moved my shoulder and was blinded by the pain.

A man's voice. "It's torn up a little. Some ligament damage, but you'll be fine. You'll be at the hospital in a couple of hours." The Coastguardsman was kneeling next to me now, too. "I'm going to give you another sedative shot, and you'll sleep. You'll be fine. A little sore for a while, maybe. They will put you on antibiotics in the hospital."

He looked at Phil and Kat, and I saw him shrug.

I felt the needle stick, then the rain on my face, then Kat's eyes, bright blue and filled with tears. Then nothing.

A Load Lifted

Hospital smells—hospital noises. I opened my eyes—*hospital room.*

My right shoulder was heavily bandaged and immobile. I had an IV stuck in that arm, dripping. My head hurt. I was sweating. I couldn't clear my eyes. Everything was blurry.

I reached out to pet Cappy. *Cappers!* He was lying on my feet. *Too heavy. Hot. He isn't there, where did he go? It's just extra blankets.*

I tried to kick them off, but I couldn't move my feet.

Get off. Get OFF!

The nurse came in then. I was thrashing, trying to kick off my blankets. *I am so hot!*

She walked over to me. "What do you need, Mr. LeClercq. Try and calm down."

"Blankets. Too hot."

"Okay, I'll pull them off."

She lifted the weight off my feet and lifted the sheet. Cool air washed over my sweating legs. *Good. That's better.*

She folded the sheet above my knees. *Refreshing. Good. Air.*

I focused on her face. "Thank you. Where...?"

"Bartlett Memorial Hospital in Juneau. You are going to be just fine. The shoulder is not infected, but we're giving you a penicillin drip, just in case. The wound missed the scapula by an inch, or it would have been shattered. The X-rays show it's been broken before, no? "

I knew Kat was good with a gaff.

"You'll be good as new in a few weeks. There are some people waiting for you outside. Do you want them to come in?" I nodded.

She left, and immediately Phil, and Kat walked in. Kat came over and kissed me softly on the lips. Phil took my left hand in his right.

Kat's eyes were red from crying. "You feeling better, Baby?"

I nodded. Phil didn't say anything, just looked into my eyes for a minute. His eyes looked kind and warm.

You look tired, Phil. I smiled at him.

Kat sat on the bed and put her hand on my thigh, "The two crewmen you saved are doing just fine down the hall, baby. You saved their lives! Cappy's fine, too! You're a *hero*! Everybody in Alaska, hell, you're on the Five o'clock National News all over the United States!

"Everybody's heard about the rescue. You're *famous*! Everybody wants to interview Little Diesel. The strength it took to hold those two men in that water...it's incredible, just amazing. They have pictures, videotape even, on the news! Of you doing gymnastics, saying that's why you're so strong. A *Champion*! I didn't know you could do that!" She started crying. "I could have ruined everything! I could have crippled you for life, I'm so sorry! I could have..."

I took my left hand from Phil's and touched her face, "*Shhhh.* You saved my life, Lover. *You're* the hero."

Phil smiled, "She is. She's amazing. And our new Second, by the way."

Kat kissed me again, eyes brimming, "I'm going to be fishing with you two next season, isn't that wonderful!"

Phil eased to his feet, slightly swaying with the effort, "We should go, get him some more sleep. Oh, by the way, Stu. Happy Birthday." He slowly moved towards the door and turned off the overhead lights.

Cool darkness.

Kat looked at me, her face a foot from mine. Perfect blue eyes filled with tears. I felt one fall on my throat. *Warm.*

She kissed me again on the lips, "I'll be here for you, Sweetheart. I'll always be here for you. *Forever.*"

I nodded slowly. "I know, Babe. I know that for sure."

They left me alone then with my thoughts, staring at the perforated acoustic tile on the ceiling and the darkened fluorescent light fixtures.

Her words sunk in. A *hero.* A *hero? I did good? I smiled a little. I did. I did GOOD.* I thought of Dad. Clearly, really clearly,

for the first time. Saw his face. His angry, contorted face. Veins bulging, neck muscles distended. Snarling at me, *"You're nothing but a weak little girl! A worthless, sniveling coward!"*

You were wrong, Dad. You were always wrong about me. I shut my eyes then and slept. Dreamlessly.

CPSIA information can be obtained
at www.ICGtesting.com
Printed in the USA
FSHW021117130520
69914FS

9 781981 022700